Pet Photography:
From
Snapshots to
Great Shots

Alan Hess

Peachpit Press

Pet Photography: From Snapshots to Great Shots
Alan Hess

Peachpit Press
www.peachpit.com

To report errors, please send a note to errata@peachpit.com
Peachpit Press is a division of Pearson Education.

Copyright © 2015 by Peachpit Press
All images copyright © 2015 by Alan Hess

Project Editor: Valerie Witte
Senior Production Editor: Lisa Brazieal
Development and Copyeditor: Anne Marie Walker
Proofreader: Patricia Pane
Composition: WolfsonDesign
Indexer: James Minkin
Cover Image: Alan Hess
Cover Design: Aren Straiger
Interior Design: Mimi Heft

ISBN-13: 978-0-133-95355-8
ISBN–10: 0-133-95355-6

9 8 7 6 5 4 3 2 1

Printed and bound in the United States of America

Dedication

To Nadra: Thank you for all your love and support.

And to Odessa and Hobbes: The reasons I started photographing pets in the first place.

Acknowledgements

I want to thank all the pets who patiently modeled for me for this book. Many of the animals in these pages were photographed while looking for their forever homes. I truly hope they'll all find good homes soon.

Thanks to all the pet owners who allowed their pets to be photographed for this project: Luna, Celeste, Audrey, Tony, the Torwicks, Kerry, Carl, Lori, Bill, Lisa, Trevor, Melissa, Scott, Salem, John, Candice, Gigi, Rochelle, Christie, Judith, Sherri, Richard, Paige, Olivia, Kira, Donna, Sheldon, Ashley, Fenella, Kathy, Matt, and Cameron—without you this book would not have been possible.

My gratitude goes out to Audrey for her assistance during many of the shoots. Describing what I was doing while we were photographing the pets made it much easier to then put all the information together to create this book.

Thank you to the team at Peachpit for their hard work and amazingly quick turnaround during the writing process. I could not have done this without Valerie Witte, Anne Marie Walker, Lisa Brazieal, Patricia Pane, and WolfsonDesign, as well as Ted Waitt, who thought this project was something that I should do. I owe a great deal to the Peachpit marketing team, including Scott Cowlin, Sarah Jane Todd, and Sheila Lease for all your hard work in getting this title out there and into the hands of photographers.

A special thanks to Brad Mathews for putting me in touch with Dr. Jeff, who took the time to answer my questions.

Finally, a *huge* thanks to my wife for her love, support, and patience. It is not easy to deal with me when I'm writing a book. Thank you.

Alan Hess
San Diego, CA
July, 2014

Contents

Introduction

Pets are tons of fun to photograph, and their distinct personalities are revealed in every image. But capturing a great shot of your pet can be a challenge. I wrote this book to help you meet that challenge and succeed in turning your snapshots into great shots.

Why I Photograph Pets

Back in 2005, my wife and I rescued a 2-year-old boxer from the San Diego Humane Society and our lives were changed forever. We had been married for a few years, had a house with a yard, and wanted to get a dog. So we started looking for a dog we could give a forever home to. We were looking for a dog, but we ended up with so much more.

Odessa became our constant companion and a part of our family. She also became a willing model for every harebrained photo idea I had. In fact, she got so used to having her photo taken that when she sees me pull out a camera and light, she just walks over in front of me, sits down, and does her best dog pose. Photographing her became not only a way to document her life with us, but also a way for me to recharge my creative batteries. Since then we've adopted another dog, Hobbes, whose photo graces the cover of this book. We worked with a rescue organization to give Hobbes his forever home, and we continue to work with the organization to try to match the animals in need of a home with people who want them.

Who Should Read This Book

I wrote this book for photographers who want to take better photos of their pets or other people's pets. I especially wanted to make sure that novices with their first DSLR would be able to create great photos, along with those who already know about shutter speed, aperture, and ISO. If you've been taking photos for a long time, you might not need all the information in Chapter 2, "Photography Basics," where I cover the basics of light and digital photography. However, the chapter contains some great photos of cool pets, so at least browse through the chapter to see all the images of the dogs, cats, and horses.

Even though dogs and cats are the most popular pets, I tried to avoid writing a book that was just for dog people or cat people. Throughout the book, I cover a wide range of subjects, including horses, birds, rabbits, reptiles, and even rodents. Although I don't own a horse or a snake, you might; therefore, tips and techniques to photograph them are also covered, along with as many photos of different subjects as I could access while putting this book together.

What This Book Covers

Not every photograph of your pet will be a fantastic masterpiece. At times you'll just want to capture a moment in their lives. The tools in this book will help you take better photos or at least give you ideas to consider to improve your photos:

- Chapter 1, "Ten Tips for Pet Photography," gets you started right out the gate. These top-ten tips can really make a difference in your pet images, from keeping the focus on the eyes to getting down to eye level with your subject.

- Chapter 2, "Photography Basics," covers light, exposure, and composition. The light section discusses the different qualities of light, measuring light, and the color of light. The exposure section explains shutter speed, aperture, and ISO, and the composition section describes the rule of thirds, space to move, and leading lines.

- Chapter 3, "The Gear," covers the equipment needed to successfully photograph pets, from the cameras and lenses to flashes and light modifiers.

- Chapter 4, "Working with Animals," discusses what to do and what not to do when you're photographing dogs, cats, horses, reptiles, and birds.

- Chapter 5, "Action Photos," is about capturing the action, both outdoors and inside. Shutter speeds for freezing the action and the best drive mode are covered, along with using a flash and pushing the ISO for those tough indoor shots.

- Chapter 6, "Pet Portraits," explains that taking pet portraits is more than just taking a snapshot of your pet. This chapter covers locations, backgrounds, lighting, and tricks to get your pet to pose.

- Chapter 7, "All Creatures Great and Small," deals with the wide variety of animals that are kept as pets, including dogs, cats, horses, birds, fish, rabbits, reptiles and amphibians, and rodents. Useful tips are provided to help you photograph these diverse companion animals.

- Chapter 8, "Working with Challenging Subjects," the final chapter, looks at some of the more challenging aspects of pet photography, including photographing the young and old, photographing multiple pets in the same image, and photographing pets along with their owners.

- The Appendix, "Working with Rescue Organizations," describes how working with an animal rescue can be a very rewarding endeavor. It also covers what you can offer these organizations and what you can get out of your time spent working with animals.

The Assignments

Assignments are listed at the end of each chapter. But don't worry; there is no grade or deadline; however, that doesn't mean you should ignore them. The best way to learn new techniques and improve your photography is to put the information you just read into practice. That's exactly what the assignments help you do. Each gives you suggestions on how to practice some of the approaches covered in the chapter. Rehearsing new techniques before putting them into practice during an actual photo shoot will give you confidence and reduce the pressure and stress for both you and your subject, allowing you to get it right when it counts.

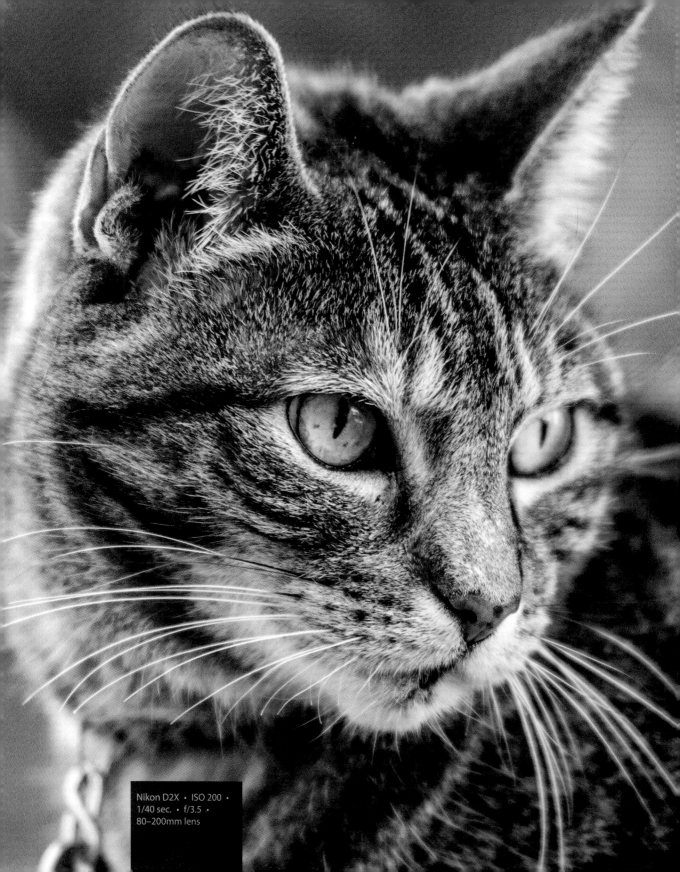

Nikon D2X • ISO 200 •
1/40 sec. • f/3.5 •
80–200mm lens

1
Ten Tips for Pet Photography

Quick tips to get you started

Taking photos of your dog, cat, hamster, horse, or any pet can be quite challenging. They don't really pose for the camera all that well and are easily distracted. If you want a quick way to start and don't feel like reading the entire book right now, I've put together ten tips to get you off and running. These tips are a great starting point, and each will be covered in more detail throughout the book.

I placed the focus point right on the eye because it's important to keep the eye in focus.

Getting down to the cat's level produces a more intimate shot.

This photo was taken in the late afternoon as the cat got ready for his nap on the porch. I waited until the cat had decided where to rest for the afternoon, and then started to take a few photos, waiting for the moment when he looked right at me.

The background is blurred by using a wide-open aperture, which creates separation between the subject and the background.

Nikon D4 · ISO 400 · 1/2500 sec. · f/4 · 70–200mm lens

1. Focus on the Eyes

When you photograph animals (and people for that matter), it is important to make sure that the eyes are in focus. When you take photos of people, you don't have to worry too much about the depth of field and keeping the eyes and nose in focus unless you are using a very wide aperture. However, photographing animals is a different story, because their faces can be much longer and their eyes and nose might be very far apart. This is more of an issue with dogs and horses than it is with cats and birds, for example, but it is a factor you have to be aware of. Using the depth of field is covered at length later in this chapter and in much more detail in Chapter 2, "Photography Basics."

In the following examples, you can see the difference between the focus point being on the nose of the dog and being on the eye. In **Figure 1.1**, the focus is on the nose of the dog, and because the image was taken at f/2.8, the eye is out of focus. In **Figure 1.2**, the focus is now on the eye, but the nose is out of focus. In **Figure 1.3**, the focus is on the eye, and because the aperture is now f/10, both the eye and the nose are in acceptable focus.

Make sure you focus your camera on what you want to call attention to—the eye. The auto focus system will usually focus on the subject closest to the camera. Put the focus point directly on the eye of the subject.

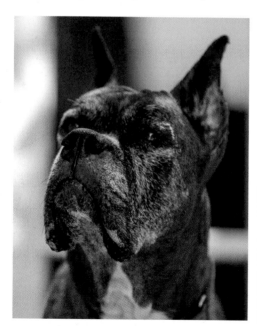

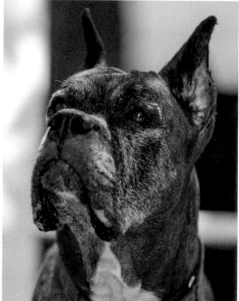

Figure 1.1 **The focus point is directly on the nose of the dog, missing the eye completely.**

Nikon D4 • ISO 800 • 1/3200 sec. • f/2.8 • 70–200mm lens

Figure 1.2 **The focus point is now over the eye, but the very shallow depth of field puts the nose out of focus.**

Nikon D4 • ISO 800 • 1/3200 sec. • f/2.8 • 70–200mm lens

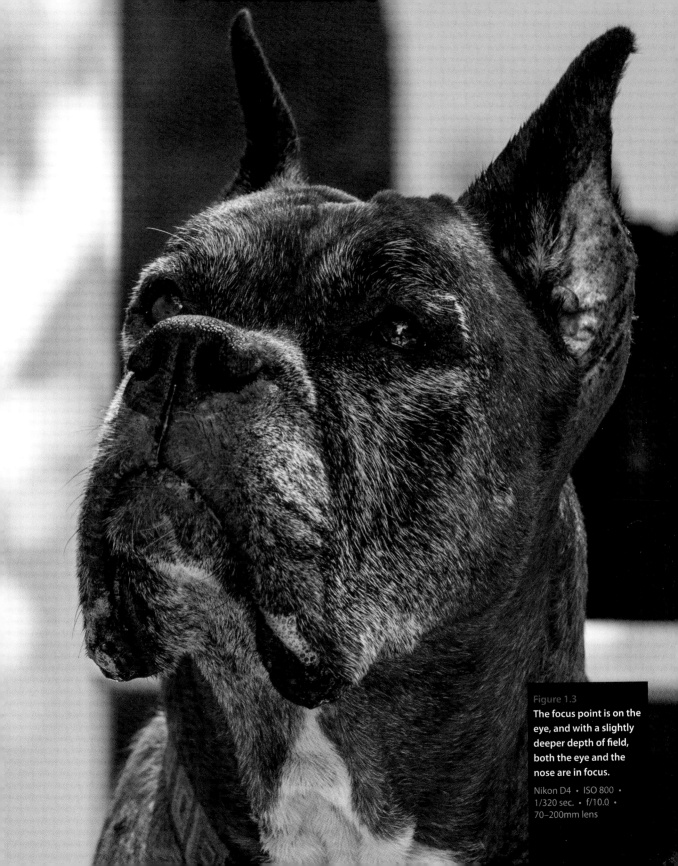

Figure 1.3
The focus point is on the eye, and with a slightly deeper depth of field, both the eye and the nose are in focus.

Nikon D4 · ISO 800 ·
1/320 sec. · f/10.0 ·
70–200mm lens

2. Be Patient

Getting your pet to pose can be an exercise in futility. Animals don't take direction like a human model unless they are well trained. Chances are that the minute you start pointing the camera in their direction, they think it's the perfect time to run right at you and play. Just let them. It might take a few minutes (or longer) for that play behavior to wind down, at which point you can pick up the camera and start capturing images (**Figure 1.4**). Patience pays off.

Getting that great shot can be very frustrating, because no matter how well trained your pet is, they still don't always understand exactly what you want from them. Relax, take a deep breath, and keep your cool. Animals can sense when you start to get frustrated, or worse, angry, and then the situation can go from bad to worse.

Using a longer focal length can help in this instance as well, allowing you to photograph the animal from farther away and not get right in the animal's space.

Figure 1.4 It took a while, but finally the cat relaxed and lay down, giving me the opportunity to capture the shot I wanted.

Nikon D4 · ISO 400 · 1/1600 sec. · f/4 · 70–200mm lens

3. Set Up Beforehand

The best way to miss that once-in-a-lifetime shot of your pet is to not have your camera ready to go before trying to get the photo. If you're not prepared, you'll have to focus and possibly adjust the exposure settings before taking the photo. But you can do the following to make sure you spend as little time as possible messing with your gear:

- **Format the memory cards in the camera.** Formatting deletes all the images on the memory card, so make sure you save or back up any older photos to your computer. Formatting the memory card in the camera readies the card to save the photos.

- **Charge the battery.** Nothing is more frustrating than taking photos and running out of power. The first accessory you should buy for any camera is a spare battery, and keep both the main and spare battery charged at all times.

- **Remove the lens cap.** Although removing the lens cap sounds simple, there are still times when I raise the camera to my eye only to see nothing because I've forgotten to remove it. That second or two it takes to reach around and remove the lens cap can mean the difference between a good photo and a great photo.

- **Set the initial settings.** The initial settings will depend on the exposure mode that you've chosen to use. You can set the shutter speed, aperture, and ISO as needed depending on the light in the scene. Just aim the camera at the spot the pet will be in and take a photo (**Figure 1.5**). Then check the photo on the back of the camera, making sure the light is right and the exposure is correct.

- **Attach the right lens.** Are you shooting from far away with a telephoto lens or close up with a wide angle? Make sure that whichever lens you plan on using is attached to the camera and ready to go. You really don't want to juggle lenses in the middle of the shoot.

Figure 1.5 **Knowing that the cat liked to sit on the counter, I cleaned off the area and made sure that my camera was set up and ready to go. Then it was just a matter of getting the cat to jump up and sit in his spot.**

Nikon D3200 · ISO 1600 · 1/125 sec. · f/4 · 17–55mm lens

- **Clean up the area.** Look around the area where you plan on photographing your subject. Can you move or adjust any items that will be distracting before the shoot starts? Anything you can do to minimize distracting elements in your photos you should do before the shoot.

- **Get a reward ready.** You can and should use treats to help get the best pose from your pet. So have a treat, or five, ready to reward your model. Also, have a clean cloth ready to wipe off the drool that will probably be present the minute the treats are used. Some animals are more interested in toys than treats, so having a favorite toy nearby is a great reward.

All this preparation does pay off when you finally take the photos. With the preparation out of the way, you can concentrate on the composition and make sure you capture the perfect moment (**Figure 1.6**).

Figure 1.6
This is the portrait I took in the area shown in Figure 1.5.

Nikon D4 · ISO 1600 · 1/320 sec. · f/2.8 · 24–70mm lens

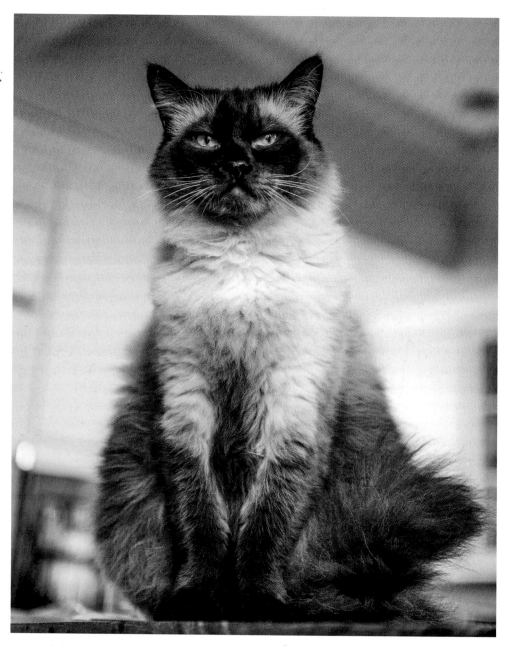

4. Know Your Subject

No one knows your pet the way you do. You know what will calm them down or get them all riled up. You know their favorite spot to take a nap and where they go to sit in the sun. You can use this information to increase your odds of getting great shots of your pet (**Figure 1.7**).

If you are photographing someone else's pet, you can still get and use this information. Talk to the pet owner a few times well before the shoot and have them tell you about their pet. Discuss all the details that make their pet so special. The more information you have before the shoot, the better off you'll be to take the best shots.

Figure 1.7
This was the easiest photo in the book to take. Our dog loves to lie in the same spot in the afternoons looking out to the yard. All I had to do was go outside and wait for him to look at me. Easy as pie.

Nikon D700 •
ISO 800 • 1/60 sec. •
f/4 • 70–200mm lens

5. Use the Right Lens

Different focal lengths can render the same scene in very different ways. Long focal lengths render subjects in a more flattering way (**Figure 1.8**), whereas shorter lengths can cause some distortion. The distortion that results when you shoot with a wide-angle lens can cause a subject to bulge. When you're shooting people with a wide-angle lens, photos can look odd because their noses seem bigger and their faces thinner. With animals, like dogs and horses, this effect can become very pronounced because they have longer faces than people. Their noses will seem even longer and more pronounced, and their heads even thinner.

If you are creating portraits of people, bulging noses and thinning heads don't make for a good look, but these effects can create an interesting photo of your pet. Just know that the focal length is creating this effect.

Figure 1.8
Using a long focal length (160mm), I minimized the background, which kept the focus on the dog.

Nikon D600 •
ISO 1600 • 1/640 sec. •
f/4.0 • 70–200mm lens

When you use a normal focal length that is between 35mm and 60mm, the resulting image is very close to what the human eye sees. This allows people viewing the image to feel like the scene is happening right in front of them. You can see this in **Figure 1.9**, where I used a focal length of 48mm to photograph the very playful Great Dane.

Chances are good that your camera came with a zoom lens as part of a kit. Go out and take a couple of shots using the wide settings. Then zoom all the way in, step back until the pet is the same size in the frame as when you zoomed in, and take more photos. You will easily be able to see the difference in the background and how your pet is rendered.

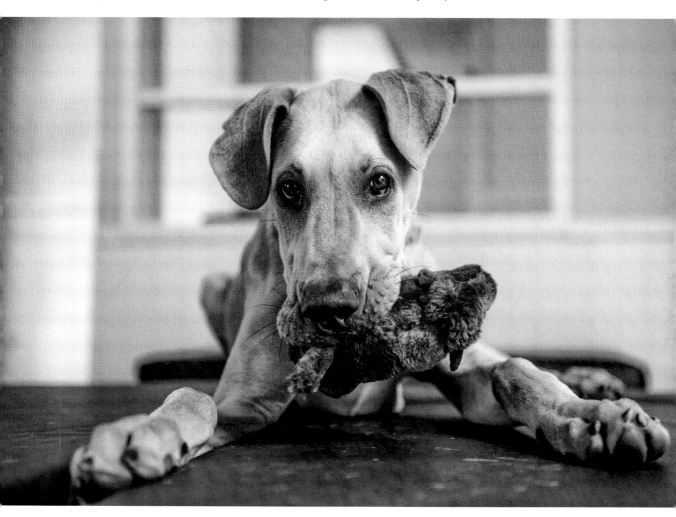

Figure 1.9 This Great Dane puppy really loved chewing on his toys. I photographed this up close with a 24–70mm f/2.8 lens at 48mm.

Nikon D600 · ISO 3200 · 1/640 sec. · f/2.8 · 24–70mm lens

6. Use the Depth of Field

The depth of field controls how much of your image is in focus. Using a wide-open aperture creates a shallow depth of field. This technique will blur the background and make the pet stand out against a busy background. **Figure 1.10** and **Figure 1.11** show the huge difference a shallow depth of field can make.

The depth of field is determined by the size of the opening (aperture) in the lens. The larger the opening, the more light is allowed through to reach the sensor and the shallower the depth of field.

Chapter 2 and Chapter 3, "The Gear," discuss more details on aperture and depth of field, because it is one of my absolute favorite methods of turning a good shot into a great shot.

Figure 1.10 A quick portrait of my dog sitting in the grass in my backyard. The background is very distracting because the grass and trees are very noticeable due to the deep depth of field.

Nikon D4 · ISO 500 · 1/80 sec. · f/14.0 · 70–200mm lens

Figure 1.11 Using a shallow depth of field blurs the background. Now my dog really pops out of the photo.

Nikon D4 · ISO 500 · 1/2000 sec. · f/2.8 · 70–200mm lens

7. Change Perspective

If you want your images to have more impact, get down on the same level as your pet and photograph them eye to eye. Photographing from above looking down at your pet creates a perspective that you see every day (**Figure 1.12**), but getting down to their level can create a great sense of intimacy (**Figure 1.13**).

Just about every pet photography session ends with me lying flat on the ground. In practical terms, wear clothing that you don't mind getting covered in hair or getting a little dirty. Even when I was photographing Hobbes, our dog, for the cover of this book, I found myself lying in the wet grass waiting for just the right moment.

Figure 1.12 **This is a pretty normal photo of taking a shot of a pet while standing up with the camera pointed down. It's not a bad photo, but it has a snapshot feel to it.**

Nikon D4 · ISO 3200 · 1/250 sec. · f/4 · 24–70mm lens

Figure 1.13 **This photo of the same dog using a very different angle changes the entire photo.**

Nikon D4 · ISO 3200 · 1/250 sec. · f/4 · 24–70mm lens

8. Turn Off the Flash

Turning off the flash when you're taking photos of pets is best for many reasons. The bright light can startle animals, making your job a lot more difficult. You are trying to create a calm environment, a place where the pets can relax and allow their personality to shine through. The hard light of the flash, especially the built-in flash, can destroy that peaceful environment and the results are usually mediocre at best.

In addition, a flash, especially the built-in flash, can cause red-eye (or blue-eye) in animals the same way as it does in humans (**Figure 1.14**). The light from the flash fires so fast that the pupil doesn't have time to close, so the light reflects off the back of the eyeball and out through the eye. This is particularly noticeable when the flash is positioned very close to the lens.

When you're photographing fish, birds, or anything in a tank or cage, the flash can cause an ugly reflection.

Figure 1.14
Using the pop-up flash on the camera results in red-eye or blue-eye, which occurs when the light from the flash is reflected back at the camera from the rear of the eye.
Nikon D3200 •
ISO 800 • 1/125 sec. •
f/5.6 • 40mm lens

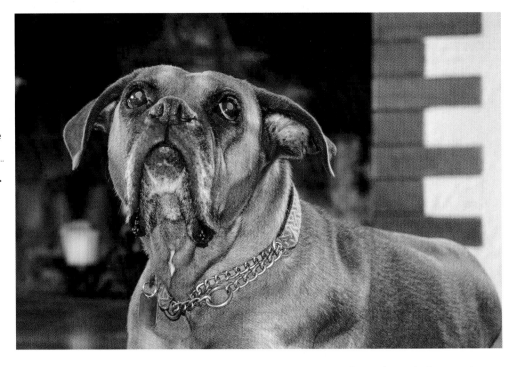

As an alternative to the flash, try to use natural light coming through a window or door (**Figure 1.15**). You might have to increase the ISO or use a slower shutter speed to get a proper exposure, but the results will be worth it. Using a flash is covered in more detail in Chapter 6, "Pet Portraits," which includes how to use a flash off your camera to get great portrait results.

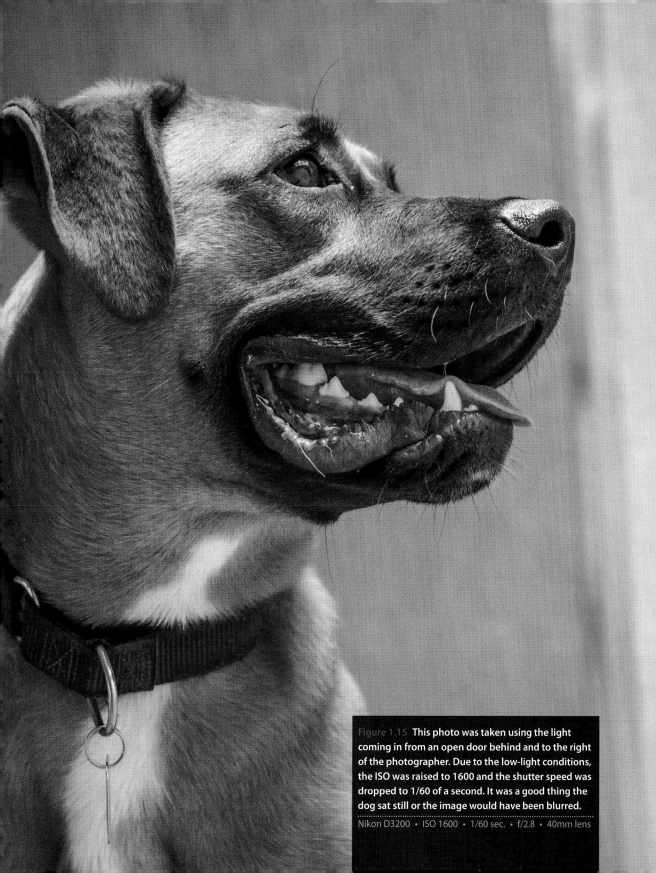

Figure 1.15 This photo was taken using the light coming in from an open door behind and to the right of the photographer. Due to the low-light conditions, the ISO was raised to 1600 and the shutter speed was dropped to 1/60 of a second. It was a good thing the dog sat still or the image would have been blurred.

Nikon D3200 • ISO 1600 • 1/60 sec. • f/2.8 • 40mm lens

9. Hand Out Rewards

One of my dogs loves treats, making it very easy to get her attention and have her pose for photos. My other dog loves tennis balls, and even though he'll sit for a treat, he will do anything to get his teeth into a ball. Knowing and using this information makes taking their photos easier. You can use rewards to get pets to cooperate with your photography endeavor by using them to get the pet to sit where you want and actually control where they look. This is when having an assistant or helper really pays off. When you're photographing other peoples' pets, you can have the owners hold the treat for their pet, which will allow you to focus on the composition (**Figure 1.16**).

When you're using a reward to elicit a behavior from a pet, make sure that you actually give them the reward. Don't just tease them with it, or it will lose its power. When you're using a food treat, make sure that you remove any drool or crumbs if you don't want them in the shot. When you're using a toy as a reward, once you give the pet the toy, there is a good chance the shoot will be over.

Figure 1.16
It's easy to get your model's attention if you have the right treat.

Nikon D4 · ISO 800 · 1/125 sec. · f/5.6 · 70–200mm lens

10. Stay Safe

Safety is extremely important when you're dealing with animals—both your safety and the safety of your subject. Never do anything that could put you, your pet, or any other person or animal in any kind of danger.

Some specific considerations to think about include the following:

- Make sure your dog is on a leash when in a public area unless it is a specific leash-free area (**Figure 1.17** on the following page). Even in these spots, make sure that your dog is safe and well behaved.

- Pay attention to any other people or animals in the vicinity. Many times, other animals in the area will be interested in what you're doing, especially if you lie down or shoot from a low position. Keep an eye open for these animals as well as your own.

- Make sure that your pet doesn't get overheated or overly stressed. When animals get excited, they can overheat or get overstimulated and start to act out. Keep the shoot light and fun, and watch for panting or rapid breathing.

- Look out for any cars or other vehicles. Pay close attention to cars when you're working anywhere near a road or parking lot. Often, drivers don't see the animals because they are too short—the same can be said for photographers lying on the ground. Either have a friend keep a lookout for you or pay attention to the surroundings yourself.

- Don't take indoor animals outdoors just to get a shot; they could easily bolt. This is especially important when you're dealing with indoor cats or any bird or rodent. No photograph is worth losing a pet over.

As the photographer, it is your job to control the shoot and make sure that nothing harmful happens. If you're photographing your own animals, you know what they can and can't (won't) do. If you are photographing someone else's animals, check with them before you try anything to make sure that they and their animals are comfortable with what you are asking.

When in doubt, stop.

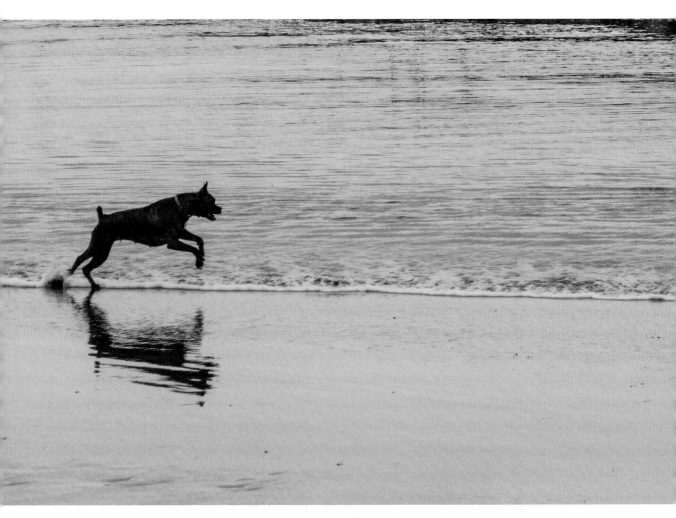

Figure 1.17 This photo was taken at a specific off-leash beach where it was possible to allow the dog to run in the water.

Nikon D200 · ISO 200 · 1/500 sec. · f/4.5 · 17–55mm lens

Chapter 1 Assignments

Try Different Apertures

Mastering control over the depth of field can make a huge difference in your photos but can be difficult to control when you're starting out. Set your camera to Aperture Priority mode and photograph your subject at the widest aperture you can. Then make the aperture one step smaller and shoot again. Keep making the aperture smaller one step at a time, and look at the sequence of photos. Which aperture had the right balance of the subject in focus with the background blurred?

Practice Patience

Being patient and remaining calm is key to getting great pet photos. Just sit with your camera and watch your pet. You don't even have to take a photo, but you do need to watch every little move they make. Just sit there and watch them until they calm down and start to ignore you. Then pick up your camera and take a photo.

Lie Down on the Job

We see the world from upright perspectives and that needs to change when you're photographing pets. Lie down on the floor and look at the world from their viewpoint. Check out the backgrounds at that height and what could be distracting in an image. Practice shooting while lying down or with your camera close to the ground aimed slightly up.

Share your results with the book's Flickr group!
Join the group here: flickr/groups/petphotographyfromsnapshotstogreatshots

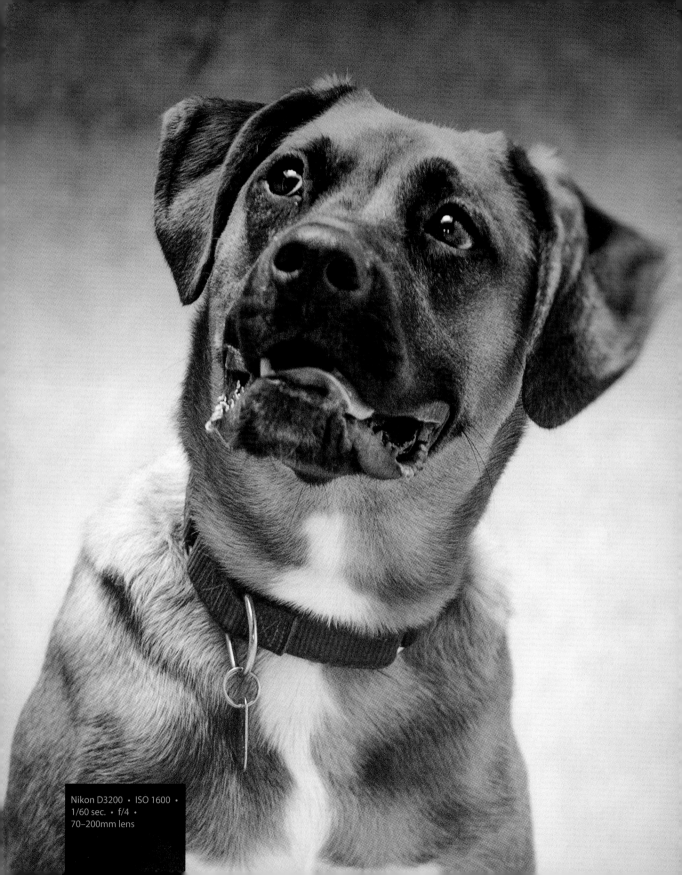

Nikon D3200 • ISO 1600 •
1/60 sec. • f/4 •
70–200mm lens

2
Photography Basics

The fundamentals of light and digital photography

To successfully turn your pet snapshots into great shots, you do need to know a little about light and how it relates to digital photography. Today's cameras are a marvel of electronics that can read the light in the scene, pick the settings to get a proper exposure, and capture pretty good photos, and all you have to do is press the shutter release button.

But to take full control of your photography, you need to start with light, and then move on to adjusting the camera settings so *you* decide how the image is captured, not the camera.

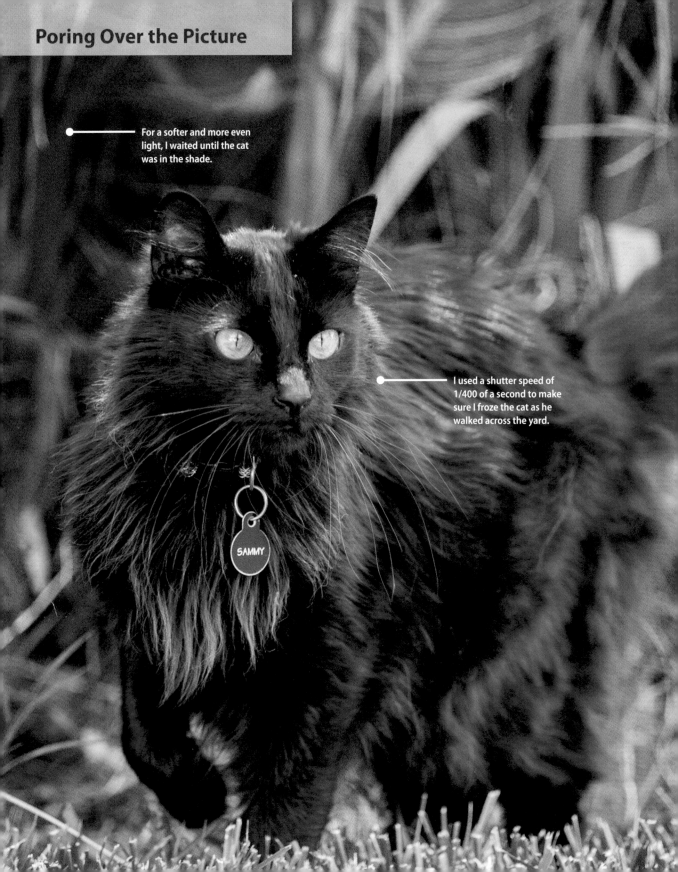

Poring Over the Picture

For a softer and more even light, I waited until the cat was in the shade.

I used a shutter speed of 1/400 of a second to make sure I froze the cat as he walked across the yard.

SAMMY

Using an aperture of f/2.8 created the shallow depth of field.

Photographing a black cat outside can be a real challenge, especially when he is constantly moving. I waited until he was walking through a patch of shade at the side of the yard and used a wide aperture to get a shallow depth of field. Using Spot Metering to check the exposure, I photographed the cat in Manual mode so I could control the exposure.

Nikon D4 · ISO 800 · 1/400 sec. · f/2.8 · 70–200mm lens

Poring Over the Picture

This photo was taken in the late afternoon on a cloudy day, making for a soft light with no harsh shadows. The puppy was sitting between two planter boxes, and the lines from the wood help draw the eye in. I also made sure that the eye was in focus, and that I was down on the same level as my subject, creating a more intimate portrait.

The lines from the brickwork on the wall also help lead the eye in toward the puppy.

Nikon D3200 · ISO 600 · 1/250 sec. · f/9.0 · 17–55mm lens

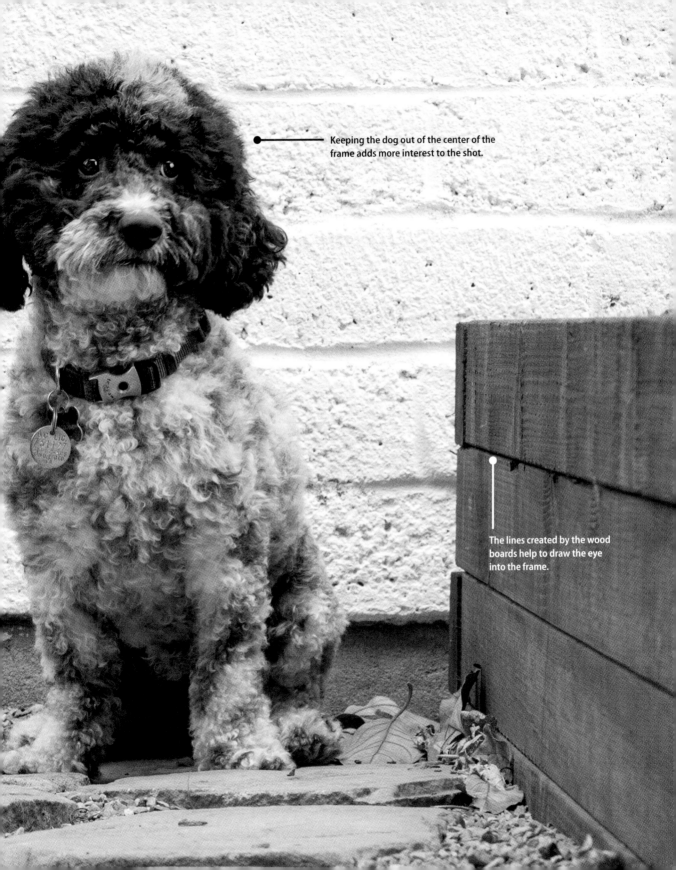

Keeping the dog out of the center of the frame adds more interest to the shot.

The lines created by the wood boards help to draw the eye into the frame.

The Importance of Light

The most important part of photography is the light. In fact, photo means light. The light determines what you can see and capture, as well as the mood of the image. The way you use the light can make all the difference between the image looking like a snapshot or a great shot.

Many of us were taught at a young age that you needed to put the subject of your photo in the brightest light possible. I still have memories of squinting with the sun beaming directly into my face while being told to smile. This bright, hard light never made anyone look good. But some of the best light is right next to that beaming sunlight, as you can see in **Figure 2.1**. The edge of the light coming through the door was used to illuminate the cat.

Figure 2.1
Sammy the cat sat just inside the door leading out to the yard. You can tell how bright it is outside from how small his pupils are.
Nikon D4 · ISO 400 · 1/400 sec. · f/2.8 · 70–200mm lens

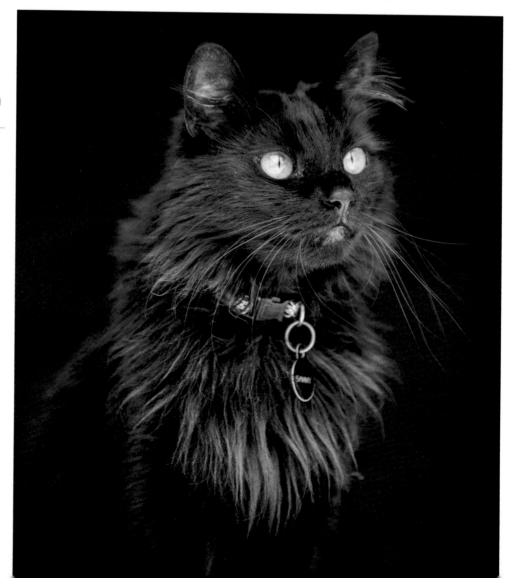

Types of Light

Most people take light for granted and don't often stop to really look at it. The various light sources all around us have very different properties, and you can think about the light present in a scene in many different ways. I like to think in terms of the existing light, or available light, and the light that I add, or supplemental light:

- **Available light** is any light that is already present in a scene. This is mainly sunlight outside or sunlight inside coming in through a window or door, or it could be artificial light that you can't really control, like the city lights at night.

- **Supplemental light** is the light that I bring with me to help illuminate the scene. It could be big studio lights, but more often than not it is just a couple of dedicated flash units and a way to trigger them off-camera.

To better suit your needs, you can modify both types of light. For example, the available light coming in through the window in **Figure 2.2** has been reflected back at the subject. I also could have used a flash to add more light to the room.

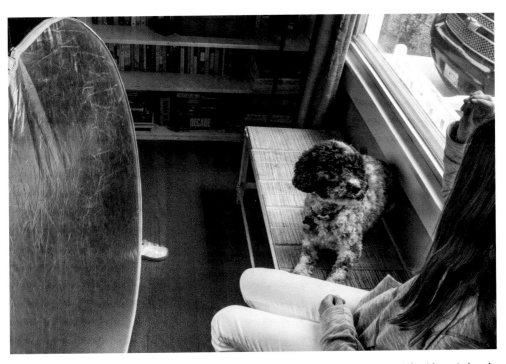

Figure 2.2 Not enough light was coming in through the window to illuminate the dog's right side, so I placed a large reflector there to bounce the available light.

Nikon D3200 · ISO 400 · 1/200 sec. · f/7.1 · 17–55mm lens

Qualities of Light

When you start to take photographs, you need to look at the light in several ways. You need to start looking at the qualities of the light, which include hard and soft light, the color, the direction, and the intensity.

Hard and Soft Light

Photographers often describe light as being either hard or soft. The actual light is not different; rather, these two terms describe how the light interacts with the subject it is illuminating. The easiest way to think about hard and soft light is to think of the shadows produced by the light. Hard light creates hard shadows, whereas soft light creates soft shadows.

The easiest example of hard light is the effect of the sun on a cloudless day. The shadows from the sun are very sharp, with practically no transition between the light and dark at the edge of the shadow (**Figure 2.3**). The reason the sun produces such a hard light is because it is a relatively small light source. Now, I didn't forget my science class; I know the sun is huge, but it is also very, very far away, making it relatively small to us.

Figure 2.3
Taken in the early afternoon, you can clearly see the hard shadow under my dog's head, which was created by the hard sunlight.

Nikon D4 · ISO 400 · 1/4000 sec. · f/4.0 · 70–200mm lens

If hard light is created by a relatively small light source, then soft light is created by a relatively large light source. Let's go back to the example of the sun, but this time let's look at the shadows on a cloudy day. They don't have the same hard edge to them, and the transition between the light and shadow is much larger. The reason is that instead of the small hard sun in the sky illuminating the scene, the clouds are now the new light source. They act as a diffusion between the sun and the subject (**Figure 2.4**). You'll find more information on diffusers and controlling light in Chapter 3, "The Gear."

Figure 2.4
Photographed in the shade of the fence, you can see that no hard shadows exist; actually, there are no shadows at all. The shaded area created a nice soft light.

Nikon D4 · ISO 400 · 1/400 sec. · f/2.8 · 70–200mm lens

Color of Light

The color of light is determined by its source. It might all look the same to us, but that's because our eyes and brains automatically adjust for any color cast. You can easily see how this works with a blank piece of white paper. Take the white paper outside and look at it under the direct sunlight; then take it inside and look at it under a fluorescent bulb or under a household incandescent bulb. The paper will look white to you in every situation. Now photograph that same paper under the different lights, and you'll see that the paper has different color casts depending on the light source. The way to fix this issue when you're photographing a subject is to tell the camera what type of light is illuminating the scene. You do this by setting the white balance. The proper white balance will render the colors in the scene accurately. Here are basic White Balance settings available on most cameras.

- **Auto.** In Auto mode the camera looks at the light present when the shutter is released and tries to render the resulting image as naturally as possible. I keep my camera set to this mode most of the time because it produces the proper color in most situations (**Figure 2.5**).

- **Incandescent.** Incandescent bulbs create light by heating a filament inside the bulb. The light produced by these bulbs is much redder than sunlight, so the camera adds in a little blue to make the subject look a bit more natural. Incandescent bulbs were the most common type of household bulbs in use, but that has started to change with the introduction of LED and compact fluorescent bulbs.

- **Fluorescent.** Fluorescent lights work by running an electric current through a gas-filled tube. The color of the light depends on the type of gas(es) in the tube. One significant issue when you're photographing under normal fluorescent tubes is that any small fluctuation in the current running through the bulb can cause changes in the color of the light.

- **Sunlight.** The Sunlight setting is best used when you're photographing under a clear, cloudless sky in the middle of the day. However, I rarely use this setting because I seldom photograph outdoors under the harsh sun during the middle of the day.

- **Flash.** The Flash setting is used when you're photographing using a small flash, like the Nikon SB-910. The Flash White Balance setting is very similar to the Sunlight White Balance setting because flash manufacturers make the light produced from the flash closely match the color of sunlight.

- **Cloudy.** Sunlight filtered through clouds can make an image look a little cool. This White Balance setting adds just a touch of warmth back into the image.

- **Shade.** The light in the shade is much cooler than direct sunlight and cloudy light. When you're using the Shade White Balance setting, the camera adds a lot of warmth (red/orange) into the image (**Figure 2.6**). I typically use the Cloudy setting instead of the Shade setting because it adds a little red into the image but retains the overall feeling of the shade.

- **Color Temperature.** The Color Temperature setting allows you to set the white balance by setting the actual color temperature directly. This is useful if you happen to know the color temperature of the lights you are shooting under. For some studio strobes and continuous lights, the color temperature information is available.

- **Preset.** The Preset setting allows you to set a custom white balance, which is particularly useful when you're photographing under mixed light sources.

To set the white balance on your camera, refer to your camera manual. Most of the time I leave the white balance set to Auto for two reasons: First, the Auto setting does a very good job most of the time; second, I can adjust the image later using image-editing software like Adobe Photoshop or even iPhoto.

Light can also pick up color if it is bounced off a colored surface. Be sure to look for such a surface if you're getting a color cast to your images and you're not sure why. For example, if you're photographing a pet in a living room using the light coming in through a window and a small table with a red tablecloth is off to the side, part of the photo might have a red cast. A red cast is probably easy to see, but what if the walls in the room are a nice light brown? The light that bounces off these walls will not have the same color as the light coming in through the window.

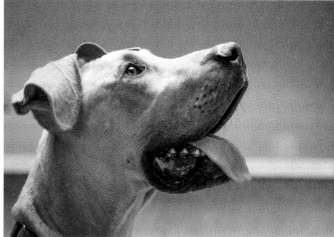

Figure 2.5 Photographed indoors under fluorescent tubes with the white balance set to Auto, the image of this loveable pooch resulted in a natural-looking color.

Nikon D4 · ISO 3200 · 1/500 sec. · f/2.8 · 24–70mm lens

Figure 2.6 The same image shot using the Shade White Balance setting creates a very obvious color cast.

Nikon D4 · ISO 3200 · 1/500 sec. · f/2.8 · 24–700mm lens

Direction of Light

The direction of the light determines what parts of the subject are seen, what parts are in shadow, and how your subject will look. The easiest way to determine the direction of the light is to look at the shadows and see how they fall, like the shadows created by the fence in **Figure 2.7**. The light can come from five main directions: above, below, the front, the back, and the sides:

- **Overhead lighting.** This is the lighting during the middle of the day when the sun is directly overhead. If the only light is coming from directly overhead, the shadows are usually small and don't help define the subject.

- **Up lighting.** This lighting comes up from below the subject and can look unnatural. Because the sun is above us, up lighting doesn't often occur with available light. However, bouncing a little light up into the subject's eyes can help a portrait by making the eyes look more alive, especially in a pet with dark fur and dark eyes where the details might be hidden.

- **Front lighting.** This light strikes the subject from directly in front as if the light source was attached to the camera. Front lighting can be very flat and lacks shadows to define the subject.

- **Back lighting.** This light is directly behind the subject and can create some very dramatic portraits. Back lighting can cause silhouettes when it is the only light, but when a backlight is added to other lights, it can create a separation between the subject and the background.

- **Side lighting.** When the light plays across the subject from the side, it can really help define the subject.

Intensity of Light

How bright is the light that is illuminating your subject? Are you photographing outside on a sunny day in the middle of summer without a cloud in the sky, or are you photographing in a dimly lit living room? The intensity of the light will determine the settings you need to make a proper exposure.

The brighter or more intense the light, the less time you need to keep the shutter open and the smaller the aperture you can use (**Figure 2.8**). If you're using a bright light, you can use a lower ISO and still get a good exposure.

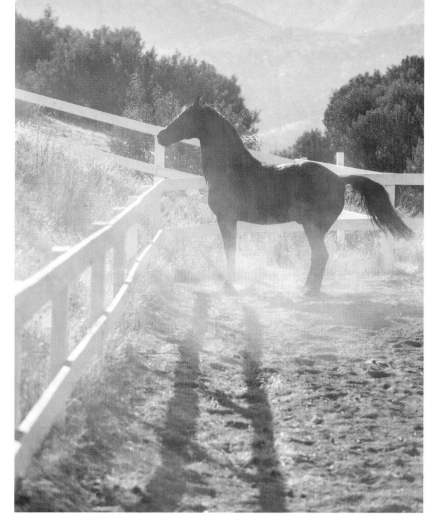

Figure 2.7
Looking at the shadows created by the white fence you can easily determine where the light is coming from. As an added bonus, the fence acts as a great example of leading lines, drawing the eye right into the horse.

Nikon D5200 · ISO 400 · 1/125 sec. · f/9.0 · 17–55mm lens

Figure 2.8
It was a bright sunny afternoon with plenty of light available for me to freeze the action. If the light had less intensity, I would have had to either increase the ISO or open the aperture wider.

Nikon D4 · ISO 400 · 1/4000 sec. · f/5.6 · 70–200mm lens

Measuring Light

When you take a photo, you are capturing the light as it bounces off the subjects in your images. You control the amount of light that the camera captures, but how do you know how much light is present? You need a way to measure the light. One way to do this is to use a separate light meter; an easier way is to use the light meter built into the camera.

Metering Modes

The camera has a built-in light meter that looks at the light coming in through the lens and tries to determine the best combination of shutter speed and aperture to produce an image that isn't too light or too dark. However, the camera doesn't actually know what the subject is, so it guesses by averaging all the light values and tries to achieve middle gray. The problems arise when the scene you are photographing doesn't average out correctly. For example, if you are photographing a white dog at the beach, a lot of white will be in the scene and your camera will give you settings that will cause your white dog to look gray. The camera manufacturers have tried to improve on the basic light meter by giving you different metering modes. The three most common metering modes are Spot Metering, Center Weighted Metering, and Matrix Metering (Nikon) or Evaluative Metering (Canon):

- **Spot Metering.** This mode looks at just a small piece of the overall scene and ignores the rest. Most of the newer cameras have linked the spot meter area to the currently selected focus point, allowing you to get a very accurate light reading from whatever you are focusing on.

- **Center Weighted Metering.** This mode looks at the light in the entire frame but pays more attention to the brightness in the center of the frame and less attention to the edges. Originally developed for portraits, this mode doesn't really work all that well because it's rare to have the subject right in the middle of the frame.

- **Matrix Metering or Evaluative Metering.** These smart metering modes are designed to look at the entire scene in front of the camera, break it into parts, and then meter each of the parts to get the best overall results. They work amazingly well for most scenes, but no matter how smart they seem, they are not as smart as the photographer. My camera is set on this mode most of the time and is a great starting point. **Figures 2.9** through **2.11** were all taken at the same time of the same cat in the same light. The only difference was the metering mode used. You can see that there's not much difference between the images except in the cat's face.

Figure 2.9

A photograph of the cat taken in the living room using Aperture Priority and Spot Metering.

Nikon D4 · ISO 1600 · 1/60 sec. · f/3.5 · 24–70mm lens

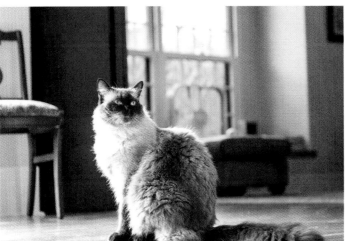

Figure 2.10

A photograph of the cat taken in the living room using Aperture Priority and Center Weighted Metering.

Nikon D4 · ISO 1600 · 1/50 sec. · f/3.5 · 24–70mm lens

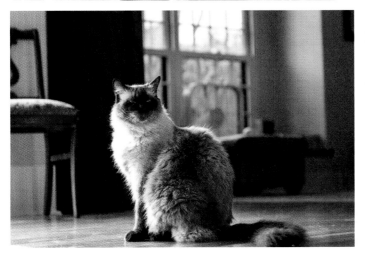

Figure 2.11

A photograph of the cat taken in the living room using Aperture Priority and Matrix Metering.

Nikon D4 · ISO 1600 · 1/80 sec. · f/3.5 · 24–70mm lens

The metering mode you choose will determine how the camera reads the light in the scene. When you start to push down the shutter release button, the built-in light meter starts to work, reading the light coming in through the lens. This information is then used to determine what the exposure should be. The camera can then set one or more of the controls that affect exposure or show you if the settings you have will result in an overexposure or underexposure. Overexposure is when too much light comes in, resulting in an image that is too bright. Underexposure is when too little light reaches the sensor, resulting in an image that is too dark.

Exposure

To control the exposure, you can adjust three settings on your camera and lens:

- **Shutter speed.** The shutter speed controls how long the light is allowed to reach the sensor.

- **Aperture.** The aperture controls the size of the opening in the lens that lets the light through.

- **ISO.** The ISO controls how sensitive to the light the sensor acts.

The goal is to allow enough light to reach the sensor so that the image is recorded in the way you want it to be.

Shutter Speed

The shutter speed is the amount of time that the shutter in the camera is open, allowing the light coming through the lens to reach the sensor when you press the shutter release button. The faster the shutter speed, the quicker the shutter opens and closes (**Figure 2.12**).

The shutter speed is measured in time. Shutter speeds on a camera usually range from 30 seconds to 1/4000 of a second, and on many pro cameras can be as fast as 1/8000 of a second.

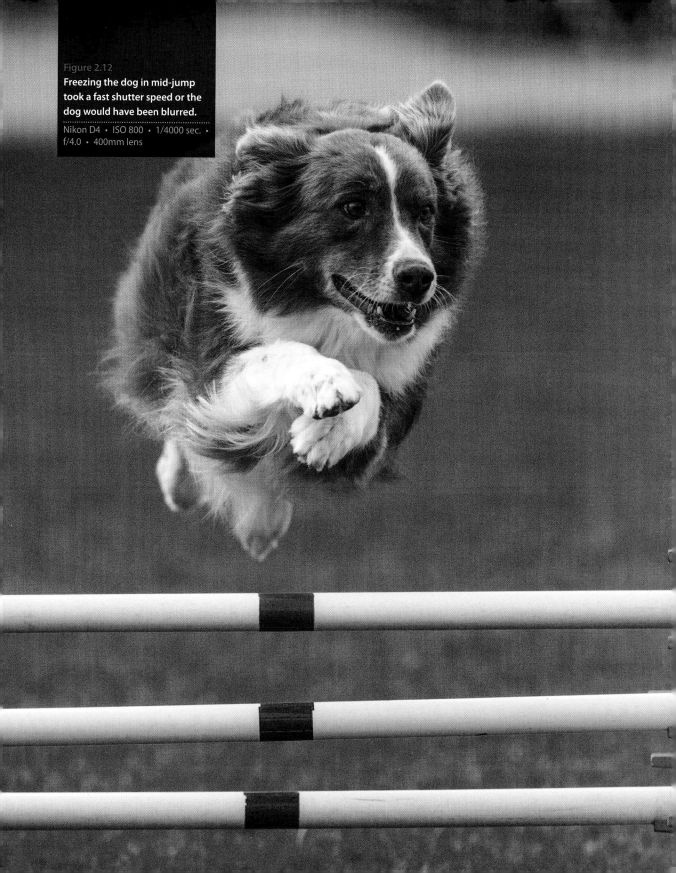

Figure 2.12

Freezing the dog in mid-jump took a fast shutter speed or the dog would have been blurred.

Nikon D4 • ISO 800 • 1/4000 sec. • f/4.0 • 400mm lens

The shutter speed controls how time is rendered in photographs. A fast shutter speed freezes time, whereas a slow shutter speed can capture movement in a single image. Using the right shutter speed is imperative to getting sharp, in-focus images. If the subject of your photos (or the camera) moves while the shutter is open, the result will be a blur in the image.

For example, if you are holding the camera steady and your pet is sitting pretty still, a shutter speed of 1/60 of a second could be fast enough to freeze the action. But if you are trying to photograph your dog running at the park, you'll need a much higher shutter speed, probably 1/500 of a second or faster. Each time the shutter speed doubles, it lets in twice as much light. Each time the shutter speed is halved, it lets in half as much light. **Figure 2.13** shows the full range of shutter speeds measured in seconds or fractions of a second.

If you are using a shutter speed of 1/125 of a second and halve it to a shutter speed of 1/250 of a second, you are letting in exactly half as much light. If instead you double the shutter speed to 1/60, you are now letting in twice as much light. Each of these changes is called a *stop*. Photographers use the term stop to describe the change in light.

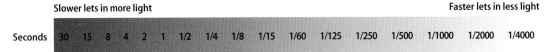

Slower lets in more light Faster lets in less light

Seconds 30 15 8 4 2 1 1/2 1/4 1/8 1/15 1/60 1/125 1/250 1/500 1/1000 1/2000 1/4000

Figure 2.13 **The shutter speeds available on most cameras range from a very slow 30 seconds to a very fast 1/4000 of a second.**

Aperture

The aperture is the opening in the lens that allows light to reach the sensor. The size of the opening is described using a mathematical formula resulting in a fraction. This is called the *f-stop* and is the way photographers describe the aperture. The fraction, or f-stop, is represented as f/2.8 or f/8.0. The important part to remember from math class is that the larger the denominator, the smaller the fraction. With apertures, because the numerator is constant, that is f, you really only have to consider the denominator. So, the bigger the number after the f/, the smaller the opening in the lens. This concept can take some getting used to.

The larger the opening, or aperture, the more light is allowed to pass though the lens. **Figure 2.14** shows the relative size of the openings and their corresponding f-stops.

Figure 2.14
As you can see, the size of the opening drastically changes with each aperture.

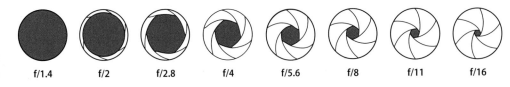

f/1.4 f/2 f/2.8 f/4 f/5.6 f/8 f/11 f/16

The different apertures not only control how much light is let through the lens but the depth of field. When you focus on a point in the scene in front of your camera, an area in front of and behind that point is also in acceptable focus. This area can be very large or very small and is called the *depth of field*, which is an incredibly powerful creative tool. Controlling the depth of field allows you to dictate what is important in your image and what people will look at. When people look at a photograph, their eyes go to the brightest, sharpest point in the image. By using the depth of field, you can control how much of the image is in focus and how much is out of focus.

The smaller the aperture, the greater the depth of field. However, the depth of field has a little more to it than just the aperture: The focal length and the distance between the lens and subject also have an effect:

- **Aperture.** The size of the aperture plays a big part in the depth of field; the larger the opening, the shallower the depth of field.

- **Focal length.** The longer the focal length, the shallower the depth of field. When you use a larger focal length, you need to make sure the focus is on the critical part of the scene or the important parts of the photo could be out of focus.

- **Distance.** The closer you are to your subject, the shallower the depth of field. When you're photographing a subject from a distance, the entire scene might be in acceptable focus. But when you move in closer to fill the frame with the subject, the depth of field will be drastically reduced.

The depth of field is always greater behind the subject than it is in front of the subject. That is, more of the scene behind the point of focus will be in focus than the area in front of the focus point, as you can see in **Figure 2.15**.

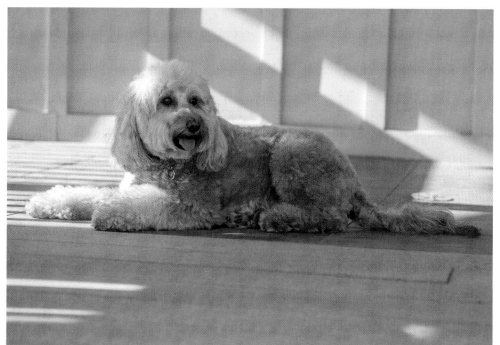

Figure 2.15
For this shot, I used an aperture of f/4.0, which kept the whole dog in focus. You can see how the area in the foreground is blurred and how the wall behind the dog is slightly blurred, keeping the attention on the pet being photographed.

Nikon D3200 •
ISO 800 • 1/500 sec. •
f/4.0 • 17–55mm lens

ISO

The ISO setting controls how much of the information that the sensor records is amplified by the camera. The higher the ISO, the more the signal from the sensor is amplified and the less light is needed. The downside to using very high ISO values is the digital noise that can be introduced into the image. This used to be a much bigger issue in the past, but camera manufacturers have really improved the high ISO capabilities of their cameras. You can now photograph with ISOs much higher than in the past and still end up with a relatively noise-free image (**Figure 2.16**).

The ISO is measured as a numerical value; the higher the number, the more sensitive to light the sensor appears to be. The ISO of modern DSLR cameras ranges from ISO 100 to ISO 6400 and higher. Each time you double the ISO, it makes the sensor seem twice as sensitive to light, meaning you need half as much light to get the same result. For example, ISO 1600 makes the sensor twice as sensitive as ISO 800.

Figure 2.16
Photographing this cat was a challenge because she didn't want to sit in the middle of the room where there was more light. I increased the ISO to 6400 to get this photo. What would have been a very noisy image in the past is now relatively noise free.

Nikon D4 · ISO 6400 · 1/50 sec. · f/2.8 · 24–70mm lens

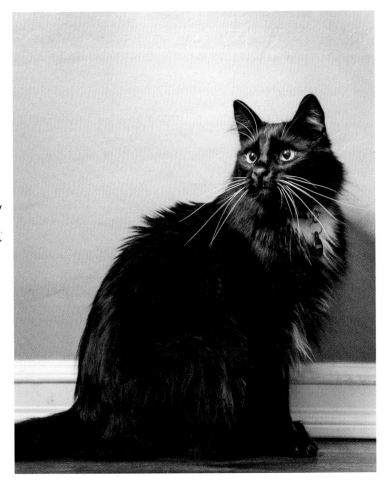

Exposure Modes

The exposure mode tells your camera which exposure setting you will set and which settings the camera will set based on the information it gets from the built-in light meter (**Figure 2.17**).

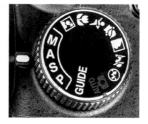

Figure 2.17 The mode dial on the Nikon D3200 shows the different exposure modes. Here the camera is set to Aperture Priority mode.

The four basic exposure modes are Program Auto (P), Shutter Speed Priority (S or Tv), Aperture Priority (A or Av), and Manual mode (M):

• **Program Auto mode.** This mode lets the camera do everything. All you do is point your camera at the subject and press the shutter release button. The camera takes the information from the built-in light meter and sets the shutter speed and aperture, and in some cases the ISO. You don't have much control over the exposure settings, and although you might get a great shot, it is not very likely.

• **Shutter Speed Priority mode.** In this mode, you set the shutter speed and the camera takes the information from the built-in light meter and sets the aperture. This mode is useful when you're photographing action and you want to make sure the shutter speed is fast enough to freeze the action.

• **Aperture Priority mode.** When you use this mode, you set the aperture and the camera uses the metering information to set the shutter speed. This mode gives you a lot of creative control over your images because you control the depth of field in your images. I prefer this mode instead of the Shutter Speed Priority mode because I want to control how much of the image is in focus.

• **Manual mode.** In this mode, you set both the shutter speed and the aperture, giving no control to the camera. In this mode, the camera still measures the light but doesn't control any of the settings, meaning that you can easily overexpose or underexpose an image, which makes this mode the most difficult of the exposure modes to use. The advantage is that any changes in the light don't immediately affect the exposure settings.

Chances are your camera has several more mode choices from which to choose. They look like little icons that you can select from for different shooting situations. Each tries to come up with the best settings for that subject, but you can do just as well using the four basic settings, and *you* get to control the settings.

Figures 2.18 through **2.20** show the same image underexposed, overexposed, and correctly exposed.

Figure 2.18 (left)
This image is underexposed; it is too dark, with a loss of detail in the dark areas.

Nikon D4 · ISO 800 · 1/2500 sec. · f/4.5 · 24–70mm lens

Figure 2.19 (right)
This image is over-exposed; it shows a loss of detail in the bright areas.

Nikon D4 · ISO 800 · 1/160 sec. · f/4.5 · 24–70mm lens

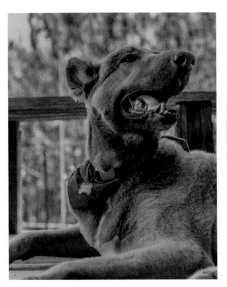

Figure 2.20
This image was properly exposed; you can see all the details in the image.

Nikon D4 · ISO 800 · 1/640 sec. · f/4.5 · 24–70mm lens

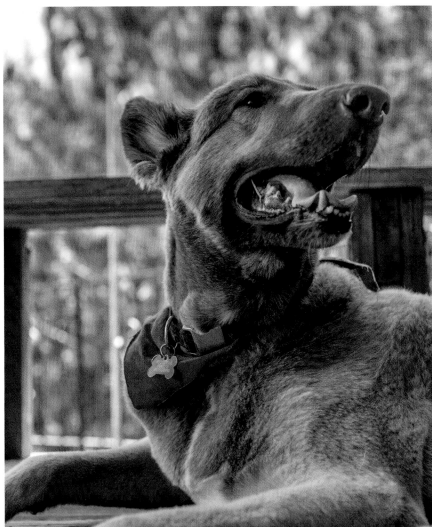

Adjusting Exposure

The camera has a readout called the *exposure meter* that shows you if the current settings will overexpose or underexpose the photo depending on the metering mode. It looks a bit different on every camera, and you'll need to read your camera manual to find out where it is on your model.

The exposure meter (**Figure 2.21**) lets you know what the camera determines will happen to your exposure based on the current meter reading and the current camera ISO, shutter speed, and aperture settings. If the indicator is at 0, the photo will be properly exposed; if the indicator is on the negative side, the photo will be underexposed, and if the indicator is on the positive side, the photo will be overexposed.

If you're photographing using Manual mode, the exposure meter will show you if the camera thinks the current settings will overexpose or underexpose the scene. It does this by indicating on the exposure meter if the scene is too light (the + side of the meter) or too dark (the – side of the meter). If you're photographing in any of the other modes, the camera will keep the exposure at 0 because that is where it calculates what the proper exposure is. You can tell the camera to purposely overexpose or underexpose the image by using *exposure compensation.* This feature allows you to adjust the exposure by simply increasing or decreasing the exposure. Many cameras have a button or dial that allows you to do this quickly and easily. Refer to your camera manual for the exposure compensation controls on your camera.

Figure 2.21
The exposure meter indicates that a 0 reading will result in a properly exposed image, a negative reading will create an image that's too dark, and a positive reading will create an image that's too bright.

Composition Basics

Photography is a combination of exposure and composition. Exposure deals with the amount of light that reaches the sensor and how to control it. Composition is what you decide to have in your image, what you leave out, and where in the frame you place objects. Photographers get to make lots of choices compositionally, including which lens to use; where and whether to stand, sit, or lie down; what to focus on; what depth of field to use; and where to place the subject in the frame.

Some basic guidelines can help you get started on where to place your subject in the frame. Compositional tips for the more specific animals and situations will be discussed in later chapters. For now, these three basic suggestions will serve as a good base from which to grow: rule of thirds, space to move, and leading lines.

Rule of Thirds

The rule of thirds might be the best-known compositional tip for good reason; it really works. That doesn't mean you have to use it for every photo you take, but it is a good place to start.

The rule of thirds is really quite simple: You divide the scene into thirds with two imaginary vertical and two imaginary horizontal lines (**Figure 2.22**). Then you place the subject at one of the four spots where the lines intersect (**Figures 2.23** and **2.24**).

Figure 2.22 **The rule of thirds grid.**

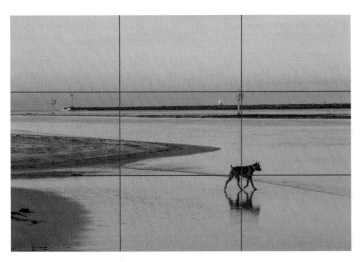

Figure 2.23 **Placing the dog one-third of the way from the bottom and one-third in from the right made for a stronger composition. As an added bonus, the horizon line is one-third down from the top, making the beach, not the sky, the subject.**

Nikon D2x · ISO 400 · 1/60 sec. · f/5.6 · 20–35mm lens

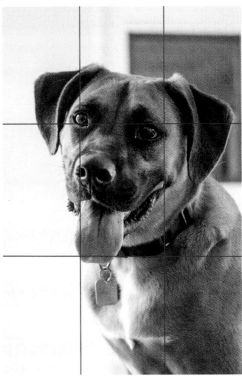

Figure 2.24 **Using the rule of thirds for portraits works well when you place one of the intersection lines right over the eye.**

Nikon D4 · ISO 1600 · 1/160 sec. · f/4.0 · 24–70mm lens

You can use the rule of thirds for all kinds of photos, from landscapes to portraits. Throughout this book, you'll learn how it to apply it and when it's best to ignore it. Remember that composition is all about personal choices, and sometimes the subject just looks better in the middle of the frame. However, in one situation you really won't want to use the rule of thirds, and that is when you're photographing using a fish-eye lens. These lenses produce massive distortion on the edges, giving the resulting images a distinctive bulging look. If you place your subjects off to the side using the rule of thirds, they will end up very distorted.

Space to Move

Space to move complements the rule of thirds because it helps you determine where in the frame to place your subject. When you're photographing animals, you want to pay attention to which way they are facing or moving, and then place them in the frame so they look as if they have more space to move (**Figure 2.25**).

When an animal is running right up against the edge of your frame, the image can seem awkward and cramped (**Figure 2.26**).

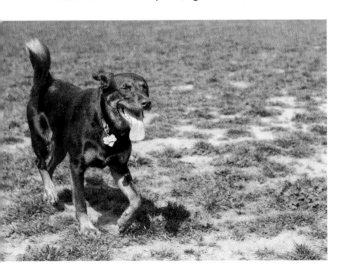

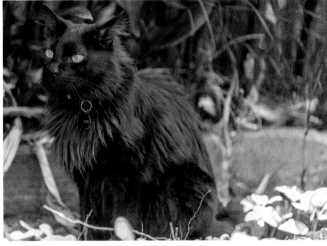

Figure 2.25 Giving an animal space to move makes the shot seem more natural and less cramped against the side of the frame.

Nikon D70 · ISO 400 · 1/250 sec. · f/5.6 · 70–200mm lens

Figure 2.26 With more space behind the cat and less in front of him, the cat has no place to go and is cramped in the frame.

Nikon D4 · ISO 1600 · 1/800 sec. · f/2.8 · 24–70mm lens

Leading Lines

Certain line elements in your images can draw the viewer's eye to the main subject. Leading lines usually start at the edge of the frame and lead toward the subject, directing the viewer's eye to naturally follow them. These lines can be natural items in the scene or can be manmade items, but either way they are everywhere.

You can categorize the lines into three groups: diagonals, straight lines, and curved lines.

- **Diagonals.** These lines come in from the corners and lead to the subject on a diagonal. They can be very obvious, like rug edges, or more subtle, like the line of the cat's back in **Figure 2.27**.

- **Straight lines.** These lines run either horizontally or vertically in your images. A good example of this type of line is a tree in your image or the horizon line. Placement of your subject to use these lines can help draw the attention to where you want it.

- **Curved lines.** Keep an eye out for lines that are not straight but instead curve. These lines are great for keeping the viewer's eye inside the picture. Curved lines appear all the time in nature and can include a variety of environmental objects, from tree branches to curved rocks.

Figure 2.27
Multiple lines in this image, from the curve of the cat's back to the rug edges on the floor, help draw your eye to the cat's face.

Nikon D4 · ISO 1600 · 1/800 sec. · f/2.8 · 24–70mm lens

Chapter 2 Assignments

Look for the Light

Look through your viewfinder at the scene in front of the camera and ask yourself the following questions: Where is the light coming from? How bright is the light? Is it hard light or soft light? Does the light have a color? These are the questions you need to answer every time you look at a scene before you can choose the best settings to use to capture it.

Explore the Metering Modes

One of the best ways to learn how the different metering modes read the light in a scene and affect the exposure settings is to photograph the same scene using each metering mode. Set the exposure mode to Aperture Priority mode, and set the aperture to f/5.6. Then take three photos of the same scene with the focus on the same spot and see what the camera calculated as a shutter speed in each case. For the first photo use Spot Metering, for the second use Center Weighted Metering, and for the third use Matrix or Evaluative Metering.

Try Manual Mode

Take back full control over the camera and practice adjusting the shutter speed and aperture yourself. The easiest way to get a good starting point is to set the camera to Aperture Priority mode, choose a starting aperture, and press the shutter release button halfway down to see what the camera calculates for a shutter speed. Then change the mode to Manual and set the shutter speed that the camera calculated when in Aperture Priority mode. Now adjust the shutter speed up and down, and take photos to see the effect of your slight adjustments. Look at what the exposure indicator does when you select a faster shutter speed; then look at what it does when you select a slower shutter speed.

Compose Using the Rule of Thirds

Many people have a tendency to place the subject smack-dab in the middle of the frame. Try to picture the rule of thirds grid in the viewfinder and place the subject in one of the points where the lines intersect. When you're photographing your pet, place them on the side of the frame that gives them some space to move so the image will seem more natural and less awkward.

Share your results with the book's Flickr group!
Join the group here: flickr/groups/petphotographyfromsnapshotstogreatshots

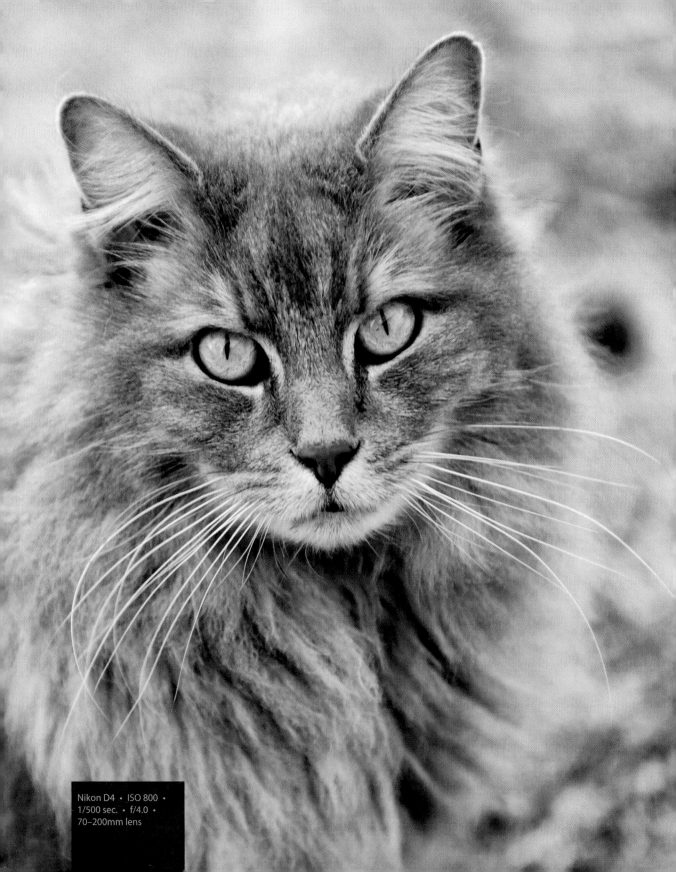

Nikon D4 • ISO 800 •
1/500 sec. • f/4.0 •
70–200mm lens

3
The Gear

The right gear for the job

Photography requires certain gear, and although you can take pet photos with just about any camera and lens combination, it does pay to know some basic information about cameras, lenses, and accessories. It isn't mandatory to spend a ton of money on the fastest lenses or the best cameras. You can get great images with virtually any camera.

Poring Over the Picture

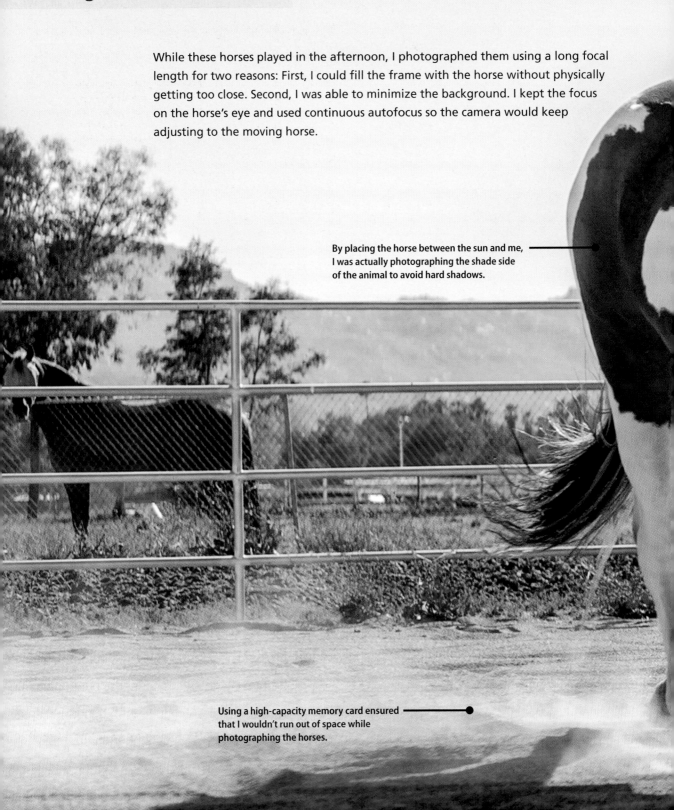

While these horses played in the afternoon, I photographed them using a long focal length for two reasons: First, I could fill the frame with the horse without physically getting too close. Second, I was able to minimize the background. I kept the focus on the horse's eye and used continuous autofocus so the camera would keep adjusting to the moving horse.

By placing the horse between the sun and me, I was actually photographing the shade side of the animal to avoid hard shadows.

Using a high-capacity memory card ensured that I wouldn't run out of space while photographing the horses.

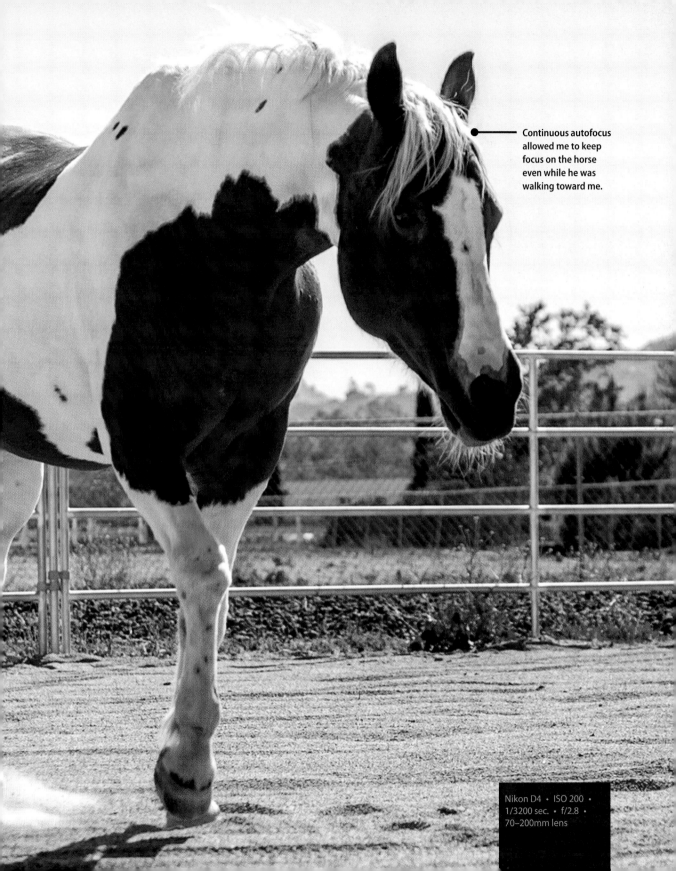

Continuous autofocus allowed me to keep focus on the horse even while he was walking toward me.

Nikon D4 · ISO 200 · 1/3200 sec. · f/2.8 · 70–200mm lens

Cameras

When you're choosing a camera, you have many options. It's important not to think of the camera alone when you're making decisions to buy one; instead, think of the purchase as a camera system that you are buying into. Once you've decided on a camera and lens, most likely you'll be using that brand for many years to come. The reason is that as you spend money on more lenses and accessories, you become invested in a certain brand.

Many years ago, I walked into a camera store looking for a new camera. I picked up a Canon and a Nikon, but the Nikon felt better in my hands, so that's what I bought. For years, I was very happy with that camera and started to expand the capabilities of the camera by buying more lenses, flashes, and other brand-specific accessories. As time went on, I replaced that camera with newer models of the same brand of film cameras and then made the switch to digital, all because of the money I had invested in lenses. If you want to buy a new camera and don't yet have any lenses, visit a local camera shop, pick up the cameras you plan on using, and see how they feel in your hands. It's important for your camera to be comfortable in *YOUR* hands. Keep in mind that it doesn't matter what your favorite photographers use; the camera must feel good to you (**Figure 3.1**).

Some important features of any camera you use include the size of the sensor, the different file types, and focus modes available. One feature that isn't very important is the number of megapixels the camera has. All current cameras have enough megapixels to make huge prints without a problem.

Figure 3.1
DSLRs have huge differences in their size, weight, and especially price. This figure shows the Nikon D3200 and the Nikon D4, which are at two ends of the camera spectrum.

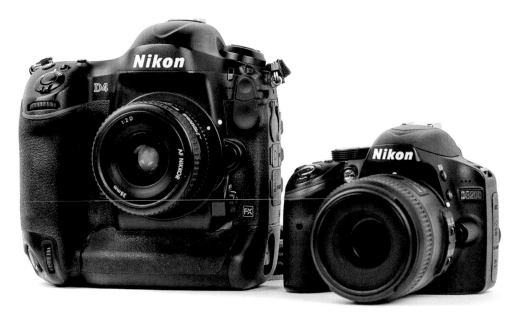

Full-Frame and Cropped Sensors

Digital cameras have two different sensor types: *Full-frame sensors* are the same size as a 35mm piece of film, and *cropped sensors* are smaller. Based on my experience using both sensor types, the image quality from both is exceptional.

The main difference between the two sensors is that when you use a cropped sensor, the smaller sensor records less of the scene than a full-frame sensor would using the same lens (**Figure 3.2**).

When you use a cropped sensor camera, it will seem as though the focal length of your lenses is inaccurate. All the lenses will appear as though their focal lengths have increased. This phenomenon is usually referred to as a *lens multiplier*. The reality is that the lens is capturing the scene the same way, but the sensor is capturing less area.

When you're using a telephoto lens, a lens multiplier can be very useful because it allows you to have a little more reach and get closer to your subject without having to move. The downside is that your wide-angle lens won't seem as wide.

A quick and easy way to determine the equivalent focal length of a lens used on a cropped sensor body is to multiply the focal length by 1.5. For example, 50mm becomes 75mm, 100mm becomes 150mm, and so on. Although using the same lens on a cropped sensor camera and full-frame sensor camera will result in different images, the reality is that it doesn't affect the composition. When you're using a DSLR, you see exactly the way the image will be recorded through the lens.

Some lenses are designed to be used on cropped sensor cameras only. These lenses will not work properly on a full-frame sensor camera.

Figure 3.2
You can see the difference between the full-frame sensor and the cropped sensor.

Nikon D4 • ISO 800 • 1/2000 sec. • f/4.0 • 24–70mm lens

File Types

Cameras can save image files in different formats. The two types that every camera can use are RAW files and JPEG files. Each file type has its advantages and disadvantages.

RAW files

A RAW file saves all the information from the camera's sensor; you can think of this file type as the digital negative. In the same way a film negative needs to be processed and printed for the image to be used, the RAW file needs to be processed and converted into a format that can then be used to display your image. To do so, you need to either process the image in the camera or use image-editing software. Because the RAW file contains all the information from the sensor, you have more data to work with when you're editing an image and are able to adjust many settings after taking the image. For example, when you edit a RAW file, you can easily adjust the white balance in the image using software.

Also, because the RAW file records all the information in an uncompressed file, the RAW file is larger than the JPEG, so it takes longer to write to the memory card and takes up more space.

JPEG files

If the RAW file is like an unprocessed digital negative, the JPEG is like a Polaroid—a fully developed image that you can use immediately after taking it. The camera converts the information recorded by the sensor and then saves it as a JPEG file. The JPEG file format is universally recognized as an image file so it can be emailed, posted on the Internet, printed, and shared right out of the camera without any additional processing. The JPEG file is compressed, making it smaller and faster to write to the memory card. A fast write time is very useful when you're photographing action. The faster the images are written to the memory card, the faster the internal buffer empties, allowing you to take more photos in a shorter period of time.

The JPEG file bakes in all the camera settings, making it tougher to edit later. Because the file is compressed in-camera, you don't have much data to work with when you do need to edit the photo, which could result in quality loss in the image. When digital cameras first became available, not a lot of options existed for editing RAW files, but now all image-editing software edits RAW files.

If you want to use the RAW file type but don't want to give up the convenience of a JPEG file, you can use both (**Figure 3.3**). However, doing so takes up more space on the memory card and takes longer for the images to be stored, but you get the benefit of both file types. You can then use the JPEG immediately and process the RAW file at a later time.

Figure 3.3
Many cameras allow you to choose saving to a RAW, to a JPEG, or both at the same time.

Focus Modes

Today's cameras now have autofocus that can track fast-moving subjects, which is very handy when you're photographing animals in action. With the camera's three different focusing modes, it's important to use the right one:

- **Manual Focus.** In this mode, the camera doesn't do anything; you achieve focus by turning the focusing ring on the lens.

- **Continuous Autofocus.** In this autofocus mode, the camera starts to focus as you press the shutter release button halfway down and continues to autofocus until you take the photo. This mode is best for photographing moving subjects and is the mode I use most of the time.

- **Single Autofocus.** In this mode, the camera starts to autofocus when you press the shutter release button halfway down. Once focus is achieved, the focus is then locked and doesn't change, even if the subject moves. This is a great focus mode to use when you're photographing subjects that don't move.

- **Automatic.** Some cameras offer a mode that chooses between Continuous and Single Autofocus automatically, depending on the subject's movement.

Many cameras allow you to choose the autofocus mode on the camera, but some lenses actually have a switch on them (**Figure 3.4**) that allows you to turn the autofocus on or off. However, this feature can cause some frustration if you have autofocus turned on in the camera but turned off on the lens, because the lens setting will override the camera setting.

Figure 3.4
The Nikon 40mm Macro DX lens has a switch on the lens barrel that allows you to switch between Manual/Autofocus and Manual Focus only.

For most of the pet photographs I take, I use Continuous Autofocus for the simple reason that most pets, even the best-trained pets, will move while I'm trying to take their photo. Using Continuous Autofocus is definitely needed when you're photographing animals in action (**Figure 3.5**).

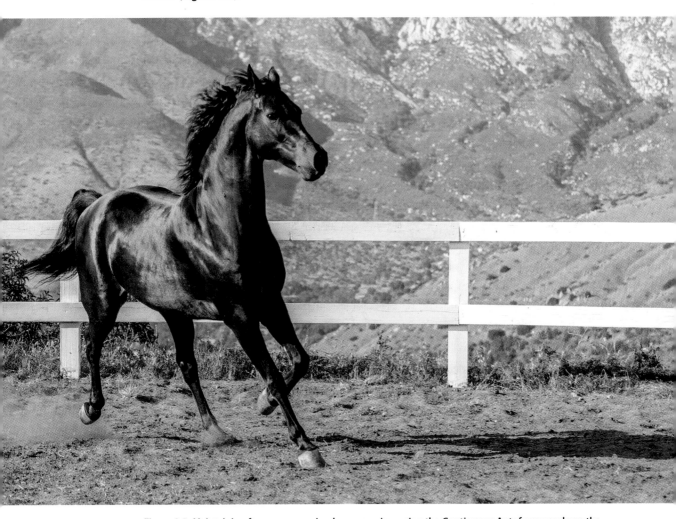

Figure 3.5 Maintaining focus on a running horse requires using the Continuous Autofocus mode on the camera. While I kept the focus point on the horse, the camera kept adjusting the focus as I pressed the shutter release button halfway down until I finally took the photo.

Nikon 3200 · ISO 400 · 1/2000 sec. · f/4.0 · 70–200mm lens

Focus Points

The autofocus system in your camera allows you to choose the spot in the frame where the camera focuses. This system lets you choose one (or more) focus points that are placed all around the frame (**Figure 3.6**).

The number and placement of the focus points depends on the camera model. For example, the Nikon D4 has 51 focus points, the Canon 1DMKIV has 45 points, and the D3200 has 11. To make matters a bit more complicated, many cameras allow you to use more than one focus point at a time. Using more than one focus point enables the camera to do a better job when it's trying to autofocus on moving subjects. But it can also cause the focus to shift from where you are focusing to where the camera thinks you should be focusing.

Figure 3.6 **This is the layout of the focus points on the Nikon D5200 with the selected point in red. You can see that I placed the focus point over the eye of the puppy because it is the most critical part of the image.**

Nikon 5200 · ISO 400 · 1/250 sec. · f/5.6 · 70–200mm lens

Although that sounds a little crazy, it has to do with how the camera always tries to focus on the object closest to the camera. When shooting portrait-type shots, I like to use a single focus point because I can ensure that the point is exactly where I want it, right over the eye of the subject. When photographing pets in action, I use a set of focus points that the camera can track and achieve focus on moving subjects.

Lenses

The real power of a DSLR is that you can change the lens, allowing you the ability to capture the world in front of your camera exactly the way you want to.

Focal Lengths

The focal length of the lens is not how long the lens is but a mathematical equation that tells you the angle of view of the lens. The shorter the focal length, the wider the angle of view, which means that the shorter the focal length, the more area you can capture in front of the camera.

Lenses are usually divided into three categories based on the focal length: wide angle, normal, and telephoto:

- **Wide angle lenses** have a shorter focal length than 35–50mm.

- **Normal lenses** have a focal length between 35mm and 60mm.

- **Telephoto lenses** have a focal length greater than 60mm (**Figure 3.7**).

Figure 3.7
To get close to this shy cat that felt more comfortable hanging out under a lawn chair, I used a long focal length.

Nikon D4 · ISO 800 · 1/3200 sec. · f/4.0 · 300mm lens

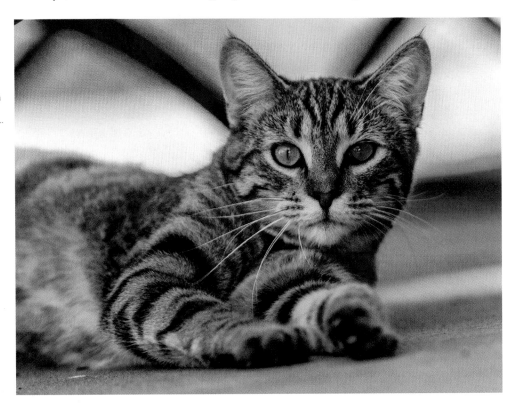

When you choose a focal length to use to capture the scene, you decide how much area in front of the camera you'll capture. Your photography life would be pretty easy if that was all the focal length did. But another effect happens that depends on the focal length you use. The longer the focal length, the more the scene is compressed, making the background look a lot closer than it really is. The opposite is true when you're using wide-angle lenses. The shorter the focal length, the more the background seems to recede. This compression and distortion can cause a major difference in the image when you're photographing animals. In **Figures 3.8** through **3.11** the same dog is photographed four times at four different focal lengths: 24mm, 70mm, 100mm, and 200mm. The change in how the dog looks in relation to the background and the general shape of his body is very obvious.

Figure 3.8 (left)
At 24mm, you can see a lot of the surrounding area, and my dog Hobbes looks quite distorted.

Nikon D4 • ISO 1600 • 1/160 sec. • f/2.8 • 24–70mm lens

Figure 3.9 (right)
At 70mm, Hobbes looks more normal and less of the background is visible, even though Hobbes is relatively the same size as in the previous figure.

Nikon D4 • ISO 1600 • 1/160 sec. • f/2.8 • 24–70mm lens

Figure 3.10 (left)
At 100mm, I moved back so Hobbes stayed the same relative size but less of the background is visible.

Nikon D4 • ISO 1600 • 1/160 sec. • f/2.8 • 70–200mm lens

Figure 3.11 (right)
At 200mm, the background is minimized and Hobbes looks very natural, especially when compared to the photo taken at 24mm.

Nikon D4 • ISO 1600 • 1/160 sec. • f/2.8 • 70–200mm lens

Maximum Aperture

The maximum aperture you can use depends on the lens you have attached to the camera. You can divide all lenses into two categories: those with a constant maximum aperture and those with a variable maximum aperture. It's important to know the difference and how each can affect your images.

Constant maximum aperture

Constant maximum aperture lenses have a constant aperture no matter the focal length (**Figure 3.12**). All prime lenses are in this category because they have only one focal length. Some zoom lenses are in this category as well, such as the 70–200mm f/2.8 lens and the 24–70mm f/2.8 lens. With these lenses, it doesn't matter what the focal length is, the maximum aperture is f/2.8. For this reason, these lenses are bigger, heavier, and more expensive than their variable maximum aperture counterparts, but they offer a great advantage for photographers.

These lenses allow you to use the same exposure settings throughout the focal range. For example, if I'm photographing a dog at 70mm and want to zoom in to 200mm for a close-up, the exposure settings don't change. Another advantage of the constant maximum aperture lenses is that they usually have a larger maximum aperture than the variable aperture lenses, making them better to use in low-light photography, and they have a shallower depth of field.

Figure 3.12
The 70–200mm f/2.8 lens has a constant maximum aperture of f/2.8 at 70mm and at 200mm. The 300mm f/4.0 lens is a prime lens with a maximum aperture of f/4.0, and the 80–400mm f/4.5–5.6 lens has a maximum aperture of f/4.5 at 80mm, but it is reduced to f/5.6 at 400mm.

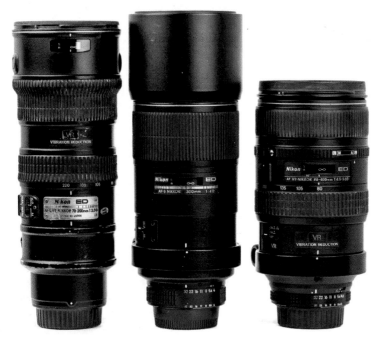

Variable maximum aperture

The variable maximum aperture lenses are zoom lenses; the maximum aperture changes depending on the focal length you use. Due to the way the lens is constructed, as the focal length increases, the maximum aperture decreases. These lenses are lighter and cheaper than their constant maximum aperture counterparts. The downside to these lenses is that as you change the focal length, you also have to change the exposure settings. For example, if you are using the Nikon 18–200mm f/3.5–5.6 lens, the maximum aperture is f/3.5 at 188mm but is reduced to f/5.6 when used at 200mm. In practical terms, this means you must use a slower shutter speed or a higher ISO when you're using longer focal lengths.

To use another example, if you're using a shutter speed of 1/250 of a second, an ISO of 1600, and f/4.0 at 18mm, and you zoom into 200mm, the aperture will have changed from f/4.0 to f/5.6, a loss of one stop of light. You then need to either increase the ISO to 3200 or reduce the shutter speed to 1/125 of a second to get a proper exposure. Depending on the setting used, the camera will do this for you. The problem is that the new shutter speed might not be fast enough to freeze the action, or the new ISO might introduce too much noise. Of course, either problem might not be an issue. These lenses are very popular and they do a great job, but you need to be aware of any problems they might cause. As you can see in **Figures 3.13** and **3.14**, a zoom lens can come in handy when you're photographing a subject like horses, but the drop in shutter speed when you're zooming in from 80mm to 400mm can be an issue.

Figure 3.13 At 80mm, you can see the entire corral, and at a maximum aperture of f/4.5 enough light is present to use a shutter speed of 1/800 of a second.

Nikon D4 · ISO 200 · 1/800 sec. · f/4.5 · 80–400mm lens

Figure 3.14 The same horse and lens were used in this image as in Figure 3.13 but this time zoomed to 400mm, which caused the maximum aperture to close to f/5.6 and the shutter speed to drop from 1/800 of a second to 1/500 of a second. This is not a big problem if the horse is standing still but could be if he was running.

Nikon D4 · ISO 200 · 1/800 sec. · f/5.6 · 80–400mm lens

Flashes

The pop-up flash on your camera impairs rather than improves your images. But sometimes you'll need to add your own light to the scene. The reason might be that you're photographing indoors and adequate light is unavailable, or perhaps you want to add some fill light to a scene. In these situations, I use a dedicated flash unit or two.

Using these small dedicated flash units offers many advantages. The units are light, easy to place, pretty powerful, and you can use them on or off camera easily. Some small flash features will make your photography life easier:

- **Adjustable angle flash head.** The pop-up flash on your camera can only point in one direction, straight ahead. When you purchase a dedicated flash, make sure it has an adjustable flash head that can rotate left and right and be angled from straight ahead to straight up (**Figure 3.15**) so you can control the angle of the light. Instead of striking the subject directly, you can bounce the light off a ceiling or wall.

- **Diffusion dome.** Most small flashes include a plastic dome that can fit over the head of the flash, diffusing the light that's produced. These diffusion domes turn the small hard light from the flash into a bigger, softer light. If your flash doesn't have a diffusion dome, you can buy one from Sto-Fen at www.stofen.com.

- **PC port.** This port on the flash allows you to plug in a radio trigger. Some flashes don't have this port, so using it with a radio trigger that needs a PC port is impossible.

- **Zooming flash head.** Many of the small flashes allow you to zoom the flash head so it covers a wide range of focal lengths. Such control allows you to adjust the light produced from the flash and gives you more creative control.

Figure 3.15 The Nikon SB-700 Speedlight mounted on a Nikon D3200 DSLR. You can angle and rotate the flash head to bounce the light instead of just aiming directly at the subject.

Accessories

The camera, lens, and flash are only a portion of the equipment you'll need for your photography. Other items can be very useful as well when it comes to pet photography. These include light modifiers that you can use indoors and out, a memory card to store your images, and cleaning supplies.

Light Modifiers

The light illuminating the scene is not always exactly what you want. So you need a way to modify the light so it better suits your purpose. Light modifiers come in handy for this function. The two basic types of modifiers are those that reflect the light and those that diffuse it. My favorite line of light modifiers is called Rogue FlashBenders, and some specialized diffusers are called softboxes.

Reflectors

Reflectors do exactly what you'd expect; they reflect light. Dedicated products are available for purchase at any camera store or online, but you can use any surface to bounce or reflect the light.

Light will pick up the color of the surface it is reflecting. Many of the store-bought reflectors come in a variety of colors:

- **White.** A white surface reflects less light than either a silver or gold surface. A white reflector, or bounce card, produces a soft, even light that works well in most instances. The color of the light is not changed much, but it can look a little cool.

- **Silver.** A silver reflector bounces the most light but doesn't drastically change the color of the light.

- **Gold.** A gold surface reflects a lot of light, more than the white but not quite as much as a silver surface. The gold reflector also adds a warm tone to the light.

- **White/Gold and White/Silver**. The mixed-color reflectors act as muted versions of gold or silver reflectors and are useful for controlling the amount of light and the color being bounced back at the subject.

Collapsible diffusers are ideal when you're working on location because you can fold them to a fraction of their size, shove them in a camera bag, and then easily open them for quick use. Many of the reflectors available today come in a variety of sizes and color combinations.

Diffusers

Diffusers can be any material or object that is placed between the light source and the subject, reducing the intensity of the light. The diffuser then becomes the new, larger, softer light source. The following are all types of diffusers:

- **Softboxes.** These are specialized types of diffusers. The light goes in the back and is fired through a piece of diffusion material in the front. These work well because they control where the light strikes, and the light produced is a nice, soft light. They come in small sizes made especially for small flashes.

- **Umbrella.** The photographic umbrella looks just like a regular umbrella that protects you against the rain but is made of a diffusion material. The flash can then be fired through the umbrella, creating a much larger light source. Because the umbrella has no way to control the light spill, like a softbox does, the light is more difficult to control.

- **Diffusion panels.** These panels are made of diffusion material that can be placed between any light source and the subject. They are very useful when you're photographing outdoors in sunlight. The diffusion panels come in different sizes, but my favorite is the TriGrip diffuser, which has a triangular shape that makes it easy to hold in one hand. The TriGrip diffuser folds up small and can be opened at a moment's notice on the job. You can see the TriGrip in use in **Figure 3.16** and the resulting image in **Figure 3.17**.

Figure 3.16
The diffuser blocks the sun from the dog, allowing me to keep him in a softer light with no hard shadows.
Nikon D4 • ISO 800 • 1/1600 sec. • f/5.0 • 24–70mm lens

Figure 3.17
Using the setup in Figure 3.16, you can still see the sun hitting the fence behind the dog, but he is in a much softer, more even light.

Nikon D4 · ISO 800 · 1/1600 sec. · f/5.0 · 24–70mm lens

Rogue FlashBender

The Rogue FlashBender line of small flash modifiers is perfect to use when you're photographing pets (**Figure 3.18**). They come in a variety of shapes and sizes, are reasonably priced, and in my experience are virtually indestructible.

The basic FlashBender is a reflector that attaches to the small flash and can be bent to adjust the angle that the light is reflected (**Figure 3.19**). The reflector is made of heavy-duty nylon with rods in the back to hold its shape. A basic reflector comes in a small and large size, and a smaller bounce card. Diffusion panels can be attached over the front of the reflectors, which softens the light even more.

The Rogue Flash Grid is a 3-in-1 stacking honeycomb grid that attaches over the front of a small flash, creating a tight spot of light with a more controlled light fall-off. Gels can be inserted into the grid to create colored spotlights. Every time I pack my camera bag for a pet photography shoot, I add a few of the FlashBender products in case I need to create a softer light easily on location.

Radio Triggers

When you use a dedicated flash unit on your camera, it is mounted on the hot shoe, allowing the flash and the camera to communicate with each other. The camera tells the flash how much power to use and when to fire. When the flash is removed from the camera, you need a way for the camera to tell the flash when to fire. Some camera manufacturers have built this capability into their cameras and flash systems. For example, the Nikon flashes can act as master units or remote units; the master units are able to trigger the remote units. These systems usually rely on line of sight, which requires the remote to see the signal from the master unit.

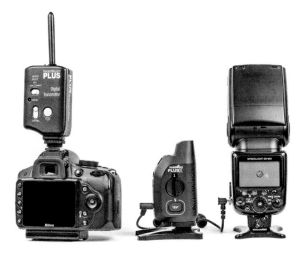

Figure 3.20 One radio trigger goes on the camera; the other is attached to the flash. When you press the shutter release button all the way, the radio triggers the flash.

Radio triggers allow you to fire your flash when it is not mounted in the camera's hot shoe. In this situation, you'll need at least two radio triggers, one to act as a transmitter that goes on the camera and one to act as a receiver that is attached to the flash (**Figure 3.20**). The radio triggers use radio signals so they don't need to be placed in a line of sight.

Memory Cards

The memory card is the digital film in your camera and is where your images are saved when you press the shutter release button. The memory card is vitally important because it stores your images before you can download them to a computer and back them up. Never skimp when it comes to buying memory cards.

Memory cards come in a variety of formats and capacities that can be confusing unless you know what all the options mean:

- **CompactFlash.** The CompactFlash memory card has been available since 1994, when SanDisk first introduced it. It was the most popular memory card format before the SD format. CompactFlash memory cards are still used in many devices, especially the higher-end, professional-level cameras. Physically, they are the biggest of the memory cards.

- **SD.** The Secure Digital card is smaller in size than the CompactFlash card yet offers comparable write speeds and capacities. The SD card comes in a variety of formats, including the regular SDSC (Secure Digital Standard Capacity) card followed by the

SDHC (Secure Digital High Capacity) card, which supports capacities up to a whopping 32 GB. The SDXC (Secure Digital eXtended Capacity) cards were announced in 2011 and can support a capacity of 2 TB.

- **MicroSD.** The MicroSD card is very small, yet it offers great speed and capacity (**Figure 3.21**). These cards were originally designed for smartphone storage but can be used in a camera using an adapter. Due to their tiny size and very low weight, these cards are used in the popular GoPro cameras.
- **XQD.** The XQD card was meant to be an update to the CompactFlash card but as of 2014 is being used only in the professional-level Nikon D4 and D4S. The card offers incredible write speeds and extremely large capacities.

Each memory card has two numbers associated with it: the capacity of the card and the speed in which information can be written to the media. The capacity determines how many photos you can store on the card, and the write speed determines how fast the camera can write the information to the card. The faster the photo data is stored on the card, the quicker the buffer in the camera is emptied and the sooner you are able to take more photos.

Figure 3.21
You can clearly see the difference in memory card physical sizes and how the size doesn't equal capacity. The smallest card here, the MicroSD, has the largest capacity at 64 GB.

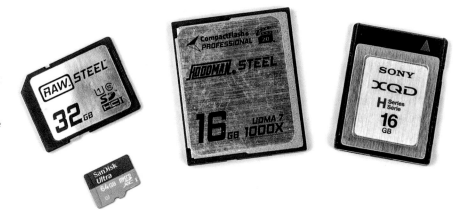

Camera Cleaning

My dogs drool. It's not a big deal, but it does tend to get on everything, including my lens hoods and sometimes the front element. They've also been known to try to lick my camera when it's too close to them. All this means is that I need to clean my camera on a regular basis.

At all times, I carry a lens cloth, a small towel, and some of the Hoodman Lens Cleanse cleaning kits in my camera bag to wipe up some of the drool, spit, and animal hair.

Chapter 3 Assignments

Know Your Camera

It's important to know how your camera works so you can change settings easily in the middle of a shoot. Practicing with your camera is easy; you can even do it while sitting on the couch. The idea is to practice in a way that allows you to familiarize yourself with the controls and settings. Set up the camera in Manual mode and hold it up to your eye; then change the shutter speed and aperture without moving the camera. Practice this until you can adjust the settings without looking at them.

Change Focal Lengths

Set up a shot using the longest focal length you have and take a photo. Then switch to the widest focal length you have and move in closer so the subject is the same size in the frame and take a second frame. Look at the difference in the way the subject and background are rendered. Which image do you prefer? Which of the focal lengths gives you the look and feel that you want in your images?

Practice Off-Camera Flash

If you will be using an off-camera flash to help you light your portraits, practice the mechanics involved in setting up the flash and the radio triggers, and choosing the flash placement.

Share your results with the book's Flickr group!
Join the group here: flickr/groups/petphotographyfromsnapshotstogreatshots

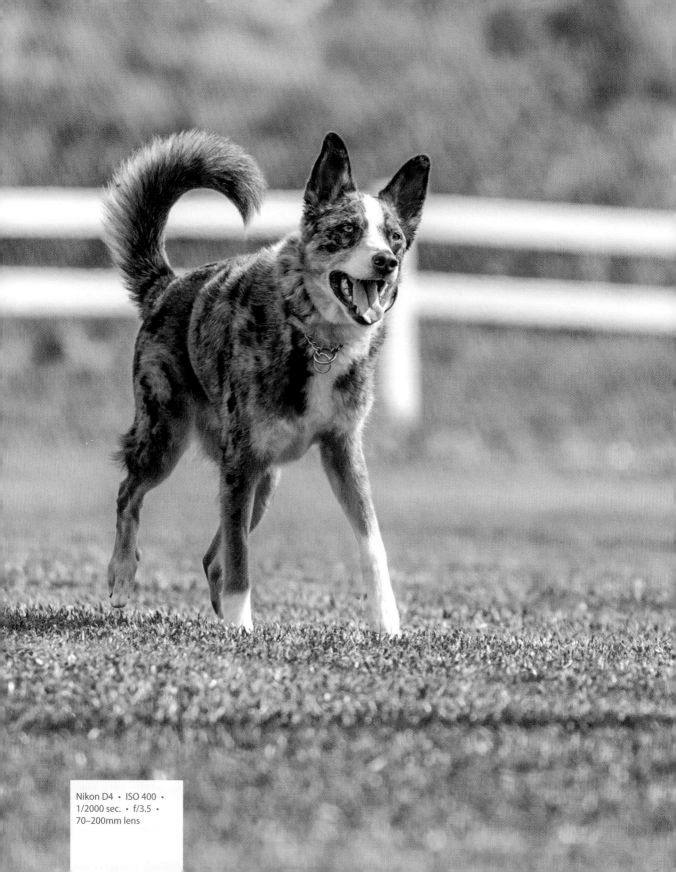

Nikon D4 · ISO 400 ·
1/2000 sec. · f/3.5 ·
70–200mm lens

4
Working with Animals

The do's and don'ts when photographing pets

Photographing your pets can be a great bonding experience, especially if you keep it fun and low stress. No matter how well behaved or trained your pet is, keep in mind that your pet doesn't really understand what's going on during a photo shoot. My older dog is so used to seeing me set up different lights and backdrops that she will go and sit in front of them without anyone asking. She doesn't really know why she is doing it but has been conditioned that when she sits there, good things happen. For her that means she gets treats.

Poring Over the Picture

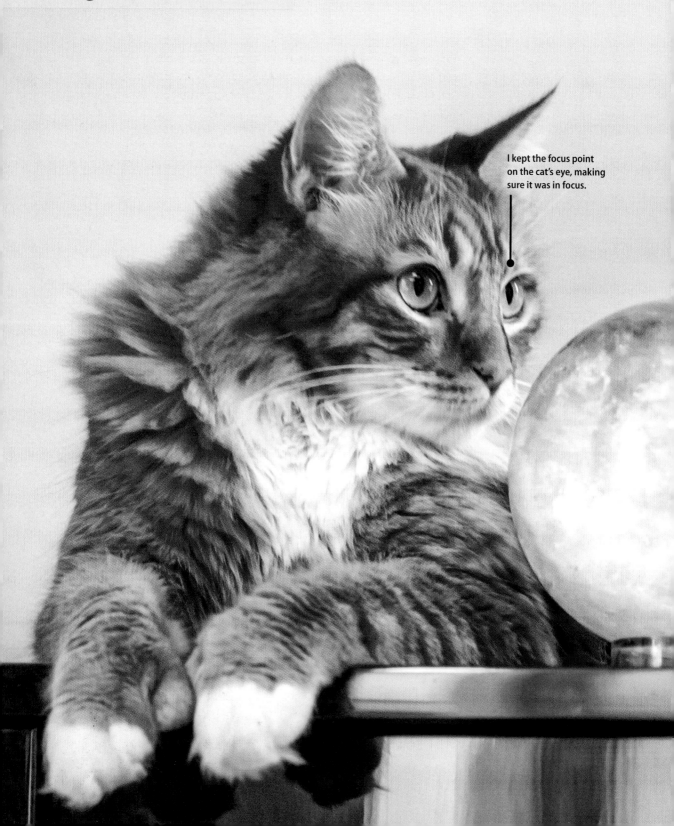

I kept the focus point on the cat's eye, making sure it was in focus.

During this shoot, I let the cat determine where it wanted to be photographed and then used my 70–200mm lens at 200mm to get in tight without encroaching on the cat's space. This allowed the cat to feel comfortable in its environment and not feel threatened by me. Once the cat relaxed and encircled the crystal ball, I started to take photos.

Photographing the cat from a distance so as not to scare him, I used a longer lens, which compressed the scene and shows little of the background.

To create a more interesting photo, I waited until the cat was looking at the crystal ball.

Nikon D4 • ISO 3200 • 1/60 sec. • f/2.8 • 70–200mm lens

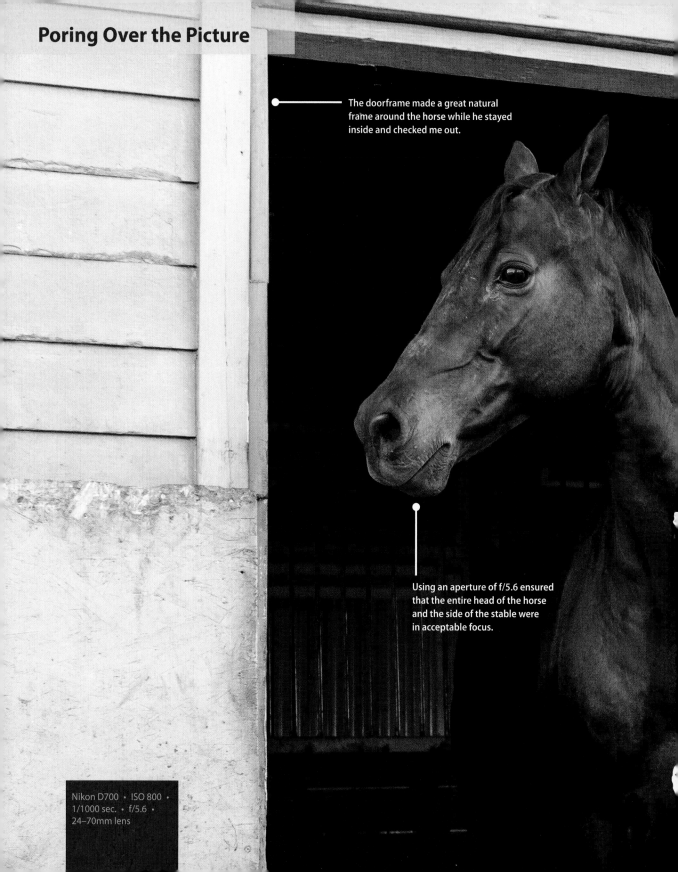

Poring Over the Picture

The doorframe made a great natural frame around the horse while he stayed inside and checked me out.

Using an aperture of f/5.6 ensured that the entire head of the horse and the side of the stable were in acceptable focus.

Nikon D700 · ISO 800 ·
1/1000 sec. · f/5.6 ·
24–70mm lens

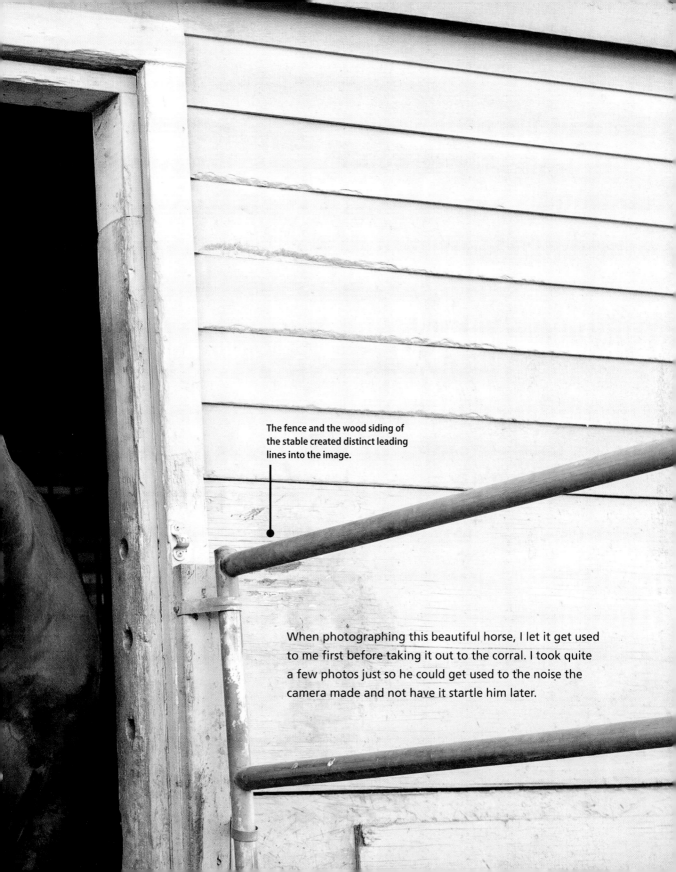

The fence and the wood siding of the stable created distinct leading lines into the image.

When photographing this beautiful horse, I let it get used to me first before taking it out to the corral. I took quite a few photos just so he could get used to the noise the camera made and not have it startle him later.

Safety First

Photographers don't always make safety a priority, and many times they are tempted to do things that nonphotographers shake their head at. If you are like me, you can get so caught up in getting a shot that your safety can take a back seat. For example, I've inadvertently stepped off a curb and into the road while photographing a subject on the sidewalk without looking at where I was going. Fortunately, no accidents occurred, so no real harm was done.

All this changes when you're working with animals because not only are you responsible for your own safety, but you are responsible for the animal's safety as well. As a pet photographer, you need to keep your subject safe, and you need to keep yourself safe from your subject. Some animals can act out when they feel stressed or threatened, and that can result in them turning on you.

You can take a few good measures to minimize the stress and increase the safety level of the photo shoot:

- **Pick a familiar spot.** As with most people, I am more comfortable in my own living room than I am when I'm in someone else's house. It's a pretty natural feeling to be more comfortable in familiar surroundings, and this is very true when it comes to animals. Photographing my pets at my home and in locations they are comfortable in is much easier than photographing them anywhere else. This is even more important when I'm photographing someone's else's pets that don't know me. Having them pose in an area where they usually hang out makes it much easier to get a great photo because they are content and calm. It's the best location to start any pet photo shoot. My dog Odessa loves to lie out in the sun on the back deck, so it's easy to capture this scene because she is very relaxed, as you can see in **Figure 4.1**.

Figure 4.1
Odessa loves to sun herself on the back deck, making it easy to get photographs of her. This is one relaxed dog.

Nikon D2X · ISO 100 · 1/80 sec. · f/4.5 · 50mm lens

- **Use a long lens.** Using a longer focal length can help you fill the frame with your subject and still stay a safe distance away. My favorite lens is the 70–200mm f/2.8, which you can purchase from Nikon or Canon, and every third-party lens manufacturer makes a version. This lens allows you to get in close and still have a very shallow depth of field with a wide aperture of f/2.8 through the full focal-length range. On the negative side, the lens is expensive and heavy, especially if you are holding the camera up to your eye for an extended period of time while waiting to take a photo.

- **Stay calm.** Animals can pick up on your mood very quickly. They can read the nonverbal cues in your body language and will sense how you feel. If you are anxious or upset, they'll know it and react. Although I'm not a dog trainer, I have worked with a few, and the one necessity that they've all discussed is that you need to be calm when you're dealing with dogs and other animals. It can be tougher than you think to remain composed, especially when your model doesn't seem to understand what you want or keeps trying to chew on your camera lens. When you feel as though you're getting frustrated, just stop and take a breath. Remember that letting the animal have fun is the most important aspect of a shoot.

- **Keep your eyes open.** Photographers tend to get tunnel vision and only pay attention to the subject that's in the image they're taking. When you're photographing more than one pet simultaneously, you need to keep an eye out for all of them. For example, recently I was photographing a pair of horses and was so fixated on one that I didn't notice the second one sneaking up on me. And yes, horses can sneak up on you. By the time I noticed the second horse, he was pushing me over with his head, which was not the best way to interact with an animal that outweighs you many times over (**Figure 4.2**).

Figure 4.2 Imagine my surprise as I looked up to find this horse much closer than I expected. I was so busy paying attention to the other horse that I lost track of where this horse was.

Nikon D700 · ISO 200 · 1/4000 sec. · f/4.0 · 70–200mm lens

- **Watch your gear.** Be aware of where you put your camera bag and any other equipment you might have with you. You want to keep your gear close to you so you can change lenses if needed or conveniently grab a reflector or diffuser to use. Keep in mind that when you open a diffuser or reflector, it could spook your subject, so work slowly. You might even find a lizard hanging out on one of your lenses (**Figure 4.3**).

- **Talk to the owner and the pet.** The best source of information about the pet that you are photographing will come from the owner. Talk to them about what the pet likes and doesn't like, or if the pet has a favorite spot or favorite toy. The more information you have, the easier it will be to get and keep the pet relaxed and calm. For example, one of my dogs loves people and has no problem with anyone coming up and scratching her head; the other is a bit timid and needs more time to warm up to strangers. Talking to the pets you're working with in a calm, low tone helps to assure them you are not a threat and that all is well.

Figure 4.3
You never want to leave your gear unattended because it might attract one of your subjects. Full disclosure: The lizard was placed carefully on the lens and enjoyed hanging out from that vantage point.
Nikon D3200 •
ISO 800 • 1/60 sec. •
f/11 • 105mm lens

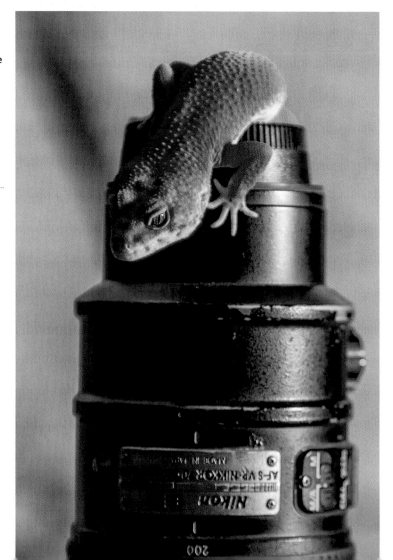

Signs of Stress

Animals can get stressed, and when they do, the results can be unpredictable. Therefore, the best strategy is to talk to the animal's owner before the shoot to find out what might cause their pet to become tense or nervous.

In the worst case, a stressed animal can act out aggressively, and someone can get hurt. The following sections provide signs of stress exhibited by some animals that you can look out for when you're photographing your pet or someone else's pet.

Dogs

Dogs yawn and lick their lips even they are not stressed, but you need to pay attention to all their behaviors as a whole. Take into account the dog's ears, the tail, and the body position overall to give you a complete picture of how the dog is feeling. Don't just rely on the old "wagging tail equates to a happy dog" theory. Here are some signs of stress to watch for when you're photographing dogs:

- **Nose and lip licking.** Excessive licking of the nose or lips can be a sign of a dog under stress. The licking is usually combined with some of the other stress indicators. You can see an example of the lip licking in **Figure 4.4**.

Figure 4.4
This dog was in the middle of a training session, which was putting the dog under some stress. You can clearly see the lip licking.

Nikon D4 · ISO 200 · 1/2000 sec. · f/4.0 · 70–200mm lens

- **Ears pinned.** A dog's ears can tell you a lot about how it's feeling. When the dogs ears are in a neutral position, not forward or pinned back, the dog is relaxed. When the ears are pinned back tightly against the dog's head, it usually means that something is making them upset, or they could be happy. Look at the rest of the dog for confirmation. If the rest of the body is tense and rigid, chances are they are upset or stressed; if the body is loose, this usually means they are just happy. The ears going forward typically means that something has their attention, and they are not sure how to deal with it yet.

- **Panting.** Dogs pant for lots of reasons. One main reason is that it is a way for dogs to cool down because they don't sweat through their skin like humans. Panting can also mean that the dog is not feeling well or is stressed out. It is especially important to pay attention and determine if the dog is panting heavily for no discernible reason.

- **Avoidance.** If the dog is actively trying to avoid you by looking away or turning their back on you (**Figure 4.5**), it is a sure sign that they are uncomfortable with the current situation. If the dog starts to show signs of avoidance, just stop what you're doing and give the dog a chance to relax.

Figure 4.5
When a dog turns their back on you, it is an obvious sign that they are trying to avoid whatever it is that is stressing them out; in this case, it was me.

Nikon D4 • ISO 200 • 1/2000 sec. • f/4.0 • 70–200mm lens

- **Tail actions.** A dog's tail can tell you volumes about its mood. When the tail is held low or tacked between their back legs, it signals that they are uncomfortable. When you see a dog wagging its tail because it's happy, usually the whole back end of the dog is moving. When you see the tail held high and stiff, and not moving, these signs indicate that the dog is tense; it is best to give the dog some space.

- **Yawning.** When a dog yawns (**Figure 4.6**), it doesn't mean that the dog is tired and needs a nap; instead, it indicates that the dog feels anxious or even threatened. A yawn is a way for the dog to try to relieve its anxiety. If your subject is yawning, try yawning back; it can have a calming effect.

- **Shedding.** Dogs shed as a way to get rid of old or damaged hair, but excessive shedding can be a sign of stress. If you don't know the dog or how much it normally sheds, this stress indicator can be very difficult to identify. If you see a lot of hair being shed when you're working with a dog, talk to the owner and keep an eye out for the other stress indicators.

- **Whining.** Dogs whine for several reasons, from trying to get your attention to when they're excited about something. But they can also whine when they're feeling stressed in their current situation. Along with the body language, pay attention to the dog's verbal cues as well.

- **Raised hackles.** You can tell quite a bit by the state of the dog's back hair, especially between the shoulder blades and down its spine. When a dog raises its hackles, the hair stands up in these spots, which means the dog is concerned or excited about something. This is a very easy sign to spot when you're walking your dog and looking down at their back. When the hair rises, it is usually combined with the tail being up and stiff, and a tensing of the whole body. It could just mean they are excited, but it is more likely that they are nervous, stressed, or basically unsure of something in their environment.

Figure 4.6 **Yawning is not a sign of the dog being tired but a way to try to reduce stress.**

Nikon 700 • ISO 400 • 1/160 sec. • f/4 • 70–200mm lens

Cats

Cats are not as easy to read as dogs, but some signs will reveal that the cat is not happy in the present situation. Many times these signs can be subtle and not that easy to see, especially if the cat is not yours. Talk to the owner and find out what the normal behavior is for the cat and where the cat usually hangs out. Photographing the cat in the areas where it is most comfortable can make the whole process less stressful for the cat and for you. Here are some signs of stress to watch for when you're photographing cats:

- **Ignoring food or treats.** Often, I use treats to get a cat to relax or pose in the right spot. If the cat is very stressed, it will ignore the treat and instead just bolt for a hiding place or for higher ground. This is a definite sign to stop and back off until the cat feels safe again.

- **Hiding.** When cats are stressed, they tend to hide. This usually means they go to a place where they feel protected, like under a bed or a chair. They can look out to see the world, but nothing can get to them. If you just wait them out, you can get some great photos as they come out of their hiding place. However, this might take patience on your part, depending on the cat and how stressed it is. The cat in **Figure 4.7** was hiding from me when I first started photographing but slowly came out from between the couch and the chair.

- **Aggression.** A stressed-out cat might just turn and swipe at you with their claws. It is a natural reaction to something that stresses them out and is one of the reasons I like to use a longer focal length when photographing pets, especially those I'm unfamiliar with.

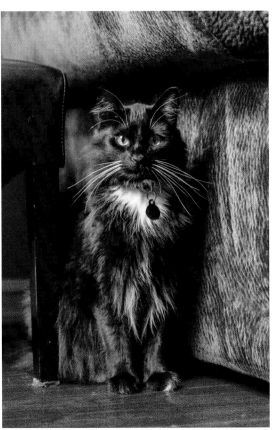

Figure 4.7 This cat was not happy with me, and although he didn't run away, he did hide between the couch and the chair, keeping a very careful eye on me across the room. It took a while for him to get used to my presence and the sound of the shutter.

Nikon D4 · ISO 6400 · 1/100 sec. · f/2.8 · 70–200mm lens

- **Body language.** A cat's body language signs are good indicators of when it is best to back off and let the cat relax. The cat will crouch low to the ground with eyes fully open, head held low, ears back, and possibly be hissing or growling. In this mode, the cat is just as likely to lash out as it is to run away, so don't take any chances; just back away and ignore the animal. A relaxed cat will sit up and pay attention, and not have an aggressive stance (**Figure 4.8**).

Figure 4.8
This relaxed cat was so used to people that it didn't even mind dressing up for the photos wearing a stylish orange witch hat.

Nikon D4 · ISO 1600 · 1/200 sec. · f/4.0 · 70–200mm lens

Horses

Horses have a very different way of seeing the world than do humans. The placement of their eyes on either side of their head means that they can see a wide area on either side of them with each eye. This is called *monocular vision*, and each eye works separately to keep track of their surroundings on that side of the horse. Because of the placement of a horse's eyes, when the eyes work together, which is called *binocular vision*, the area it sees is down the nose and directly in front. This creates a blind spot at the forehead and poor vision. So you need to be careful when you're approaching a horse and come toward the animal from an angle, not straight on.

Once again, the best strategy when you're photographing a horse is to talk to the owner first, because they know the horse and its behaviors better than anyone. However, a few signs can tell you how a horse is feeling:

- **Whinnying.** Horses whinny as a form of communication that can mean they are not happy, but it can also have other meanings as well, so use the verbalization as part of the whole picture.

- **Eyes.** A horse's eyes can tell you if the horse is relaxed or scared. If the eyes are slightly closed, the horse is relaxed and calm, but if you can see a lot of white, chances are the horse is stressed or scared.

- **Ears.** The position of the horse's ears can help you determine the horse's mood. If the ears are pinned back against the horse's head, the horse is angry or upset. If the ears are upright, all is well, as shown in **Figure 4.9**.

- **Head up high.** Check how the horse is holding up its head. If the head is held high in the air, there's an issue and the horse has some anxiety. When they lower their head, it is a way to reduce their anxiety and they could be trying to relax.

- **Sidestepping or stamping.** If a horse is stamping on the ground, it indicates that it is not happy. When the horse starts to sidestep away from you, it shows that it wants to get away from the situation it's in. When horses are spooked, they have a tendency to move backwards or sideways quickly. You can avoid this behavior by being calm and allowing the horse to see you and the camera before you start taking photos.

If you do start to see any of these stress indicators and believe that the horse is starting to stress out, having the owner around with a reassuring touch or a treat can really help defuse the situation (**Figure 4.10**). I always want the owner to be close by to help with the horse and to act as a second set of eyes, making sure the horse is comfortable and all is going well.

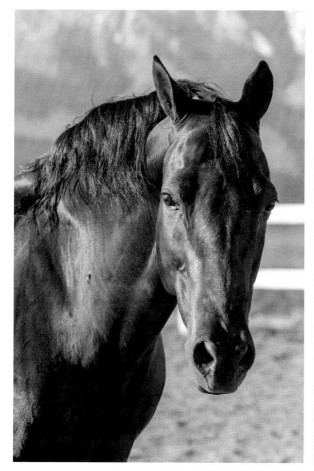

Figure 4.9 A relaxed horse shows its calmness when the ears are up and out to the side, breathing is easy, the head is held in a neutral position, and no whites of the eyes are visible.

Nikon D4 · ISO 400 · 1/500 sec. · f/5.6 · 70–200mm lens

Figure 4.10 Having the horse's owner at the shoot makes it easier to keep the horse stress-free. A simple touch or treat can do wonders.

Nikon D4 · ISO 500 · 1/320 sec. · f/5.6 · 24–70mm lens

Reptiles

Working with reptiles can be quite a challenge. They can get stressed easily, and because they can't verbalize what they like and dislike, you need to learn how to read the danger signs.

When you're photographing snakes, watch out for when the snake wraps its body tightly around your hand or arm. The snake may also draw back its head and rise up in the classic S curve as it prepares to strike. An upset snake might also strike out and bite without warning. These acts are not done to intentionally hurt you but are just instinctive behaviors that reptiles exhibit when they feel threatened.

Lizards will dig their claws into you and try to crawl away from whatever it is that is upsetting them. Sometimes they whip their tails around and try to puff up so they appear bigger and more threatening to whatever they perceive to be the threat. They also might gape as a warning or as another way to appear more dangerous.

Turtles or tortoises have the perfect way to show their dislike of their surroundings; they just retreat into their shell. This makes it very difficult to photograph them when they are stressed.

When a reptile is happy and comfortable being handled, it will rest comfortably on your hand or arm (**Figure 4.11**), looking around and flicking its tongue. It will move smoothly and not thrash around trying to get away.

With reptiles, you must rely on the pet owner to give you feedback on their behavior. But in general, you need to move calmly and avoid making big, sudden movements.

Figure 4.11
A nonaggressive, happy lizard just hanging out on his owner's hand.

Nikon D4 · ISO 800 · 1/250 sec. · f/11 · 105mm lens

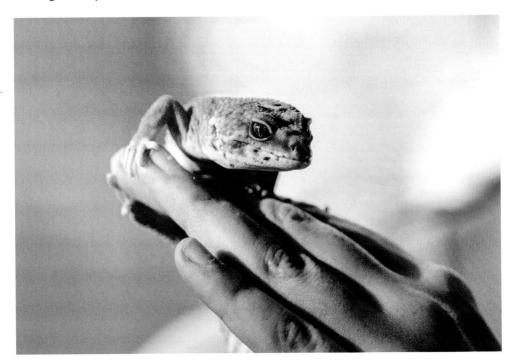

Birds

The signs of stress in birds can include feather picking, ruffled feathers, pacing, and even some biting. All of these behaviors make a stressed bird very difficult to photograph. Birds are very sensitive to changes in their environment and can stress over even minor changes, including the introduction of a new person with a large camera that produces shutter noise. You need to take it slow: Start off with a longer lens at a greater distance,

and don't make any sudden moves around birds. It's always a good idea to discuss the best way to approach the bird with the owner. A happy bird will sit comfortably on a perch, as shown in **Figure 4.12.**

Birds can be very cute, but keep in mind that they can have sharp beaks and claws, so pay attention to their movements, especially when you're working in close.

Pre-Shoot Planning

Preparing for a pet photo shoot is a combination of planning what you want to capture and being flexible enough to change your plans on the fly. Much of my planning depends on whether I am photographing my pets or photographing other people's pets. When I decide to get some new photos of my pets, I don't have to worry about making sure I have all the right equipment or a spare battery, because I'm home and can just go grab the accessories I need. But if I'm photographing someone else's pets or taking mine to a different location, I plan out what I'm going to do and what I need to have with me.

The first part of the preparation when I'm photographing someone else's pet is to talk to the pet owner and see what they want from the photos. Are they looking for an action shot of the dog

Figure 4.12 **Harley is a happy macaw as she sits comfortably on her owner's arm. But when she gets upset, she pushes up against him.**

Nikon D4 · ISO 400 · 1/1250 sec. · f/2.8 · 70–200mm lens

or horse, or do they want a portrait of their pet sitting in their favorite spot? The more information you have before the shoot, the better.

I then make sure that I have freshly charged batteries for my cameras. This means that the battery in the camera is fully charged, and I have a spare battery in my camera bag that is also fully charged. Chances are I will never need the extra battery in the camera bag, but why gamble?

When I ready my camera, I make sure that in addition to a freshly charged battery, the camera has a formatted memory card. I always start any shoot with an empty memory

card so I have plenty of storage space to capture images. I also carry extra memory cards with me because you never know how many photos you will take during any given shoot.

It's important to have a system when it comes to managing your memory cards. After a shoot, I download the images from the memory cards to the computer and to a backup drive so the images are stored in two places. Then I format the cards in the camera they are used in. For example, I format the XQD cards in the Nikon D4 and the SD cards in the Nikon D3200. The CompactFlash cards are formatted in either the Nikon D4 or the Nikon D700. Then I place the cards face forward in the card wallet. The used cards are placed with the back of the card facing forward so when I open the card wallet, I can tell immediately which cards are ready to go and which are already used. This technique also helps when I'm sitting at the computer and downloading the images; I instantly know which cards have images on them and which are empty.

With the batteries and memory cards prepared, I pack the lenses and cameras I plan on using. My favorite lens to use is the 70–200mm f/2.8 because it allows me to fill the frame with the pet but still stay a respectful distance away. The other lens that I use often is the 24–70mm f/2.8, which gives me a wider view of the scene. Next, I add a small towel to the bag and other camera cleaning supplies that might come in handy if the camera or lens gets drool, dust, or grime on it during the shoot.

Finally, I pack the specialty items that I need or might need for this specific shoot. If I'm working indoors on a more portrait-type shoot, I add some flashes, radio triggers, and a reflector. For an outdoor shoot, I'll add the reflector and diffuser. For shoots where I'll need to get close to a small subject, like a lizard or a snake, I add a macro lens. Which equipment you decide to take with you is just a matter of building the gear for the type of shoot you are planning.

For example, when I went on location to photograph some dogs going through a training session, I knew I wouldn't need a flash or any gear that might distract the dogs. All I took was a camera body, the 70–200mm lens, the 24-70mm lens, batteries, and memory cards. When photographing my friend's cats, I packed up everything because I didn't know if the cats would be more comfortable inside where I might need a flash or outside where I might need the diffuser.

But always keep in mind that pets have a mind of their own, and many times the best ideas or plans will be wrecked in seconds when you realize that the pet has a very different idea of how to pose. You need to roll with the changes, keep your calm, and work with what you have; don't try to force any animal to do something they don't want to do.

Chapter 4 Assignments

Discuss the Shoot

Communication makes any shoot work best, and photographing pets is no different. When you're photographing someone else's pets, create a worksheet for the shoot, and then fill it out when discussing with the owner what they want from the shoot. Include the number of animals, the type of pets, the pets' names, if the owner wants shots indoors or out, the time of the shoot, and any special details you need to know about the pet. This will help you keep the details straight and plan for the shoot. For example, if you plan on an evening shoot, you need to discuss if the owner should feed the pet before or after the shoot. Which is best will depend on how food motivates the pet or how grumpy it gets when it's not fed on time. You may need to adjust the shoot accordingly.

Watch Your Subjects Carefully

Before you lift the camera to your eye, watch the pet for a few minutes (sometimes longer) to try to get an idea of how they will react to the camera and the shutter noise, and which direction they might move if they decide to run away. This will allow you to be ready when the pet calms down. Also, pay attention to your surroundings with your other eye, especially if another animal is around. Look for signs of stress during the shoot, and check with the owners constantly to see if they are noticing any stress in their pet.

Create a Pre-Shoot Checklist

When you're getting ready for a shoot, make a checklist on a notecard of all the equipment and accessories you might need. This checklist will then help you pack the right gear for the job. In fact, it's best to make this list when you talk to the owners about what they want from the shoot. For example, if they are looking for a portrait-type photo of their indoor cat, be sure to add flashes, radio triggers, and a softbox to the list. When the shoot is finally scheduled, the list will indicate what you need to bring. Making a list can work for when you take photos of your own pets as well. Knowing the gear needed for a certain type of shot will keep you organized as you set it up.

Share your results with the book's Flickr group!
Join the group here: flickr/groups/petphotographyfromsnapshotstogreatshots

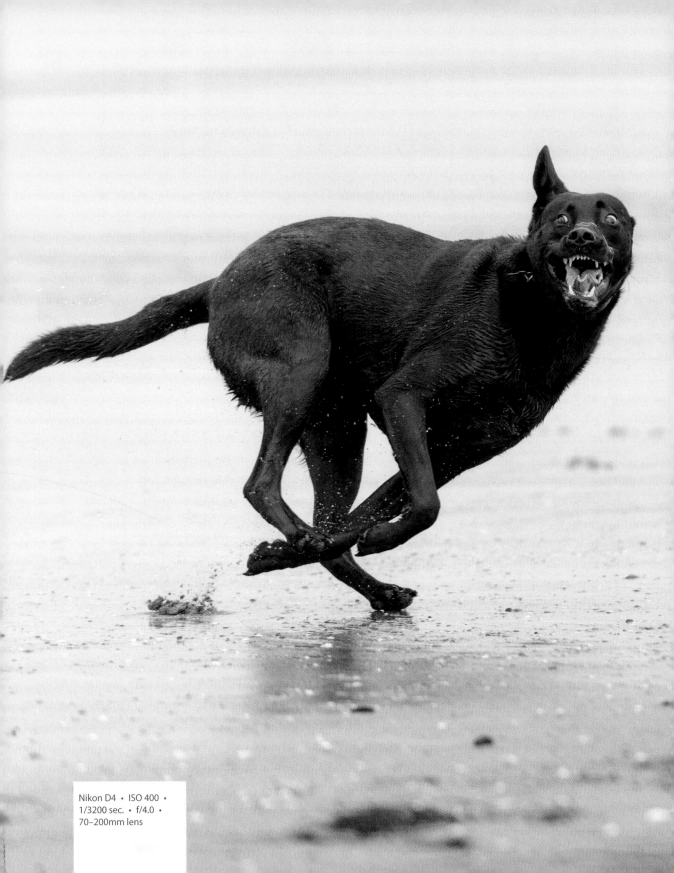

Nikon D4 · ISO 400 ·
1/3200 sec. · f/4.0 ·
70–200mm lens

5
Action Photos

Capturing your pet in action

Watching a dog run and play on the beach is truly a beautiful sight.
Watching a dog or a horse run, or a cat leap out of hiding, can fill you
with a sense of awe and wonder as to how they move so fast and so
gracefully. Photographing a pet in action can produce stunning images.
But to capture the action effectively, you need to anticipate where it will
happen, set the camera to freeze the action, and hope for a bit of luck.
Capturing the action outdoors in bright light is easier than indoors, but
both endeavors can be successful with the right settings, proper gear,
and a little planning.

Poring Over the Picture

I photographed this image during an agility training session in which the dog had to weave between the upright poles. Using a long focal length and lying on the ground, I positioned myself so the dog was running right toward me. Although it might look as though the dog is looking directly at me, he is actually focusing on the obstacles and his handler.

I used continuous autofocus and kept the focus point on the dog's face.

Using a shutter speed of 1/3200 froze the action as the dog came through the poles.

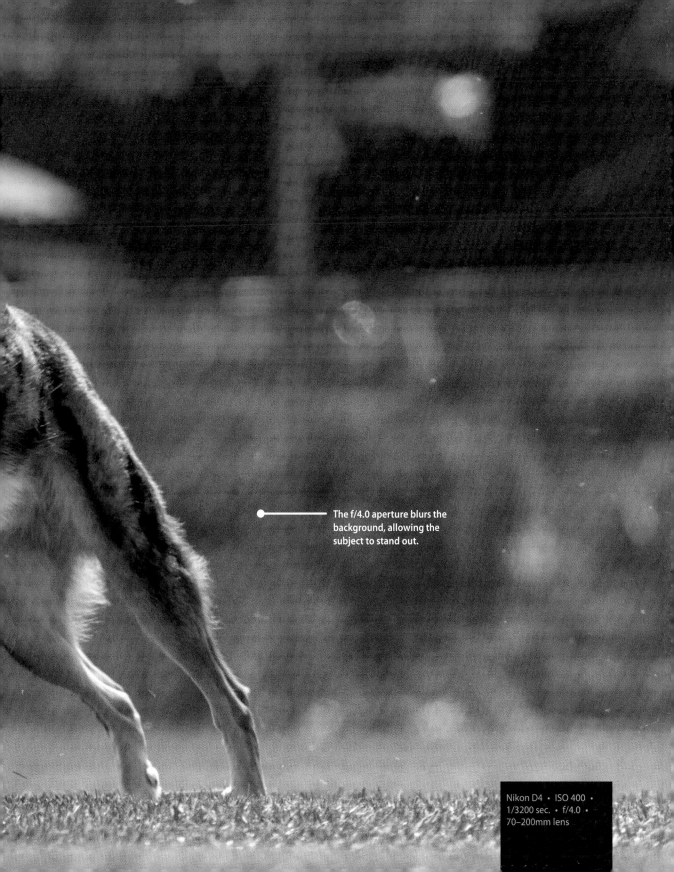

The f/4.0 aperture blurs the background, allowing the subject to stand out.

Nikon D4 · ISO 400 ·
1/3200 sec. · f/4.0 ·
70–200mm lens

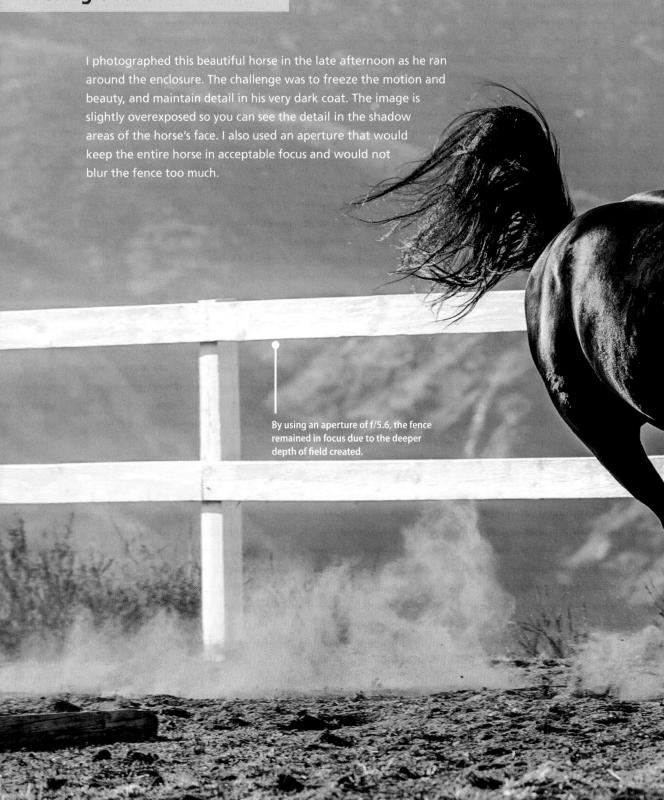

Poring Over the Picture

I photographed this beautiful horse in the late afternoon as he ran around the enclosure. The challenge was to freeze the motion and beauty, and maintain detail in his very dark coat. The image is slightly overexposed so you can see the detail in the shadow areas of the horse's face. I also used an aperture that would keep the entire horse in acceptable focus and would not blur the fence too much.

By using an aperture of f/5.6, the fence remained in focus due to the deeper depth of field created.

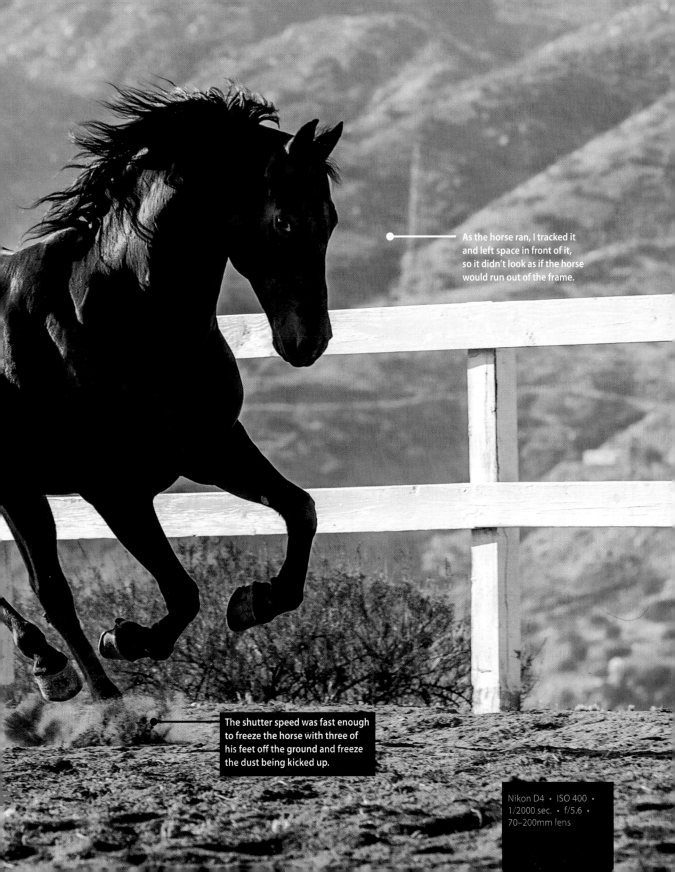

As the horse ran, I tracked it and left space in front of it, so it didn't look as if the horse would run out of the frame.

The shutter speed was fast enough to freeze the horse with three of his feet off the ground and freeze the dust being kicked up.

Nikon D4 · ISO 400 ·
1/2000 sec. · f/5.6 ·
70–200mm lens

Watch, Learn, Anticipate

To get great photos of animals in action, you need to identify the location of where the animal will move to and be ready to capture it. You also need to be able to anticipate the action before it happens. For example, if you throw a ball for a dog to chase, the dog will run after the ball and then (hopefully) come back. If you know in which direction the dog will run and when it will start running, you can plan how to photograph it. The behavior and speed of some animals are harder to anticipate than other animals. Cats tend to move in very fast, sudden movements, making it significantly more difficult to time the photos.

Also, the size of an animal makes certain behaviors more likely to occur outdoors than indoors. For example, you might photograph a horse in a stable or barn, but you would not expect the horse to be running in the barn.

Watching the way a pet moves before photographing the action is the best way to learn where the pet will move to and where the best spot to photograph the action will be.

Some pet activities, such as dog agility courses or horse-riding events, lend themselves to action photographs. The action takes place in a controlled environment and in an orderly manner, which makes it very easy to know where and when the action will take place, allowing you to plan ahead. An agility course is repeatedly run the same way; therefore, I knew exactly where a jump would take place in **Figure 5.1**.

Figure 5.1
Catching a dog
mid-jump during
an agility course
run isn't that
difficult because
you know exactly
where the dog will
be and when.

Nikon D4 • ISO 500 •
1/4000 sec. • f/4.0 •
400mm lens

Working Outside

Photographing animals in action outside requires a combination of fast shutter speeds, a continuous drive mode, continuous focus, a good background, and a plan. When you're photographing outdoors, you should first look at where the light is coming from and where the action will take place. The best situation is when the sunlight is diffused by clouds, creating a nice, even, soft light. In the even lighting, you don't have to worry about heavy shadows.

The dog photographed in **Figure 5.2** was running at the beach on an overcast day, which made it easy to capture all the details without any hard shadows.

Figure 5.2 **The soft light made it easy to freeze this Husky in mid-stride as he ran across the sand, as well as capture all the details in the scene.**

Nikon D4 · ISO 400 · 1/2000 sec. · f/4.0 · 70–200mm lens

When photographing in direct sunlight, it is very difficult to try to diffuse the sunlight because the subject is moving and probably traversing a greater area than the diffuser can cover. In this situation, I position myself so the light is to my left or right, ensuring that I am not facing the light, nor is it directly behind me. The result is a shadow on one side of the subject and sunlight on the other, allowing me to possibly use the shadow as an element in the image. For a better chance of capturing a great shot, it's best to not have the sun directly overhead but instead at a lower angle, either in the morning or evening. In **Figure 5.3**, you can see how the sun makes one side of the dog much brighter than the other, and you can tell where the sun is by the location of the dog's shadow.

Figure 5.3
The shadow on the sand places the sun high up and on my right.

Nikon D4 · ISO 400 · 1/4000 sec. · f/4.0 · 70–200mm lens

Photographing dogs in action on the beach is one of my favorite pastimes, and I'm lucky enough to be able to do this on a regular basis. The real advantage to photographing at this location is that the wet sand is a great surface, because it bounces some light back at the subject and creates a nice, even light, especially on a cloudy day. The water and wet sand also create some interesting reflections, as shown in **Figure 5.4**.

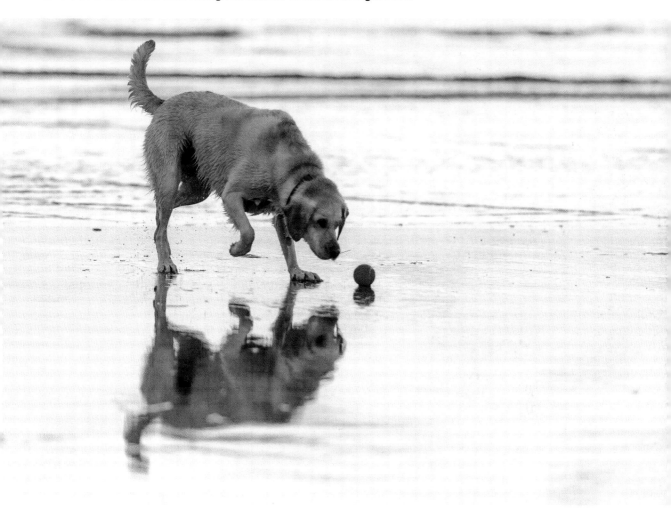

Figure 5.4 The reflection of the dog in the wet sand makes for a more compelling image.

Nikon D700 · ISO 1600 · 1/500 sec. · f/4.0 · 70–200mm lens

Setting Shutter Speed for Action

The shutter speed freezes the action by opening and closing the shutter so fast that the subject doesn't have a chance to move. The minimum shutter speed needed to freeze the action depends on the speed at which the subject is moving, the direction it is moving, and how close it is:

- **Speed of the subject.** When it comes to setting the shutter speed, you need to determine how fast the subject is moving. You don't have to use a radar gun to get an accurate speed of your subject; instead, you need to judge the general speed of the subject. For example, a dog chasing a ball moves faster than a horse just walking along. A cat darting across an open yard moves very fast, especially compared to a turtle traveling the same ground.

- **Direction of movement.** You need to use a faster shutter speed for subjects that are moving across the frame than for subjects coming straight toward you or away from you. The farther the subject is traveling across the frame during the exposure, the faster the shutter speed needs to be. The horse in **Figure 5.5** was moving across the frame and running fairly fast, so I made sure I was using a shutter speed high enough to freeze the action, in this case 1/2000 of a second.

- **Distance to subject.** The closer you are to the subject, the more the subject fills the frame and the faster it will appear to move through the frame. The same is true when you're using a long focal length and the subject takes up much of the frame.

Figure 5.5
A very fast shutter speed was needed to freeze the action of the horse running across the frame from left to right because it is taking up much of the space in the frame.

Nikon D4 · ISO 800 · 1/2000 sec. · f/5.6 · 70–200mm lens

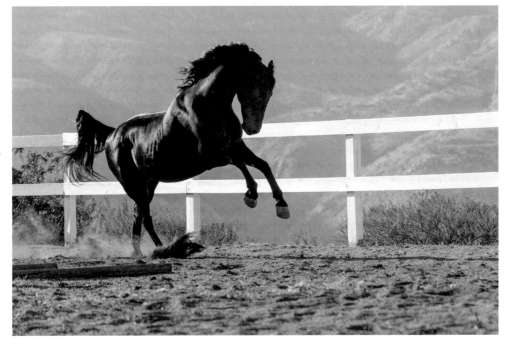

When I photograph animals in action, I try to use as fast a shutter speed as possible, usually 1/2000 of a second or faster. Such a fast shutter speed requires a significantly bright outdoor light, a wide aperture, or a high ISO. My preference is to shoot under a cloudy sky using a wide aperture and an ISO of 400–800.

To get the proper exposure when you're photographing animals in action, just follow these steps:

1. Set the aperture to f/4.0 or as wide open as possible if it is smaller than f/4.0.

2. Set the ISO to 400.

3. Set the metering mode to Matrix Metering.

4. Take a photo of your subject; don't worry about the subject actually doing anything important.

5. Change the exposure mode to Manual, and input the aperture and shutter speed that the camera calculated when photographing in step 4.

6. Check the exposure on the LCD on the back of the camera.

7. For black pets, you'll usually have to increase the shutter speed one-third or two-thirds of a stop.

8. For white pets, you'll usually have to decrease the shutter speed by one-third or two-thirds of a stop.

When I have the exposure settings dialed in, all I have to do is adjust the shutter speed, depending on the amount of light. For example, if I'm photographing dogs running on the beach and the clouds part to create a brighter, harder light, I'll need to increase the shutter speed to compensate for the brighter light. If the sun moves back behind a darker cloud, I'll need to decrease the shutter speed to counteract the lower intensity of light. If the shutter speed drops too low, I increase the ISO so I can increase the shutter speed and freeze the action.

You can use this same technique to capture any animal playing outside. Prior to the shot of the cat in **Figure 5.6** on the following page, I took a test shot in Aperture Priority mode and then switched to Manual mode and adjusted the exposure as the light changed. I had to decrease the shutter speed slightly so the color of the cat was accurate.

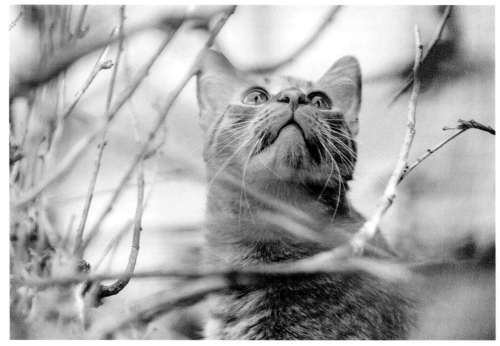

Figure 5.6
When photograph-ing this cat climbing a tree, I had to pur-posely overexpose the image slightly due to the cat's light coat.

Nikon D4 · ISO 1600 · 1/800 sec. · f/2.8 · 70–200mm lens

Setting the Drive Mode for Action

Being able to take a series of photos rapidly greatly increases your chances of getting a great action shot. The number of photos you can take in quick succession depends on your camera and the frames per second (FPS) rate. Cameras have different drive modes that control the number of photos taken when you press the shutter release button. In Single Shot mode, the camera takes a photo each time you press the shutter release button. In Continuous Drive mode, the camera keeps taking photos as long as you hold down the shutter release button.

Many of the professional cameras have a higher FPS rate than consumer-level cameras. Numerous consumer-level cameras can shoot at 4–5 FPS, whereas the high-end professional cameras can shoot at 10 FPS or higher.

Set your camera to the highest FPS rate as possible and shoot a sequence of images; then you can select the best one. As you can see in **Figure 5.7**, I shot a sequence of images as the dog ran so I could choose the best shot from the series.

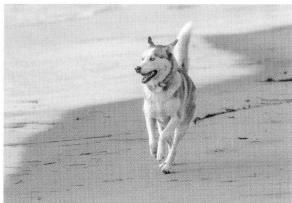

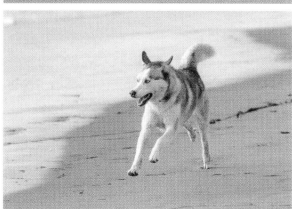

Figure 5.7 While taking this sequence of four frames of the Husky running on the beach, I kept the focus point on the dog's face and used Continuous Drive mode. The camera kept taking photos as long as I held down the shutter release button.

Nikon D4 · ISO 400 · 1/2500 sec. · f/2.8 · 70–200mm lens

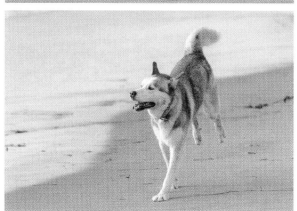

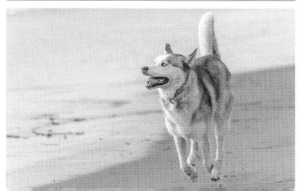

Setting the Focus for Action

Continuous Autofocus is specifically designed for action photography. In Continuous Autofocus mode, the camera continues to focus until you press the shutter release button all the way down. Then the shutter moves out of the way, and the photo is taken. When combined with Continuous Drive mode, the camera will try to maintain focus as the subject moves and adjust the focus between each frame.

For the best results, I keep the focus point right on the face of the pet I'm photographing (**Figure 5.8**). I track the subject as I take the photos, moving the camera along with the action. Many cameras allow you to use more than one focus point (**Figure 5.9**) to help you keep the focus on the moving subject. When you're photographing moving subjects, these other focus points allow the camera to predict where the subject is moving.

The faster the subject moves, the harder it is to keep the focus sharp. Practice leading the subject with the camera, and allow the subject some area to move into so as not to crowd the edge of the frame.

Figure 5.8
The focus point is directly on the eye of the cat, and the camera will continue to adjust the focus as the cat moves and the shutter release button is pressed halfway down.

Nikon D4 • ISO 1600 • 1/800 sec. • f/2.8 • 70–200mm lens

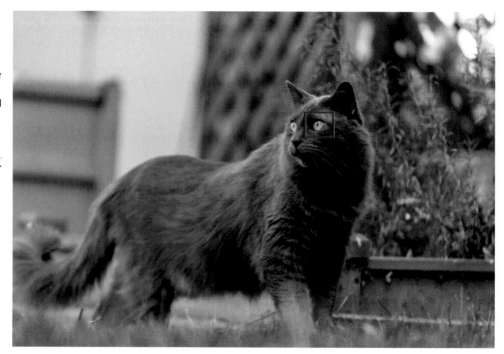

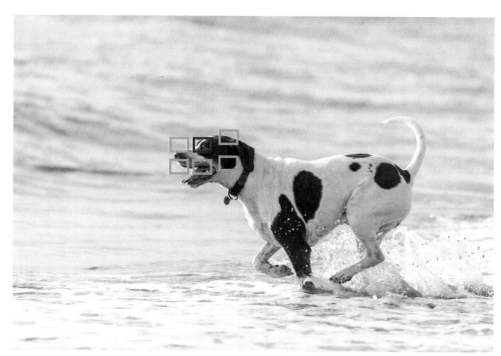

Figure 5.9
The primary focus point (in red) is aided by the focus points around it (shown in pink), keeping the running dog in focus.

Nikon D4 · ISO 400 · 1/2000 sec. · f/4.0 · 70–200mm lens

Working Inside

Photographing action indoors is considerably more difficult than shooting outside due to the low light. With the limited amount of light available inside, it is very challenging to get the high shutter speeds needed to freeze action.

When you're shooting under available light, you must either increase the ISO a great deal or add more light by using a flash to get an action shot. In **Figure 5.10** on the following page, I had to increase the ISO to 3200, and I used an off-camera flash to freeze the action and get a properly exposed photo.

Figure 5.10
The cat really likes to play with her string. Freezing the action took a combination of a high ISO and some added light from a flash.

Nikon D4 • ISO 6400 • 1/500 sec. • f/4.0 • 24–70mm lens

Push the ISO

Digital camera technology makes it possible to shoot at much higher ISO settings than ever before and still produce a usable image. I routinely photograph at ISOs of 1600, 3200, and even 6400 if needed.

To capture a good action shot, the first step is to make sure you are using a shutter speed fast enough to freeze the action, and then start increasing the ISO to get a proper exposure. As you can see in **Figure 5.11**, using an ISO of 6400 allowed me to use a shutter speed of 1/500 of a second, which was enough to freeze the action.

It's essential to try to use as much natural light as possible when you're shooting indoors. By having the pet play in an area illuminated by a window or door, your image will benefit from the added bonus of softer light with no harsh shadows.

Figure 5.11
Using a high ISO can introduce digital noise into the image, but if it freezes the action and captures the moment, it's well worth it.

Nikon D4 · ISO 6400 · 1/500 sec. · f/2.8 · 70–200mm lens

Use a Flash

Flashes were created to add light to a scene when you need it. But a couple of issues arise when you're using a flash to capture the action: One is that the flash needs time to recycle between flashes. Another is that you are limited to a shutter speed of 1/250 of a second or less due to the flash sync speed. Let's explore each of these obstacles in more depth.

Flash recycle time

A flash works by emitting a very bright blast of light. To produce this burst of light, a current is applied to a metal plate inside a gas-filled tube. Most flashes take four AA batteries, which isn't enough power to actually create the flash of light. So, to get the amount of power the flash needs from the batteries, flash manufacturers design the flash to accumulate and store the charge needed and then release it all at once. The process of storing the power takes time.

To see how a flash works, insert a set of fresh batteries in a flash and attach the flash to the camera. Then set the camera's drive mode to Continuous, point the camera at any subject, and press and hold down the shutter release button for ten photos in quick succession. When you look at the photos, you'll see that the first few will look good. However, when the flash runs out of power, subsequent photos will be too dark because either the flash didn't fire at all, or if it does, it doesn't put out enough light.

You can increase the recycle time in a few ways:

- **New batteries.** Fresh new batteries work better than old batteries. I prefer to use rechargeable batteries and always start a shoot with a fully charged set.

- **Extra battery pack.** You can buy an external battery pack for some flashes directly from the manufacturer. For example, the Nikon SD-9 works with the SB-900 and SB-910 flashes, and the older SD-8a works with the SB-800 or SB-900 flashes (**Figure 5.12**). The extra AA batteries a battery pack holds makes a huge difference in the flash's recycle time and the number of flashes output before the battery pack and flash need new batteries.

- **Use less power.** You can set the output power of the flash when you're using the Manual Flash mode. If you set the flash to manual output and the power to 1/2, you use half the full power each time you shoot, which means the flash doesn't need as long to build up a charge.

Figure 5.12 The SD-8a battery pack attached to the Nikon SB-900 flash.

Flash sync speed

To understand the flash sync speed, you have to know what is happening inside your camera when you press the shutter release button. The DSLR shutter has two curtains that control how long the light can reach the sensor. When you press the shutter release button all the way down, the first curtain opens, revealing the sensor to the light. At the end of the exposure, which is determined by the shutter speed, the second, or rear curtain, closes, blocking the light. This sequence is shown in **Figure 5.13**.

The flash needs to fire when the front curtain is fully open and the rear curtain has not yet started to close. The fastest shutter speed that you can use and still have both the front curtain open and the rear curtain open is 1/250 of a second in most cameras. In some cameras, the sync speed is a little slower at 1/200 of a second. Check your camera manual to find out what the flash sync speed is for your camera.

When you use shutter speeds faster than 1/250 of a second (or 1/200 of a second in some cases), the rear curtain starts to close before the front curtain is fully open. This creates a black bar in your image that comes in from the edge as the rear curtain closes.

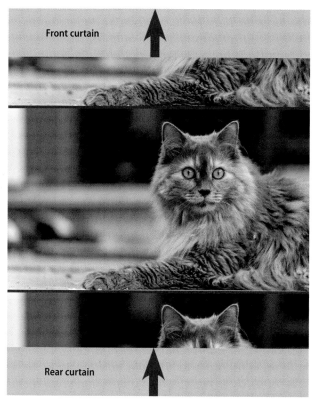

Figure 5.13 When you press the shutter release button, the front curtain opens, allowing the light to reach the sensor, and then the rear curtain closes.

Some cameras have the ability to use faster shutter speeds with a flash, which is called *high-speed sync*. It allows you to use the flash at a much higher shutter speed. Instead of one burst of light, the flash actually fires multiple times so that each slice of the image is lit as the front and rear curtains move across the sensor. The downside is that high-speed sync uses a lot of power, and getting multiple flashes in quick succession is not possible. In **Figure 5.14** on the following page, I used the high-speed sync mode, which enabled me to use a shutter speed of 1/800 of a second.

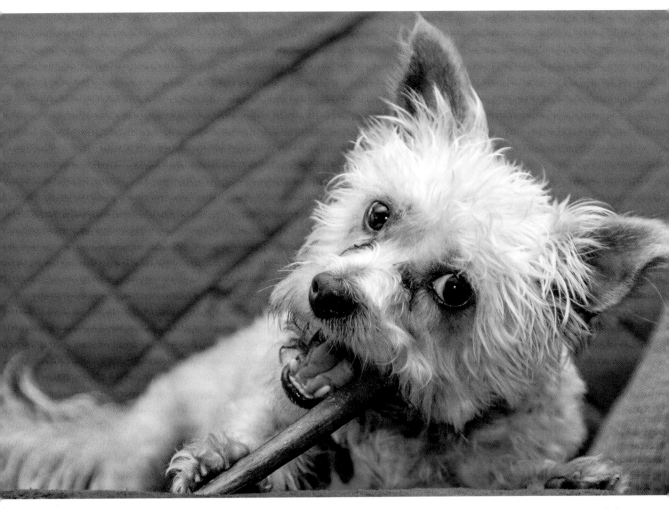

Figure 5.14 Using the high-speed sync mode, I was able to capture this image, but I then had to wait until the flash recycled before taking a second shot.

Nikon D4 • ISO 800 • 1/800 sec. • f/4.0 • 70–200mm lens

Freezing action

The light produced by the flash is a very quick burst of light and can be fast enough to freeze action, but doing so indoors in low light is extremely difficult. The best way to use a flash indoors to freeze the action and get the best results is to bounce the flash off the ceiling or wall, creating a bigger, softer light, combined with any window light and a high ISO setting. For example, when photographing the lizard in **Figure 5.15**, I combined a high ISO and a flash bounced off the ceiling to get a proper exposure and freeze the action.

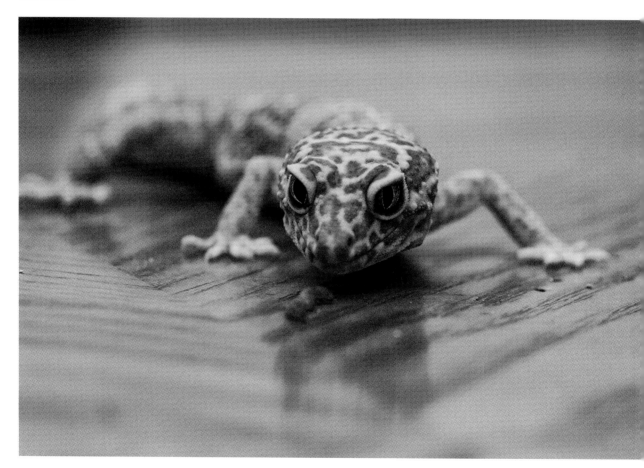

Figure 5.15 **Using a high ISO and bouncing the flash off the ceiling, I was able to photograph this lizard going after his dinner.**

Nikon D4 · ISO 1600 · 1/250 sec. · f/5.6 · 105mm macro lens

Showing Motion: Panning

Panning is a technique used by photographers to show motion in their images. This technique uses a slower shutter speed combined with camera movement to keep the subject in focus while the background blurs. To use this technique successfully, your subject needs to be moving across the frame in a straight line, and you'll need a lot of practice.

To show motion in a photograph using the panning technique, you must keep the subject in the same place in the frame for the entire time the shutter is open. You do this by moving the camera at the same speed as the subject. The shutter speed needs to be long enough that the subject has adequate time to move to blur the background. The faster the subject is moving, the faster you have to move the camera and the shorter the shutter speed can be.

To blur the background of an image when a pet is running (**Figure 5.16**), you'll need to use a slow shutter speed of 1/30 of a second to 1/100 of a second.

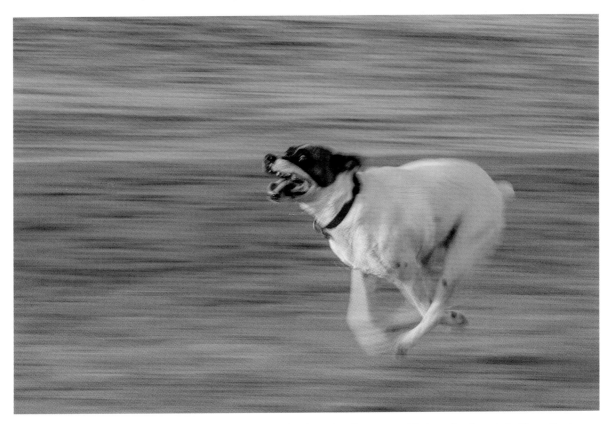

Figure 5.16 Using a slow shutter speed and panning the camera with the action, I created a blurred background and showed the movement of the subject.

Nikon D4 · ISO 100 · 1/40 sec. · f/5.6 · 70–200mm lens

Chapter 5 Assignments

Freeze Outdoor Action

Go to your local, leash-free dog park or an area where people let their animals run and watch how the animals run. Pick a spot that allows you to observe the action but not be in the way. Watch how the light strikes the subject, and practice adjusting your camera's exposure accordingly. Then work with the camera's autofocus system and practice tracking a moving subject while taking a sequence of photos.

Work with a Flash

When you're capturing action indoors, there is a good chance you'll need to add some light to the scene. Practice setting up a flash off-camera in Manual power mode and bouncing the light off the ceiling. This added light will help you get a proper exposure in low light and capture the action.

Try a Panning Photo

Panning can be very difficult to do, and it takes lots of practice to synchronize moving the camera while keeping the subject in the same place in the frame during the exposure. The more you practice, the easier panning becomes. The key is to set up the shot so the action happens across the frame, not at an angle or head-on.

Share your results with the book's Flickr group!
Join the group here: flickr/groups/petphotographyfromsnapshotstogreatshots

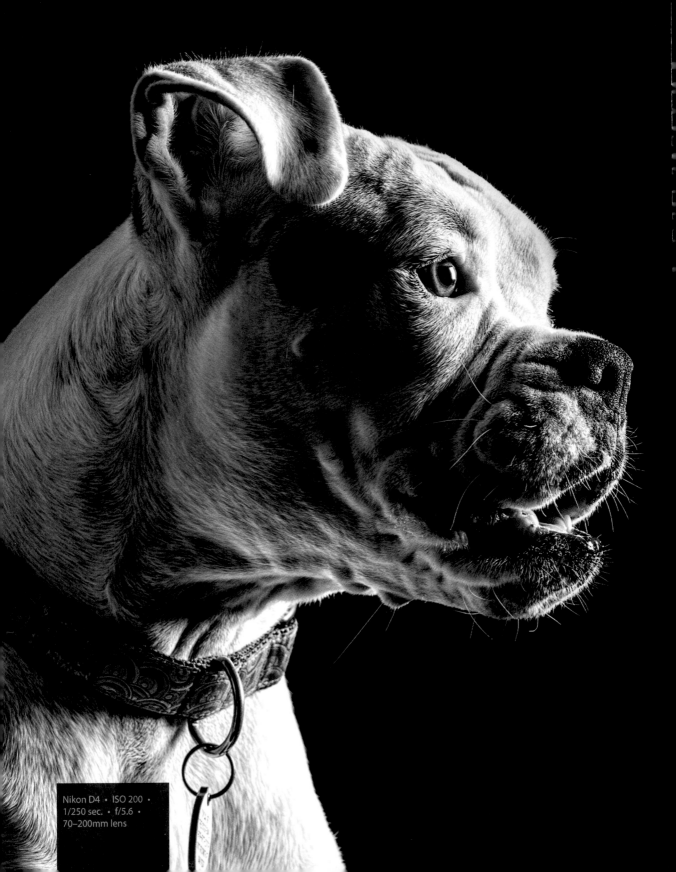

Nikon D4 · ISO 200 ·
1/250 sec. · f/5.6 ·
70–200mm lens

6

Pet Portraits

Creating a portrait of your pet

A portrait is more than just a quick, candid snapshot of your pet. Taking a portrait of your pet requires planning to find the best location, the right lighting, and a background that keeps the focus on the subject. Photographing a pet portrait is a lot like photographing a celebrity; you need to have all your equipment set up beforehand and have a plan in place, because you won't get a lot of time with your subject.

While keeping the focus on the eye, I also used an aperture that kept the nose and paws in focus.

This puppy was done posing and just hopped down on the kitchen floor with his head on his paw. The off-camera flash was placed on the kitchen counter and aimed at the ceiling so the light would bounce down onto the dog.

A black background placed far behind the dog helps keep the attention on the subject.

Using a long focal length minimized the background and filled the frame with the dog without me having to get too close.

Nikon D4 · ISO 800 · 1/250 sec. · f/5.6 · 70–200mm lens

Poring Over the Picture

Taking this cat's portrait was just a matter of patience as he lay out in the shade. I positioned myself where I could get a clean shot, and then waited until he turned his head to look at me. The shallow depth of field minimizes the details in the background and still keeps the cat in focus.

The shallow depth of field creates a pleasingly blurred background.

Because the cat hadn't warmed up to me yet, the long focal length allowed me to shoot it from a safe distance.

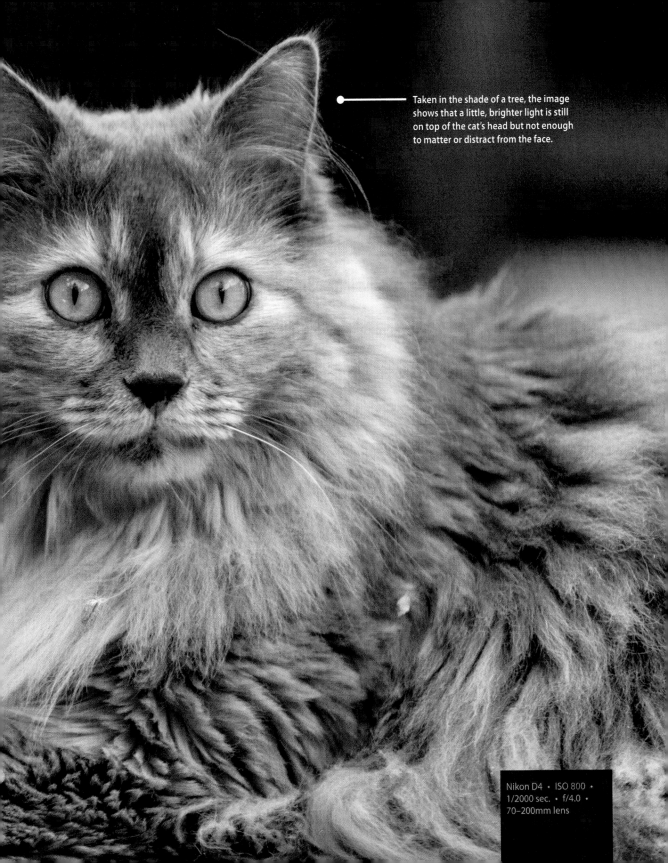

Taken in the shade of a tree, the image shows that a little, brighter light is still on top of the cat's head but not enough to matter or distract from the face.

Nikon D4 · ISO 800 ·
1/2000 sec. · f/4.0 ·
70–200mm lens

Choosing a Good Location

Portrait photography is a lot like real estate in that location is extremely important. Shooting at a good location can make taking a portrait easier and the resulting image much better than shooting in a poor location. Poor locations are those that distract from the main subject or don't allow you enough space to work properly. A poor location could also be a setting that puts the pet at any kind of risk. When you're choosing the best location for a pet portrait, you should consider the following features:

- Safety
- Background
- Distance
- Lens choice

Let's look at each in more detail.

Choosing a Safe Location

The safety of the pet, any other animals in the area, and the owner needs to be your top concern when picking a location for the portrait. It doesn't matter how great the light or how stunning the background, if the location is not fully under your control, you need to reconsider its use.

Many times the best location is a place where the pet is the most comfortable, like in their own home. The Bullmastiff in **Figure 6.1** was photographed in his front yard, a spot in which he was very happy hanging out. The Bullmastiff was actually timid around people and wasn't comfortable with me being too close, so the yard not only kept him calm but allowed enough space for me to work with a longer focal length and keep a respectable distance from him.

Here are some considerations to keep in mind when it comes to the safety of the pet when you're shooting portraits: It's important to keep indoor pets indoors, no matter how great the outside looks. Cats, birds, reptiles, and other animals that live indoors might bolt if they are allowed outside. The new environment can spook them and cause them to run. If you've ever tried to catch a cat that has run outside, it can be a very frightening and frustrating experience to try to get them back. The same can happen when you take a dog off a leash in an open area. You need to be very sure that the dog is trained and comfortable off leash and that the dog will not run away. Even in off-leash areas dogs are not always safe, especially if other dogs are around. Make sure the dog is comfortable around unfamiliar animals and people. One of my dogs loves people but is not fond

of other dogs, so she's never allowed off leash around dogs she doesn't know. Talk to the owner and make sure they understand that pet safety is of utmost importance.

Above all, use your common sense, and if a situation seems like it could cause some problems, stop photographing immediately and reassess the entire setting. Keep in mind that you can get great portraits in the comfort and security of your own home or yard.

Figure 6.1 Being photographed in his front yard was comforting to this timid Bullmastiff, making it a good, safe location for the portrait.

Nikon D4 · ISO 800 · 1/800 sec. · f/4.0 · 70–200mm lens

Choosing a Background

The background of your portrait can make or break your photo. The background needs to add either a sense of place and time to the image, or it needs to be plain and nondistracting so as not to draw attention away from the subject.

One of the easiest ways to create a simple background is to use a plain backdrop. Some great options for backgrounds include:

- **Collapsible backdrops.** These backdrops are built like regular reflectors or diffusers, but instead of using reflective or semitransparent material they are solid colors on both sides, such as black and white or yellow and orange. Lastolite Plain Collapsible Backgrounds sell for about $200 for the 6x7-foot large models or $140 for the smaller 5x6-foot reversible models. Also, the 6x7-foot Black/White Collapsible Backdrops from Westcott are available for about $240. All these backdrops collapse to a compact size for ease of use on location and for storage.

- **Black foamboard.** This is the cheapest and easiest background material you can use, and is my favorite, especially when I'm photographing small pets. Any good art supply store will have pieces of black foamboard in stock. You only need a piece larger than the pet you want to photograph, so it's perfect to use when you're photographing cats or small dogs.

- **Backdrop stand and seamless paper.** Seamless paper has long been a standard in portrait photography. To use seamless paper, you need to hang the roll from a backdrop stand; therefore, you'll need to purchase a stand as well if you don't already have one. The seamless rolls come in various sizes; the smallest is usually 53 inches wide by 12 yards long. This is a good solution if you already have a backdrop stand and just need to buy some seamless paper.

- **30-inch solid black block.** This solid, black light modifier from Westcott makes a perfect backdrop for small pets at a great price. It's only 30x20 inches, but it collapses down to one-third its size, making it easy to pack and use on location. It is built to last and costs only $50.

Using a plain backdrop gives you several options when choosing locations for your pet portraits. You can see a setup shot in **Figure 6.2** and the final image in **Figure 6.3**.

Figure 6.2
Here you can see the white backdrop in use, and the bird is being held by its owner.

Nikon D4 · ISO 500 ·
1/4000 sec. · f/4.0 ·
400mm lens

Figure 6.3
A close-up of the bird in front of the solid white backdrop.

Nikon D4 · ISO 500 ·
1/4000 sec. · f/4.0 ·
400mm lens

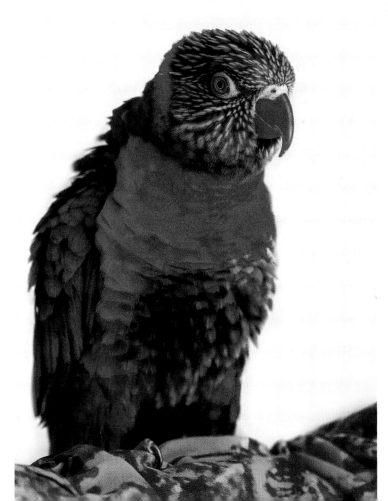

Another way to create a pleasing background is by using a shallow depth of field to blur the background. A blurred background allows the pet to pop out of its surroundings and keeps the viewer's attention focused on the animal.

In **Figure 6.4**, I used an aperture of f/4.0 to create some separation between the dog and the background, because I didn't want the bicyclists to be in focus and draw the attention away from the dog.

Figure 6.4
While photograph-ing this dog outside in San Diego, I used a shallow depth of field, making the background out of focus and keeping the attention on the pooch.

Nikon D4 · ISO 200 · 1/2000 sec. · f/4.0 · 24–70mm lens

An alternative background I use for many of my pet portraits is accomplished by using the inverse square law, which dictates how light behaves over distance. Using this method, you can create a solid black background without any backdrops.

Place the light as close to the pet as possible. The flash needs to illuminate the pet but not reach much beyond the pet. You can place the light pretty much anywhere in front of the pet, and the position of the light will directly affect how the pet looks. If you have the time and are working with a patient pet, try a couple of angles and observe how the light's position changes the appearance of the animal. I start by placing the light off to the side at roughly a 45-degree angle, and then adjust the angle depending on the specific animal I'm photographing.

You can see the results in **Figure 6.5.** The cat was illuminated by an off-camera flash, and the light never reached the background.

Figure 6.5 This cat was photographed indoors using an off-camera flash, which created a clean black background.

Nikon D4 · ISO 100 · 1/250 sec. · f/11.0 · 24–70mm lens

Determining Distance

The distance between the subject and the background is as important as the amount of space between the front of the subject and where you photograph from. The more space you have in both cases, the better your image will be.

Let's consider the distance between the pet and the background first. The greater that distance, the easier it is to separate the subject from the background. When you use a shallow depth of field to keep the subject in focus and blur the background, there must be enough space so the background isn't also in focus.

When you use a flash to light your portrait and you want the background to go solid black, you need sufficient space so the light has enough distance to fall off and not reach the background. The intensity of the light from a flash is reduced as the light travels; therefore, keep the subject close to the light but far away from the background. The more space you have in this situation, the better the outcome.

Figure 6.6 Having ample distance between my subject and me allowed me to choose the lens and focal length I wanted to use for the image.

Nikon D4 • ISO 1600 • 1/500 sec. • f/4.0 • 70–200mm lens

The amount of space in front of the subject is important because it gives you options when you're choosing which lenses to use. Every lens has a minimum focusing distance; usually, the longer the focal length, the greater the minimum focusing distance. For example, the 70–200mm f/2.8 Nikon lens has a minimum focusing distance of 4.6 feet, which means you need at least that much space in front of the subject to even consider using that lens. Typically, I try to achieve at least double the minimum focusing distance. The more space you have between you and your subject, the easier it is to work. In **Figure 6.6**, I had approximately 18 feet between my dog and me, which allowed me to use the 200mm focal length to minimize the background.

Deciding on the Right Lens

The focal length of the lens that you use can make a huge difference in how much of the background is actually in your image. When you're choosing a lens, the primary factor is usually how the lens depicts the subjects, but the focal length affects the background as well. Short focal lengths show more of the background than longer focal lengths. For example, the cat lounging on the sofa in **Figures 6.7** and **6.8** didn't move between the two photos, but I did, and I changed the focal length. At 24mm (Figure 6.7), you can see more of the surrounding area, and the cat actually looks smaller in the frame. At 100mm (Figure 6.8), I had moved backward as far as I could and zoomed in; the cat looks bigger, and you see less of the background.

Using a longer focal length makes it possible to create a clean, simple background in many locations and even have the pet owner be close by without being in the frame.

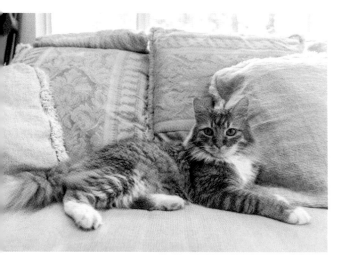

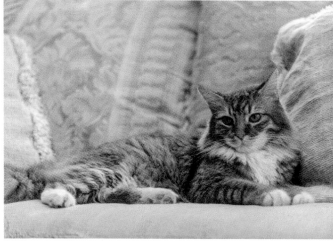

Figure 6.7 I photographed this very mellow, lounging cat at 24mm. You can see quite a bit of the background, even though I am very close to the cat.

Nikon D4 · ISO 800 · 1/250 sec. · f/5.6 · 24–70mm lens

Figure 6.8 At 100mm, the amount of background visible is greatly reduced.

Nikon D4 · ISO 800 · 1/250 sec. · f/5.6 · 70–200mm lens

Using Available Light

Sunlight can be some of the best light for portraits. It's very bright, it's available in some form every day, and you can see exactly how your subject will look in it. But you need to keep one important detail in mind, which is that sunlight changes continually as the earth rotates around the sun. That beautiful light from the south-facing window in the wintertime might not look the same during the summer months. That great light early in the day or late in the afternoon will look very different at noon. The main advantage of working with sunlight is that you can work with the available light indoors and outside. The macaw photographed in **Figure 6.9** was sitting just inside the doorway and was illuminated by the edge of the afternoon light. Because it was much darker inside than in the light, the background went dark, except for the round skylight way in the back of the room, which added the lighter round areas in the background.

Figure 6.9 The afternoon light coming through an open door was perfect for this photo of the macaw. I used a long lens and a low angle to take this portrait.

Nikon D4 · ISO 600 · 1/500 sec. · f/5.6 · 70–200mm lens

Using Available Light Indoors

Sunlight coming in through an open window or door makes beautiful portrait light. Instead of the light being a small, hard light source, the window or door becomes the new light source, creating a much softer, more pleasing light.

The key is to place the pet at the edge of the light, allowing the light to feather over the subject. One of the best places to photograph a pet is just inside a doorway as the pet looks outside, especially when the light is overhead so just the edge of the doorway is in direct light. **Figure 6.10** was taken from outside as the cat was sitting inside, just behind the doorsill, and looking out. You can see how just a bit of light is being reflected up from the metal trim in the doorway, but because the light is overhead, very little light is making it to the background.

Figure 6.10
This cat wasn't sure what to make of me, so I kept my distance and instead waited outside the door. The combination of the soft light and the reflected light made it easy to get this great portrait.

Nikon D4 • ISO 800 • 1/4000 sec. • f/5.6 • 70–200mm lens

At times, working inside is a necessity. For some pets, going outside is not an option and not worth the risk. But it is still possible to create great portraits by just using some window light. Place the pet perpendicular to the window so the light washes across its features and isn't directly behind or in front of it. Using a reflector on the opposite side of the window can help to even out the light if needed, and a diffuser in the window can help if the light is too bright. The dog in **Figure 6.11** was photographed using the light coming in through a big window off to the right.

Because the light will constantly change during the day, try to time the shoot when you will get the best light for the location.

Figure 6.11
This cute little guy was lit with the afternoon sun coming in through a big window on the right. The white chair helped to bounce and soften the light.

Nikon D4 · ISO 800 · 1/250 sec. · f/5.6 · 24–70mm lens

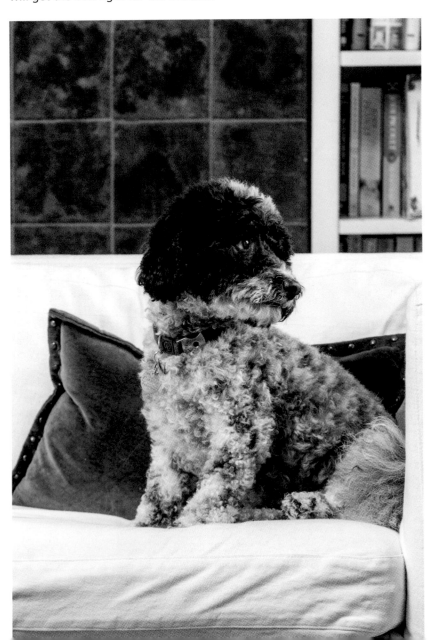

Using Available Light Outdoors

The best light for taking portraits outdoors isn't direct sunlight but diffused sunlight that you find in the open shade. Open shade is a term you will hear photographers throw around when they're talking about light. It basically means any spot that is shaded from direct sunlight and allows the subject to be illuminated by the reflected light. Open shade is great light because it is an even, soft light that appears across the subject. It is the same light that is present when you place your subject inside a doorway and have them face out. To quickly test for this type of lighting, just hold your hand out and look at its shadow. It should be barely noticeable if visible at all.

Some open shade locations are under a tree or against the side of a building, or you can create the same light using a diffuser. One word of caution when you're photographing under a tree: There could be speckling, which is where the hard sunlight comes through gaps in the foliage and creates little bright spots on your subject.

By photographing the cat in **Figure 6.12** late in the afternoon, the angle of light created a shadowed area on the back porch, which made for the perfect spot to take a portrait.

Figure 6.12
Here, Snowball is photographed in the open shade, which was created by the sun being on the other side of the house in the late afternoon.

Nikon D4 · ISO 800 · 1/800 sec. · f/2.80 · 70–200mm lens

If no open shade is available to use and you can't change locations, using a diffuser can help turn the hard, direct sunlight into a softer, more distributed light. In **Figure 6.13**, I had to use a diffuser to create an area of shade for the dog to sit in because it was a cloudless day and the sun was directly overhead.

Figure 6.13
This beautiful Great Dane puppy was photographed in the shade created by a TriGrip diffuser, which was held by an assistant while the pet owner helped to pose the dog.

Nikon D4 · ISO 400 · 1/800 sec. · f/6.3 · 24–70mm lens

You'll need help to hold the diffuser in place, pose the pet, and take the photo simultaneously. If the area in which you are photographing has heavy shade or it is a very cloudy day, use a reflector to bounce some light back into the photo. Position the reflector so the light washes over the pet and doesn't blind them, because they will move if they feel uncomfortable. A small reflector on the ground in front of them can bounce enough light into the scene to help brighten the pet. Keep in mind that the color of the reflector will play a part in the color of the light. When you're photographing outside in the shade or under a diffuser, the light can look a little cold, so make sure you have the white balance on your camera set to either Shade or Cloudy.

I usually let the pet just do their thing as I set up where the portrait will be taken. Then after all the preparation has been done, I bring them to the spot and start taking the photos. Usually, you can get a good number of images as the pet looks around and poses.

I try to start at the longest distance possible with the longest focal length possible and move in toward the pet as I work. If I plan on changing lenses, I make sure everything is close at hand so I can make any changes quickly. You never really know how long you have until the pet decides to move, lie down, or turn their back on you.

When it comes to getting the best exposure settings outdoors, carefully decide on and be aware of what it is you are metering on, the color of the pet, the metering mode, the exposure mode, and how you want the final image to look. All of these determinations need to be set before the pet is in place.

The steps I used to photograph the Black Lab in **Figure 6.14** (on the following page) are as follows:

1. Locate a shady spot in the yard under some trees.
2. Set the camera to Spot Metering.
3. Set the exposure mode to Aperture Priority mode.
4. Set the aperture to f/5.6, which creates a deep enough depth of field that the entire dog is in focus, but the background is slightly blurred.
5. Set the ISO to 400 to make sure the shutter speed freezes any action if the dog moves during the photo.
6. Have the pet owner stand roughly where the pet would be and take a photo.
7. Change the exposure mode to Manual and enter the shutter speed the camera determined in step 6.
8. Have the owner walk the dog over to the photo location and sit her in the shade.
9. Take a photo and check the screen on the back of the camera. In this instance the dog was too light.

10. Increase the shutter speed slightly, take another photo, and check the exposure again. Because I had dialed the exposure in pretty close before the dog was in place, it only took a quick moment to get it just right.

11. Start concentrating on the composition and the angle of the dog's head. You can see a small spot of sun right on the dog's nose that was created as the dog turned, and her head was lit by some sun coming in through the tree.

If the dog had had light fur or mixed fur, I might have had to decrease the shutter speed to let in a little more light.

Figure 6.14
Photographing a wet, black dog is not as hard as it might seem at first. Get the exposure close before taking the photos, and then just fine-tune the exposure as needed.

Nikon D4 · ISO 400 · 1/500 sec. · f/5.6 · 70–200mm lens

Using a Flash

Using a flash to light your pet portrait is pretty easy, especially when compared to trying to capture that pet in action. In a portrait, your subject will be in a controlled area and (hopefully) sitting still.

When you're using a flash, you control all aspects of the light: the direction, intensity, color, and how hard or soft the light is. You can use a flash indoors or out to either completely illuminate your subject or just add a little fill light where needed.

The easiest way to use a flash is mounted on the hot shoe of the camera in TTL (Through The Lens) mode, where the camera determines the light in the scene and indicates to the flash how much light is needed to make a good exposure. This setup works well when your only concern is getting a proper exposure, and you are not concerned about how the background is lit or where the shadows fall. With the flash on the camera pointed directly at the subject, the resulting image will most likely look as though you took a passport picture of your pet. It's not a very flattering look for people, and certainly not a flattering look for your pets either. To create better flash photos with the flash on the camera, try the following techniques:

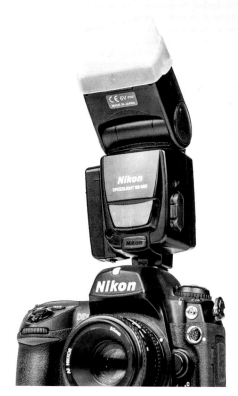

- **Bounce the flash.** You need to use a flash that allows you to adjust the angle of the flash head and in turn you can adjust the angle of the light. Instead of aiming the flash directly at the subject, you can aim it at the ceiling or a nearby wall, thereby diffusing the light.

- **Use a diffusion dome.** A diffusion dome is a plastic piece that fits over the flash head and diffuses the light produced by the flash. The diffusion dome is made of semi-opaque material, which lets the light bounce around in the dome to create a softer light. You can see the diffusion dome on the flash in **Figure 6.15**.

Figure 6.15 **The diffusion dome on the flash helps to create a softer light than using the straight flash.**

When photographing the puppy in **Figure 6.16**, I aimed the flash straight up toward the ceiling, allowing the light to bounce off the ceiling and come out the sides of the dome. I also got down on the dog's level, which just made for a more intimate photo.

Figure 6.16
It's tough being
a dog. Using an
on-camera flash
with the flash head
aimed at the ceiling
and covered in a
diffusion dome, this
portrait perfectly
represents the dog's
temperament.

Nikon D4 · ISO 400 ·
1/60 sec. · f/5.6 ·
24–70mm lens

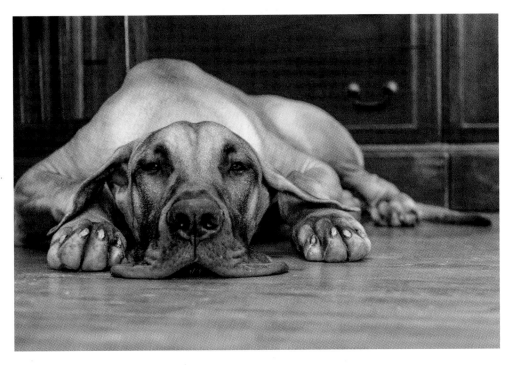

Using the flash on-camera can help you create a good portrait, but when you take the flash off the camera, you can really start to shape the light. The way an off-camera flash works has some limitations, but the advantage is that you can control exactly where the light goes and how bright it is. With the flash off-camera, the camera needs to indicate to the flash when to fire, and that's accomplished by using radio triggers, such as those made by PocketWizard. One of the triggers attaches to the camera, and the other attaches to the flash. When you press the shutter release button, the flash fires. The power of the flash is controlled by using the flash in Manual mode, where you can adjust the power as a ratio: 1/1 is full power, 1/2 is half power, and so on. With the camera in Manual mode, you set the power of the flash on the flash.

In this shooting mode, unlike TTL mode, the camera has no idea that the flash will fire and doesn't control the flash output. Therefore, you'll need to set up the exposure before taking any photos. When shooting in this mode, the shutter speed controls how much of the ambient light is in your photos, and the aperture controls how much of the flash is used. Creating portraits this way allows you to balance the ambient light with flash and control how much of each is used.

To create a portrait in which the background goes completely dark (**Figure 6.17**), you need to set your camera to negate any of the ambient light in the scene. It's very easy to set up your camera this way; just follow these steps:

1. Set your camera to the lowest native ISO, usually either 100 or 200.

2. Set the exposure mode to Manual.

3. Set the shutter speed to 1/250 of a second, which is the usual maximum sync speed when you're using remote triggers.

4. Set the aperture to f/11.

5. Make sure the off-camera flash is off.

6. Take a photo.

7. Check the image on the back of the camera to see if it is solid black.

8. Make your aperture even smaller, such as f/16, if you can still see any background in the image.

9. Take another photo to check for a solid black background.

Figure 6.17
This portrait of Odessa, our Boxer, was taken for the cover of *Pet Portraits That Stand Out: Creating a Classic Photograph of Your Cat or Dog* **(2013), which is part of Peachpit's** *Fuel* **series.**

Nikon D4 · ISO 100 · 1/250 sec. · f/11.0 · 70–200mm lens

Once the picture on the back of your camera is solid black, add the flash. Now the only illumination will come from the light you add to the scene. I prefer to set the light to either the left or right at a 45-degree angle. The small flash unit is usually attached to a small light stand to get the light at the right height and angle, and has a light modifier attached. This type of portrait is covered in more depth in the *Pet Portraits That Stand Out: Creating a Classic Photograph of Your Cat or Dog*, which is available at www.fuelbooks.com.

Using a flash to add a little fill light to an outdoor portrait can also be done with the on-camera flash, but it's preferable to use a diffusion dome and angle the light over the pet's head as well. The real key to making the light look natural is to not use the flash at full power but at a greatly reduced power to match the light in the image, as shown in **Figure 6.18**. Keep in mind that you're adding just a bit of fill light; it's not the main source of illumination.

Figure 6.18
I used a little fill light here to even out the light on the cat. The flash was used at –2 power with a diffusion dome angled up and over the cat.

Nikon D4 • ISO 400 • 1/250 sec. • f/5.6 • 70–200mm lens

Posing Pets

Some pets love to pose for the camera, whereas others can be very camera shy. To get a pet to sit still and pose for the camera takes a very well-trained pet or an assistant and a high-value treat.

Your pets might be the best-trained animals on the planet, and getting them to pose could be as simple as just telling them to sit and stay. Unfortunately, most pets are not that well trained or well behaved and need a little help when you want them to pose for portraits.

Before the pet arrives, it's best to set up the area where you plan on taking the portrait. Get the background just right, figure out where the light will strike your subject, and choose the right lens. Then set up the camera and dial in the exposure settings. Many times I do this using a stand-in for the pet, for example, a stuffed animal, a chair, a book, or anything that is roughly the same size as the pet. Once the pet is in place, it is up to the pet owner to help with posing the pet. Usually, this means adjusting where the pet is looking. This is actually easy to do because most animals will move their heads when you, your assistant, or their owner is holding food or a special reward (**Figure 6.19**).

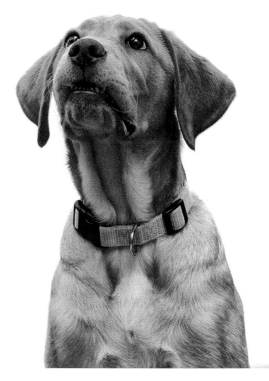

When the pet is sitting in the right spot, take a test shot to fine-tune your exposure. When the exposure is right, have your assistant use a treat to help position the pet's head and eyes. Clearly tell the helper where you need the pet to look and have them move the treat (or toy) slowly up, down, left, or right. Moving slowly prevents the pet from jumping up and trying to get the treat. It does take some practice and patience, but this technique usually results in getting the portrait you want.

Figure 6.19 The puppy, Harley, was very interested in the new treats. It was easy to control where she looked just by moving the treat.

Nikon D4 · ISO 800 · 1250 sec. · f/5.6 · 70–200mm lens

The distance between your helper and the pet can be pretty close, especially if you're using a long focal length. Remember that you need to tell the helper what to do and where to move the treat. Make sure the helper is not standing between the light and the pet because the helper could cast a shadow where you don't want one.

Sometimes you'll need your helper to hold the treat until the last minute and then drop the treat or move out of the way when you take the frame. For the lizard in **Figure 6.20**, the owner held the mealworm very close to the pet and then dropped it on the table at the last minute, giving me a second to take the shot before the lizard ate the treat.

Some pets don't respond to food treats, so you'll need to use a favorite toy as a reward. It's very important to let the pet play with the toy between takes (**Figure 6.21**) so the reward will actually work when you need it to. You can still take the toy back and keep the pet's attention where you need it for the portrait.

One major consideration that helps when it comes to getting that perfect pose from your pet is to make sure the area in which you're taking the photo is as distraction free as possible. If you're working inside, you might have to close the window or door so the pet is not distracted by things outside the room. If you're working with more than one pet, it's best to have some extra help to keep the other pet calm while you photograph your main subject.

Figure 6.20 **The lizard calmly waits for the mealworm to drop.**

Nikon D4 · ISO 800 · 1/250 sec. · f/8.0 · 105mm lens

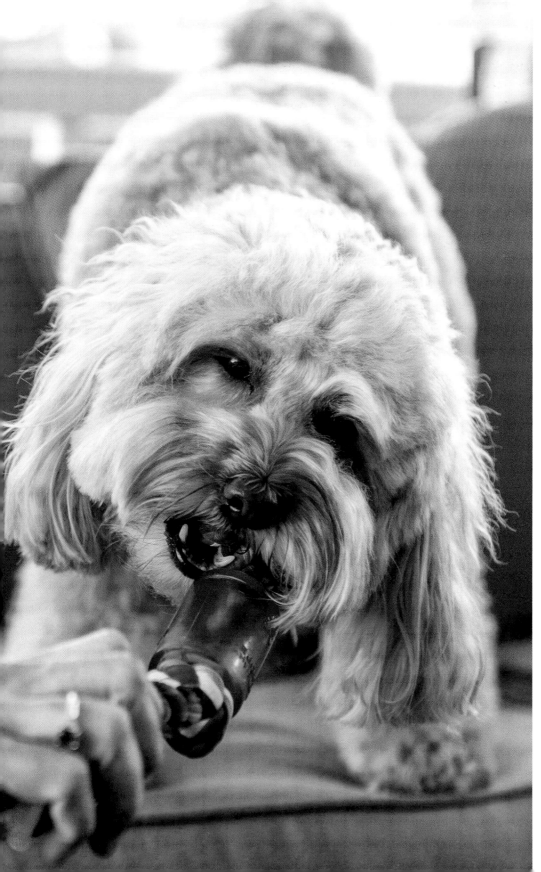

Figure 6.21
Letting the dog play
with its toy is impor-
tant when you use it
as a reward to help
pose. The dog needs
to know that it will
get the toy if it does
what you want.
Nikon D4 · ISO 800 ·
1/2000 sec. · f/4.0 ·
24–70mm lens

Capturing Pet Personality

The goal in any good portrait is to let some of the subject's personality shine through. This might be demonstrated in the tilt of the head or the shape of the mouth, or even the look in their eye. It might just be revealed by a big goofy grin or when they just roll over and stare at you upside down, as shown in **Figure 6.22**. The key is to get the pet to relax and act naturally in front of the camera.

Figure 6.22
After sitting quite still and posing for a few minutes, this playful Lab just decided to roll over, something the owner said happens a lot.

Nikon D700 •
ISO 640 • 1/60 sec. •
f/3.5 • 80–200mm lens

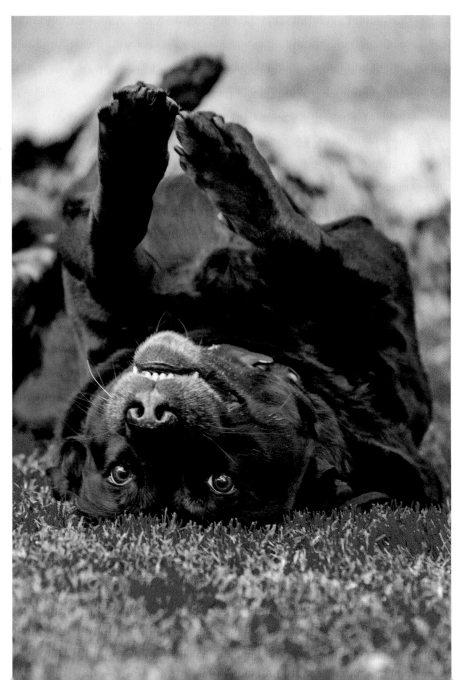

Some pets are more playful than others, and some can be rather serious. It takes time to discover these personality traits, which you typically won't have much time to do when photographing other people's pets. But when you're photographing your pets, you'll know what to look for to create a great portrait. To help other people's pets relax around you when you're photographing them, especially for the first time, try these tactics:

- **Ignore the pet.** Although it might seem rude, when I meet a pet for the first time, I ignore them. Because the pet doesn't know me, and I arrive holding a large camera and possibly a light stand with a flash and light modifier, the pet will most likely be frightened or on edge. So I first spend some time talking to the owner, letting the pet get to know me on their terms. After a few minutes I'll sit on the floor, allowing the pet to come to me, which sometimes takes a while. But it's important to allow the pet to relax so their true personality will be revealed.

- **Talk to the owner.** The more information you have, the better. Ask about the little things and behaviors that make their pet unique. It could be anything from the way they look at you sideways or how they twitch their ears. Ask if they have a favorite toy or treat, or whether they can do a trick on command. All these little pieces of information can help you know exactly when to press the shutter release button. Much of this information would have been discussed before the shoot, but it's best to talk about the pet with the owner during those first few minutes on-site when you're ignoring the pet and letting them become familiar with you and your gear.

- **Make noise.** Point the camera at the ground and take a few photos so the pet can hear the camera and the noise it makes. Often, I'll also place all my gear out in the open so the pet can come over and inspect it, preventing it from becoming a distraction later in the shoot. The more comfortable the pet is with me and my equipment, the better.

- **Have patience.** You'll have to wait until the pet is ready for the shoot and not force it. It's a great idea to make sure the owner of the pet knows this up front and doesn't just think you are wasting time. While I spend time watching the pet, I also explain what I'm doing to the owner.

When you start to take the portraits, take as many photos as possible. The more shots you take, the better your chances of getting that one shot that makes the whole day worthwhile. In **Figure 6.23**, I was photographing outside in a great patch of shade when the cat just stuck her tongue out at me. This behavior seems to happen quite often to me (**Figure 6.24**).

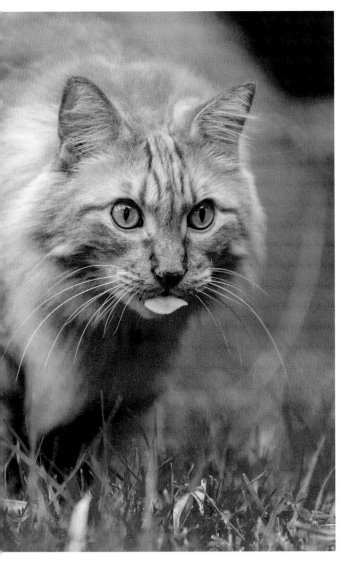

Figure 6.23 Sometimes it can seem as though our pets have very human characteristics.

Nikon D3200 • ISO 400 • 1/500 sec. • f/4.0 • 17–55mm lens

Figure 6.24 I seem to bring out the best in pets, or they just like to stick their tongues out at me to see my reaction.

Nikon D2x • ISO 200 • 1/250 sec. • f/2.8 • 50mm lens

Chapter 6 Assignments

Use Natural Light Indoors

Taking a pet portrait indoors is the easiest place to start learning how to use natural indoor light. Look for a window or doorway that gets a good amount of light, and place your pet just behind the spill of light. Get down on their level, use the Spot Metering mode, and take the photo. Check the exposure and adjust it accordingly. Pay attention to how the light changes during the day. Is it better in the morning or in the evening; does the light change colors as it bounces off surrounding walls? Determine whether you should have your pet face the light or if it's better to have the light come in at an angle and spread across the pet.

Bounce the Flash

Using the small pop-up flash on your camera will produce horrible results, but using a dedicated flash unit on the camera with the flash head angled to bounce the light can help you illuminate a dark scene. Practice moving the flash head off to the sides or aimed at the ceiling to make for more natural lighting. Start with the flash pointed directly at the subject, and then begin to rotate the head so it points to the side. Continue taking photos to see how the change in the flash position changes the light in the scene.

Practice Posing Your Pet

Practice having your pet sit and stay in one position while you feed it treats and heap on lots of praise. Get them to watch your hand with the treat or reward in it until you give it to them. Slowly increase the amount of time they need to sit and watch, but don't push it too far or they will get up and walk away. You want to keep the activity fun for your pet and not produce any stress or anxiety if they don't behave perfectly right away. Practicing with your pet can also help you when you're photographing other people's pets. You'll know how long it can take to get a pet to pose and how slow to move so as not to upset them.

Share your results with the book's Flickr group!
Join the group here: flickr/groups/petphotographyfromsnapshotstogreatshots

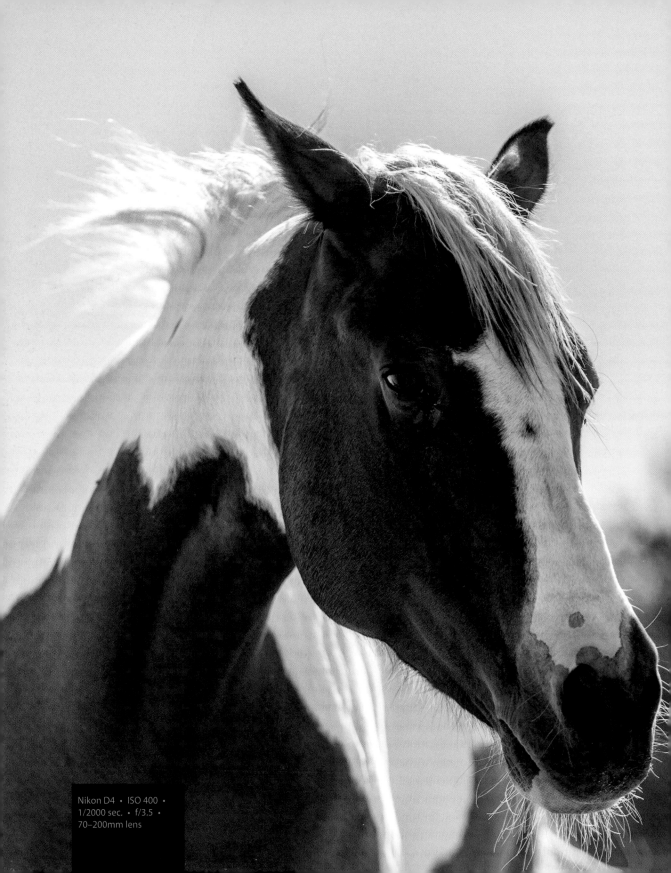

Nikon D4 · ISO 400 ·
1/2000 sec. · f/3.5 ·
70–200mm lens

7

All Creatures Great and Small

Helpful tips for photographing specific pets

Cats and dogs are the most popular pets, but they are not the only creatures that are kept as pets. Pets can range from a horse to a hamster and just about everything in between. Most of the tips and techniques covered in this book apply to all types of pet photography, but some specific practices only apply to certain animals. I'll explain the best methods to use to get great shots of each type of pet throughout this chapter.

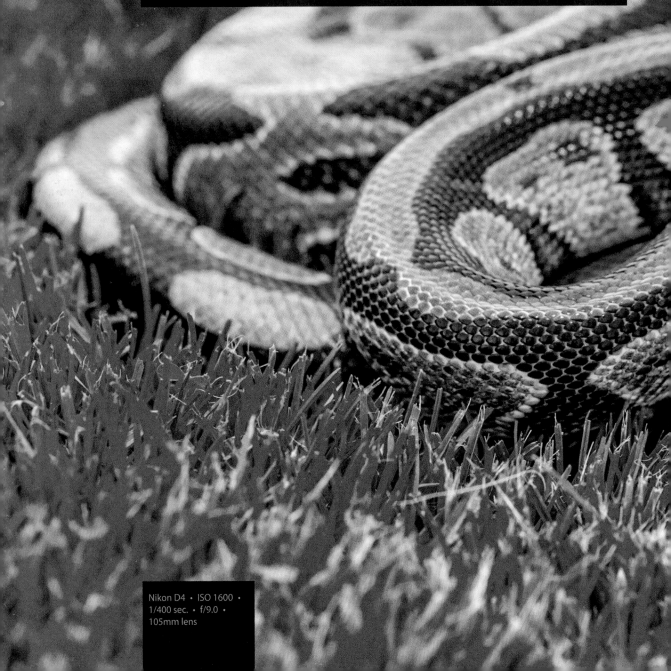

Poring Over the Picture

I photographed this pet ball python on a small patch of grass in the owner's yard. The snake was not dangerous and was not able to escape the small area. The grass also made for a natural background for the snake. The only issue was that the snake kept moving toward me, forcing me to move backwards while lying down holding a camera—not one of my more graceful moments.

Nikon D4 · ISO 1600 · 1/400 sec. · f/9.0 · 105mm lens

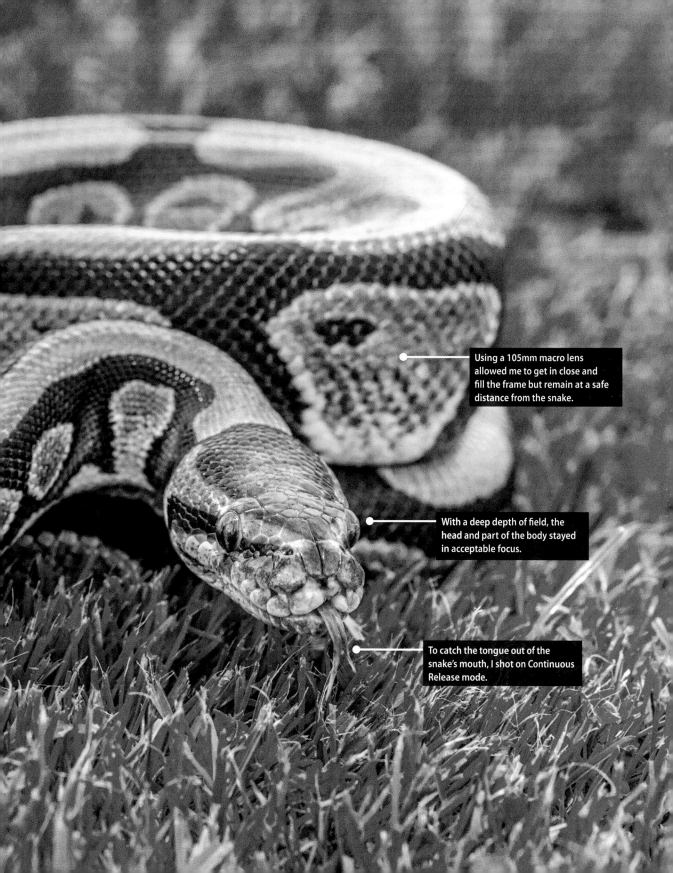

Using a 105mm macro lens allowed me to get in close and fill the frame but remain at a safe distance from the snake.

With a deep depth of field, the head and part of the body stayed in acceptable focus.

To catch the tongue out of the snake's mouth, I shot on Continuous Release mode.

While awaiting his forever home, I photographed this wonderful rabbit at the San Diego House Rabbit Society facility. As I was looking for a neutral location for the photo, I spotted this great chair. For about 15 seconds the rabbit sat in the chair perfectly still, and then started to examine his environment and move around. The entire shoot from start to finish lasted less than 5 minutes.

Using a 200mm focal length allowed me to work farther away so as not to upset the rabbit, and it minimized the background.

Nikon D4 · ISO 1600 · 1/400 sec. · f/4.0 · 70–200mm lens

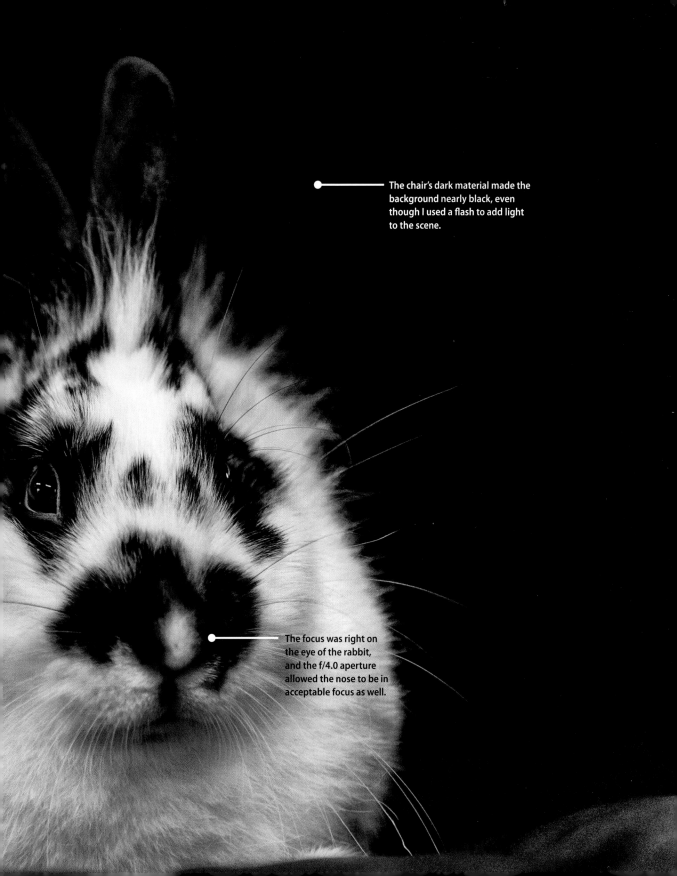

The chair's dark material made the background nearly black, even though I used a flash to add light to the scene.

The focus was right on the eye of the rabbit, and the f/4.0 aperture allowed the nose to be in acceptable focus as well.

Photographing Dogs

According the American Society for the Prevention of Cruelty to Animals (ASPCA), approximately 70–80 million dogs are owned as pets in the United States. That's a lot of subjects available to photograph. When you're photographing dogs, knowing the breed of each dog and characteristics of that breed can be a great help in capturing great dog photographs. This knowledge will help you understand the dog's behavior.

Because dogs have been selectively bred for thousands of years, a huge number of genetically diverse dog breeds have resulted. For example, consider that the Great Dane and a Chihuahua are the same species but are very different animals. Even dogs that are the same breed can vary widely in their appearance. The two Labradoodles in **Figure 7.1** are a mix of both a Labrador and a Poodle, but their coloring and even their fur is quite different.

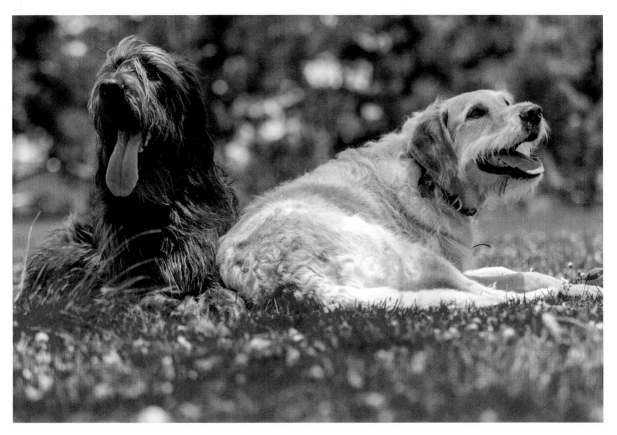

Figure 7.1 **Even though these two Labradoodles have very similar genetics, their color and fur length differ.**

Nikon D4 • ISO 400 • 1/800 sec. • f/5.6 • 70–200mm lens

The American Kennel Club (AKC) recognizes 180 different dog breeds, and if you add to that the mixed breeds, many distinct dog groups result. Each group consists of dogs with the same general characteristics:

- **Sporting group.** This group includes the Spaniels, Retrievers, and the Pointers, among others. The dogs in this group are used in hunting and retrieving small game and birds. Because they need a lot of exercise, they are happiest when they're tracking and retrieving. The Vizsla pictured in **Figure 7.2** is part of the sporting group, and as a natural hunter can be trained to retrieve very easily.

- **Toy group.** This group includes the small dogs that were bred as companion animals for people: the Chihuahua, Pug, Shih Tzu, and Pomeranian. These dogs can be quite difficult to work with. In fact, a study released by the *Journal of Applied Animal Behavior Science* noted that the Chihuahua is one of the most aggressive dogs. Therefore, it's best to treat all the dogs with respect, even those in the Toy breed, and let the owners pick up and pose these dogs.

- **Working group.** This group includes the Doberman, Great Dane, Boxer, Bullmastiff, Husky, and Saint Bernard. These dogs were bred to work and are usually big, strong, very intelligent, and can be rather imposing to someone who doesn't know them. Their sheer size requires you to be careful while working around them. Because these dogs were bred for work, they are happiest when they're performing a task. Make the photo shoot a job for them, and you will get great images. Run the dogs through any training exercise, which will put them into a working frame of mind, and they'll look more alert.

- **Terrier group.** The dogs in this group are all Terriers and range from the Rat Terrier to the Airedale Terrier to the Staffordshire Bull Terrier. Originally, these dogs were bred to hunt and kill vermin. But an important fact about these dogs is they don't always get along with other animals.

- **Hound group.** This is a very diverse group, but all the dogs in this group were originally bred to help in the hunt, either by using their amazing sense of smell or their incredible stamina. Dogs in this group include the Bloodhound, Beagle, and Rhodesian Ridgeback. Give any of these dogs a scent to track and watch them go to work.

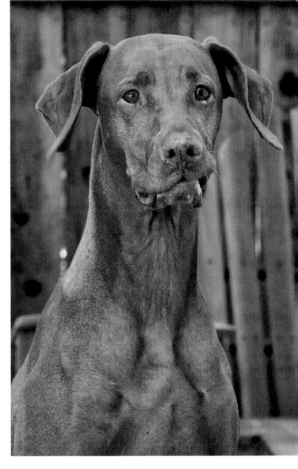

Figure 7.2 **Because Vizslas are very active and need a lot of exercise, it was much easier to get a portrait of this dog after he had run around for a while and calmed down. Vizslas form very close bonds with their owner, so I asked the owner to position the dog and stay close by.**

Nikon D4 • ISO 400 • 1/250 sec. • f/2.8 • 70–200mm lens

When you're photographing a dog, consider what the breed was bred for to help you define its behavior. Is the dog a Retriever? If so, a few minutes of throwing a ball or stick might put it into working mode and make it easier to pose. Is the dog a feisty Terrier? If so, it might need to be ignored for a while to calm down, and should probably not be photographed with other animals unless it knows them and has already proven to get along with them.

Here are some tips on how to react the first time you meet a strange dog to make your meeting go smoothly:

- **Ignore the dog.** One of the best actions is not to react when you're photographing or meeting a dog for the first time. Just pretend it doesn't exist and let the dog come to you. This also works if the dog is jumping up and trying to get your attention: Just turn your back and ignore the dog until the behavior stops. Dogs are smart; they will figure out that the jumping is not getting your attention and will discontinue that behavior.

- **Relax.** If you are stressed out, the dog will be stressed out. To show you are relaxed, yawn and blink slowly but don't tense up. All these signals indicate to a dog that you are not a threat.

- **Eye contact.** When you're meeting people, eye contact is a welcoming sign, but when you're meeting a dog, eye contact usually means you are a threat. Don't make eye contact with the dog at first; don't worry, the dog won't hold it against you.

- **Posture.** One of the biggest mistakes people make is to lean over a dog. It's best to stand up straight or squat. Imagine what it would be like if every time you met a new person, that person leaned over your head. I doubt it would be very enjoyable. It is also preferable to turn your body sideways to a dog, not meet the dog head-on. When two dogs meet, they usually start circling each other, and do not meet straight-on.

- **Avoid the top of the head.** Although it seems to be a part of our DNA, when you meet a dog for the first time, don't pet the top of their head. Instead, touch them on the shoulder, neck, back, or chest. Scratching the dog under his or her chin (as shown in **Figure 7.3**) is a much better alternative.

Photographing dogs can be a lot of fun for you and the pet. Keep the shoot light and playful, and the dog will enjoy the sessions where he gets to sit and eat treats while you lie on the ground getting that perfect angle. As long as the dog is having a good time, everyone is safe, and when the light is good, there is nothing I enjoy more than capturing dog photos. Cortez, the Bullmastiff in **Figure 7.4,** was great fun to photograph. In fact, I spent all morning watching and capturing his playful side. When he was done, he got comfortable in a nice patch of shade. The final photos of the morning are some of my favorites.

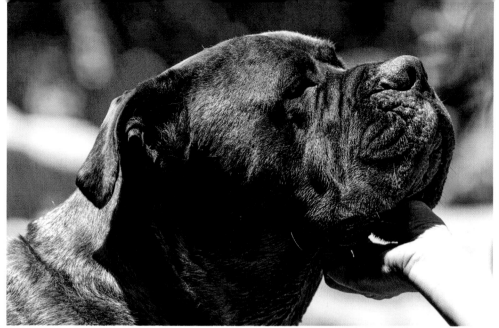

Figure 7.3
A scratch under the chin is a much better option when meeting a dog than a pat on the head.

Nikon D4 • ISO 400 • 1/1250 sec. • f/5.6 • 24–70mm lens

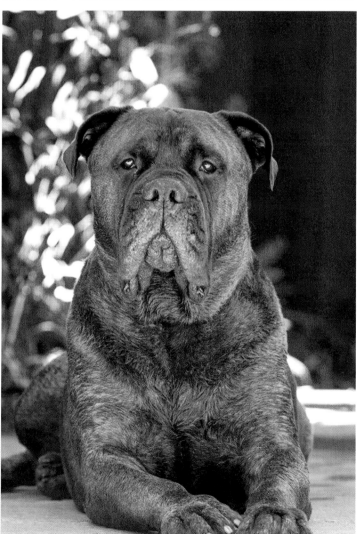

Figure 7.4
Cortez poses for the camera a final time before calling it a day and going off to nap.

Nikon D4 • ISO 1600 • 1/800 sec. • f/5.6 • 70–200mm lens

Photographing Cats

Cats are amazingly complex creatures that can go from cute and cuddly to ferocious hunters in a blink of an eye. If you've ever watched a cat stalk an unsuspecting ball of string or their favorite toy, you know how fast they can move.

To get great cat photographs, you need to look for some specifics and use their natural behaviors.

Cats' Eyes and Body

When you look at a cat, the first two characteristics that usually stand out are the way they move and their large eyes. Their eyes are the largest of all mammals in relation to their body size and are a wide variety of colors and textures. A cat's eyes seem to bulge slightly, giving them much wider peripheral vision and a serious advantage when hunting and avoiding predators. At times it might seem as though cats have eyes in the back of their heads because they react to events that other animals don't. Another very noticeable aspect of a cat's eye is the vertical pupil, which allows cats to very quickly change the size of their pupils in relation to the amount of light present—much faster than round pupils. When your cat comes in from the bright outdoors, their vision adjusts much quicker than yours. Their pupils also make for a great photo subject. In **Figure 7.5**, the cat's pupils are about halfway open due to the light level present in the room.

A cat's body has more bones in it than a human body, allowing a cat to move and twist in ways we can't. Watching a cat walk, jump, and stalk is pure poetry in motion. And because cats don't have a collarbone, they can fit their body through any opening their head fits through, making them experts at getting in and out of small spaces.

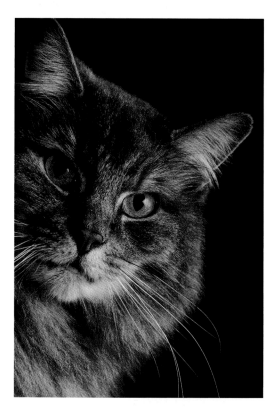

Figure 7.5 Beast's (that's his name, I swear) eyes adjust to the light coming in through the door.

Nikon D3200 · ISO 200 · 1/200 sec. · f/9.0 · 70–200mm lens

Capturing the Stalk

Cats stalk because it's coded into their genes. They stalk so they can eat in the wild. Domestic cats no longer need to hunt for food because their owners feed them. But even though they no longer have to hunt, they still have the drive to hunt. If this drive goes unfulfilled, the cat can become frustrated or even depressed. Playing with your cat or allowing it to stalk and hunt outside can be very healthy for the cat, and it can be a great opportunity for you to capture great photographs.

When I was photographing the cat in **Figure 7.6**, I watched him hide behind the large water bottle on the porch before darting behind the tree and then over to the fence while keeping me in his sights. Using this behavior, I set up to catch him as he peeked out from the water bottle while hunting me in the yard.

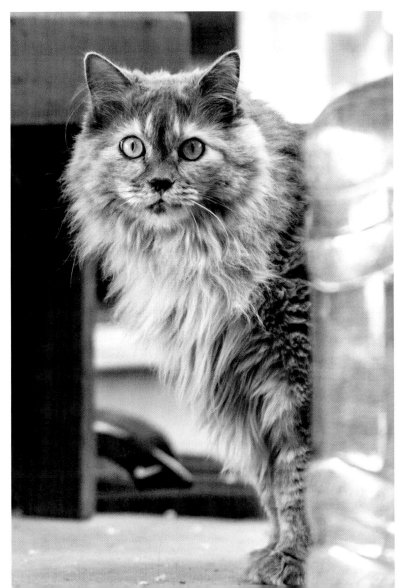

Figure 7.6
I believe the cat was actually stalking me as he looked out from behind the water bottle.

Nikon D4 · ISO 1600 · 1/640 sec. · f/2.8 · 70–200mm lens

Many cat toys are designed to simulate a cat's prey drive and can be used to make the cat active for a photograph. A few minutes of playing in the yard can produce some great cat images. Look for the moment the cat catches sight of the toy and then stalks and attacks it. Sometimes the best image is when the cat is getting ready to pounce, as in **Figure 7.7**.

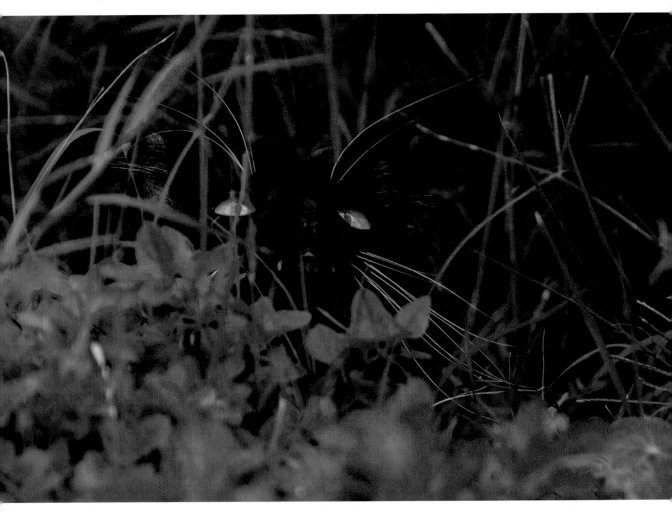

Figure 7.7 **Sammy patiently waits in the grass to pounce on the toy being moved around by his owner.**

Nikon D4 • ISO 400 • 1/1000 sec. • f/4 • 70–200mm lens

Cat Grooming

A routine grooming can make your cat feel great and look even better because it reduces hairballs and prevents matted fur. Consider grooming your cat on a regular basis so it's always ready for a photo session. If you are photographing someone else's cat, discuss grooming with the owner so they don't try to groom the cat for the first time right before the photo shoot and upset the cat.

Long-haired cats, like the one in **Figure 7.8**, need more brushing than short-haired cats, but that doesn't mean you should skip grooming your short-haired cat.

In this book I've mentioned only our two dogs, until now. When my wife and I met, she had a cat that reluctantly adopted me. Kaila, the cat, lived a good life and passed away a few years ago. But I bring up Kaila now because one day back then I had the bright idea to give the cat a bath. As you can imagine, it did not turn out well, and I still have the scars from when she decided that enough was enough. However, my experience doesn't mean a cat shouldn't be bathed. Just don't ask this photographer to do it. Again, don't give your cat a bath on the day of a photo shoot unless it really enjoys it and it won't negatively affect the cat's mood.

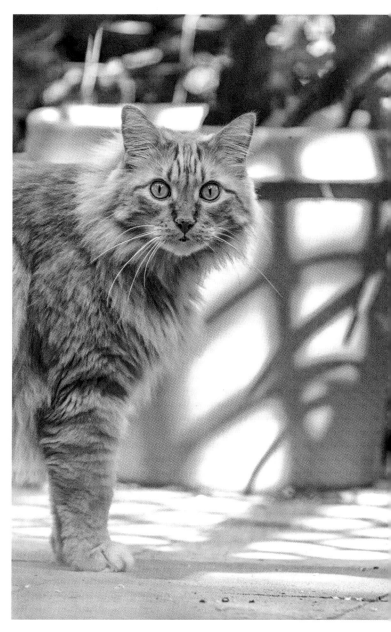

Figure 7.8 This young beauty grooms herself, but a weekly brushing helps keep her coat looking its best.

Nikon D4 · ISO 1600 · 1/1250 sec. · f/4.0 · 70–200mm lens

Photographing Horses

Photographing horses takes space, and the more space, the better. It took me a while to get used to photographing horses. The simple truth is that horses frightened me due to their power and size, and due to my lack of understanding. But after talking to some horse owners and getting out there and photographing horses, my fear has evaporated; instead, I am filled with awe and appreciation.

To help the horse get to know you, taking a few measures can alleviate your stress and the horse's when you're meeting each other for the first time:

- **Be confident.** Approach the horse from a 45-degree angle so it can see you coming. Keep in mind that a horse has a blind spot in the middle of its head. Walk confidently so the horse knows you're not afraid and that you are the one in charge.

- **Calm and quiet.** Talk calmly to the horse, and don't make any unnecessary noise. The horse might not understand the words you are saying, but it will pick up on your tone.

- **Lead with your hand.** Allow the horse to sniff your hand by holding it out with a flat palm. If the horse shies away from your hand, take a deep breath, take a few steps back, and then start again.

- **Firm gentle strokes.** When you stroke the horse, start on the shoulder or neck and use firm gentle strokes so as not to tickle the horse. Above all, be confident and careful. If you have any questions, just ask the horse's owner.

Horses have a wide variety of colors and markings, and the combination of those colors and markings differentiates one horse from another. Here are some details to watch for when you're photographing horses:

- **White horses and Paint / Pinto horses** with lots of white coloring are very difficult to photograph in direct sunlight because their bright white coats can easily be overexposed. A very fine line exists between the white coat and pure white. If possible, photograph these horses on overcast days or you'll need to slightly underexpose the shots so the white areas will show some detail.

- **Black horses and Bay horses** are tough to photograph in bright light because the camera meter wants to create an 18% gray, which will overexpose the horse and lose detail. However, it's best to overexpose the image a small amount so the detail in the black areas remain but not so much that the horse turns gray.

- Pay attention to the **facial markings** on a horse—the white areas on an otherwise darker coat. The facial markings identify the horse because each horse has different markings. Facial markings include a blaze, a wide stripe down the middle of the face; a strip or race, a narrow stripe down the middle of the face; a star, a white marking on the forehead; or a snip, a white mark on the muzzle. You can see the blaze on the face of the horse in **Figure 7.9**.

- **Leg markings** are described as stockings, socks, and boots depending on how high the white hair on the horse's leg extends. A stocking spans the area from the foot to the knee, a sock ends below the knee, and a boot covers only the fetlock.

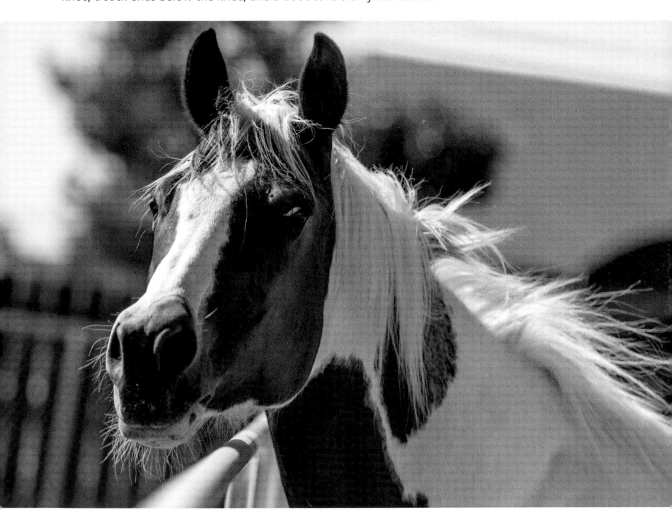

Figure 7.9 **In this photo you can clearly see the blaze on the horse's face.**

Nikon D700 · ISO 400 · 1/3200 sec. · f/5.0 · 70–200mm lens

A few horse accessories, such as fly masks, blankets, and halters can distract from an otherwise great horse photo. Fly masks cover the horse's eyes and at times the ears and muzzle to protect them from flies. The horse can see through the mesh, but the masks look terrible in photos because they make the horse look like it's trying avoid the photographer by wearing the equine equivalent of big dark sunglasses. You can leave them on while you're setting up and fine-tuning your exposure, but it's always best to remove them before you take the actual photos. The same goes for any blankets and the halter, unless you're photographing the horse and trainer together and need the halter in the image to tell the story.

Many horse owners like to make sure their horse is groomed before the photo shoot. But sometimes the horse has different ideas. After being perfectly groomed, the horse in **Figure 7.10** immediately started to roll around in the dirt.

The reason horses roll in dirt or mud is not to get back at you for washing them but instead because it mainly feels good, especially after a nice bath. Just be aware that this is a possibility once horses exit the restrictions of their stalls. Discuss the likelihood of this behavior with the owner because they might need to stay close to the horse to stop it from rolling, so you can capture photos of a clean horse.

Figure 7.10
All the hard work of grooming went down the tubes when this horse decided to go for a roll in the dirt.

Nikon D4 · ISO 200 · 1/4000 sec. · f/2.8 · 70–200mm lens

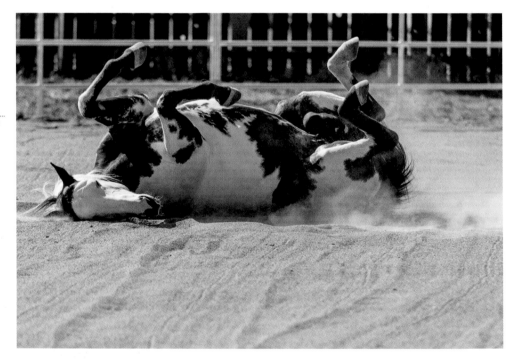

Photographing Birds

According to the American Veterinary Medical Association, birds are the third most popular pet after dogs and cats. Photographing birds can be a little tricky, but with some knowledge, patience, planning, and a little luck, you can capture some great images. Although I can't help you with the luck part, I can give you some tips that will help to make your bird photo shoot run smoothly:

- **Clean feathers.** Birds spend a lot of time preening, that is, grooming their feathers to keep them in tip-top condition. That doesn't mean they don't need to bathe; they do because it helps keep the natural production of dust and dander to a minimum and can help the bird look attractive. It's best to wash the bird a day or two ahead of the photo shoot so it has time to preen.

- **Favorite treat.** A common solution to posing animals, including birds, is to have a favorite treat nearby. You can get a bird to move in a certain way just by showing them the treat.

- **Front feathers / back feathers.** On many birds the tail and back feathers are more colorful than the breast and stomach, so try to pose the bird facing away from you so you can see the back. Then try to get the bird to turn its head to the side. As a result, you'll get the colorful back feathers and the profile in the same shot.

- **All about the colors.** Birds have an amazing variety of feather colors. The color is created from the pigment in the feather or from the way the light refracts from the structure of the feather, or a combination of both. Moving the light relative to the bird can produce color changes in the feathers. Before you start shooting, try moving either the light or the bird to see how the colors change. The bright colors of the Lorikeet in **Figure 7.11** really pop against the white backdrop.

Figure 7.11 **This beautifully bright Lorikeet enjoyed showing off its feathers of blues, greens, and reds.**

Nikon D4 · ISO 800 · 1/1000 sec. · f/5.6 · 70–200mm lens

- **Disappearing cages.** If you're working with a small bird or a bird that is not trained to sit calmly outside of its cage, you can still practice taking photos through the cage. The trick is to use a shallow depth of field and get very close to the cage while the bird is toward the back of the cage. In **Figure 7.12**, I positioned the front element of the lens very close to the cage, focused on the birds in the back, and the cage disappeared, at least the bars in front of the birds did. Not much could be done with the bars behind the birds.

- **A natural perch.** Many birds have no problem sitting on their perch in their cage or sitting on their owner's arm, which can produce a more intimate photo. If the bird doesn't have a problem with it, consider using a stick as a perch because it gives the image a more natural look. In **Figure 7.13**, a natural piece of wood used as a perch created a more authentic look.

- **Background.** When you want a natural look for the background, think green. A green background could include leaves of a tree or a bush, making the setting seem quite realistic.

Figure 7.12 (left) **Placing the lens close to the cage and using a shallow aperture of f/2.8 made the front bars of the cage disappear, enabling me to clearly capture these two birds inside.**

Nikon D3200 • ISO 800 • 1/1000 sec. • f/2.8 • 40mm lens

Figure 7.13 (right) **Using a wooden perch makes the entire image seem more natural.**

Nikon D4 • ISO 3200 • 1/500 sec. • f/4.0 • 70–200mm lens

Don't take your bird (or anyone else's bird) outside just to get a photograph unless the bird is well clipped or has been trained to fly back. The camera shutter noise can startle a bird, so make sure the bird is safe and is used to the camera before you even consider going outdoors with it.

Focus on the details of the bird and use a macro lens if possible. Take your time because you will have to get pretty close to the bird to fill the frame with detail. The feathers, beak, and talons all make great subjects for a close-up. In **Figure 7.14**, I focused closely on the Macaw's eye and beak, making sure to capture the texture and color in the feathers.

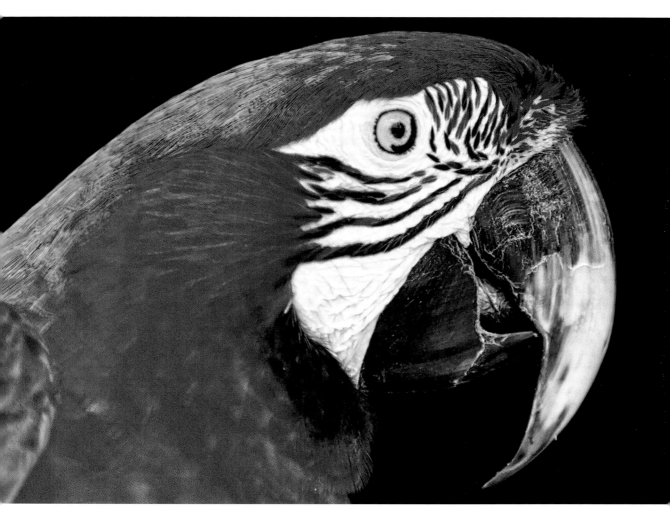

Figure 7.14 **A macro lens allowed me to fill the frame with the bird's head and capture all the fine details.**

Nikon D4 · ISO 800 · 1/800 sec. · f/9.0 · 105mm lens

Photographing Fish

Many folks have fish as pets. Watching the fish swim around in their glass homes can be fun and quite relaxing. Due to their low cost and ease of maintenance, fish are typically the first pet for some kids.

The fish tank can make photographing fish tough to accomplish. The sides of the tank reflect back everything around it, including you, your camera, and anything else in the room. That doesn't mean you can't get great photos of the fish in the tank; it just means you have to work a little harder at it.

A rubber lens hood is a piece of gear that can make all the difference in the world when you're photographing fish in their tank, because it blocks the light from reflecting off the tank. You can use a plastic lens hood, but you'll need to be more careful that you don't damage the tank in any way. You'll need to be close enough to the tank with the lens hood to block out the light and reflections from the glass.

Here are a few tips on getting great fish shots:

- **Use a tripod.** One of the advantages of photographing fish is that you know exactly where they will be, so it's easy to set up a tripod to hold your camera steady. A tripod also ensures that the camera and lens are in the right position to minimize glare, as shown in **Figure 7.15**.

Figure 7.15
With this setup, the camera is set on a tripod and the lens is perpendicular to the tank. The other lights in the room were turned off to reduce reflections.

Nikon D3200 •
ISO 800 • 1/250 sec. •
f/5.6 • 40mm lens

- **Lens placement.** The front of your lens should be placed perpendicular to the glass of the fish tank. If the camera is at an angle, the glass will distort the light, making it difficult to get a photo that is in focus and natural looking. A tripod helps in this situation as well, because it's challenging to sit and hold the camera and lens at the correct angle while waiting for the fish to swim past the lens. When you handhold the camera, you'll track the fish and shoot, not realizing when the lens is not perpendicular to the glass and ruining the shot.

- **Background.** If you're photographing fish in a big fish tank, a background most likely won't be a concern. But if you're working with a small tank, it's best to place some kind of background behind the tank to block what is there. A piece of foam board works well. Try either black or white, depending on the look you want and the color of the fish.

- **Proper lighting.** For the best results, you'll need good lighting. If the fish tank has lights, turn them on, and then dim or turn off the other lights in the room. The less light in the room, the less light will be able to reflect off the glass of the tank.

- **Lots of light.** You'll need lots of light to achieve a shutter speed to freeze the fish and get a deep-enough depth of field. If the tank has lights, make sure they are all working and are the brightest they can be. If you need to, you can use flashes to add light to the tank, but their placement is extremely important. Try to avoid reflections and keep the scene looking natural.

- **Main light.** If you need to add a flash, position it over the tank pointing down at the water. The fish scales can reflect the light, but if the light is coming from above, it will seem natural.

- **Second light.** Having a second flash can help create a separation between the fish and the background, producing a more pleasing image. Place this second light near the side of the tank if possible, and position it so it doesn't bounce off the glass and reflect at the camera. Consider triggering the main and side lights by using radio triggers. The side light will need to be adjusted so the flash output is less than the main light and not too bright. You want just a little light, not the full blast of the flash.

- **Clean water.** Dirty water will look dirty in the photos and makes it more difficult for the light to reach the subject. The water should be clean anyway, but every little thing will be noticeable in a photo.

- **Clean aquarium.** Because you are shooting through the glass walls of the fish tank, they need to be clean. Pick a dirt-free, scratch-free, and smudge-free spot in the glass to aim through. It's much easier to clean the tank before taking the photo than it is trying to edit out the dirt using image-editing software later.

- **Exposure.** Getting the right exposure can be a challenge, but once you have the right settings you don't have to worry about changing them, because the light won't change. Set your camera to Aperture Priority mode, set the aperture to f/8.0, and take a photo of anything in the tank. Change to Manual mode and input the shutter speed the camera selected. Then check the exposure on the back of the camera. If it is too bright, increase the shutter speed; if it is too dark, decrease the shutter speed.

- **Flash exposure.** If you are using a flash, set the shutter speed to 1/200 of a second due to the flash sync speed. If the image is still too dark, increase the ISO. It can take a few tries to get the exact setting, but once it is set, you are good to go.

- **Patience.** No matter how many times you tell fish to swim in a certain direction, they will ignore you. So you'll have to wait until they come into your frame, which can take a while. Again, it's a lot less tiring to use a tripod to hold your camera steady. It took over 45 minutes to capture the fish in **Figure 7.16**. During the entire time I had to look through the viewfinder and wait for a fish to swim into the right spot.

- **Safety.** Whatever you do, don't drop your flash into the fish tank. It's not good for the fish or the flash. Make sure that anytime you are working with gear over a fish tank you secure it properly to avoid harming any of the fish.

Figure 7.16
Capturing this shot took a very long time because I had to wait for the fish to swim into the frame. The shallow depth of field meant that I had to focus on the eye, making this an even tougher shot.

Nikon D4 · ISO 1600 · 1/200 sec. · f/2.8 · 105mm lens

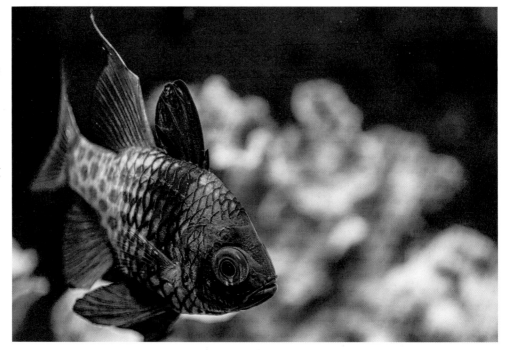

The water in the fish tank creates two issues that can make fish photography difficult. One is that the color of the light changes as the light travels through the water. Water is much denser than air, which means that as the light enters the water, it loses intensity and color. The deeper into the tank the light has to travel, the bluer the image will look because less light is available for the exposure. One way to counteract this issue is to set the tripod to focus the camera on the top part of the tank; however, this can limit the type of fish you'll capture because not all fish like to swim near the top of the tank. Some only hang out on the bottom.

Another issue is that it is challenging to get a very sharp photo when you're shooting through the glass tank and water. The closer the fish is to the glass, the better.

At times you'll want to capture more of the decor in the tank. For **Figure 7.17**, I turned off as many lights as possible in the room to decrease the glare and reflections, stepped back from the tank, and used a shorter focal length to capture more of the tank in a single image.

Figure 7.17
Here you can see more of the big fish tank, but the entire image has a blue cast created by the distance the light has to travel into the water.

Nikon D4 · ISO 1600 · 1/400 sec. · f/2.8 · 24–70mm lens

This technique works best when you're shooting through a bigger fish tank because it gives you more space to move. But that doesn't mean you can't get a good shot in a small tank. Shooting in a small tank just means you'll need to work in tighter conditions and in a much smaller spot from which you can take the photo. The Siamese fighting fish image in **Figure 7.18** was taken in a small, single-gallon tank. Patience is a virtue when you're waiting for a fish to swim into the perfect position for your photo.

When you're working with a small fish tank, take the lid off the tank, attach a flash to the camera hot shoe, and aim it at the ceiling so the light bounces off the ceiling and back down into the tank. This allows you a little extra space to work and removes some of the hazards of working with a flash near water.

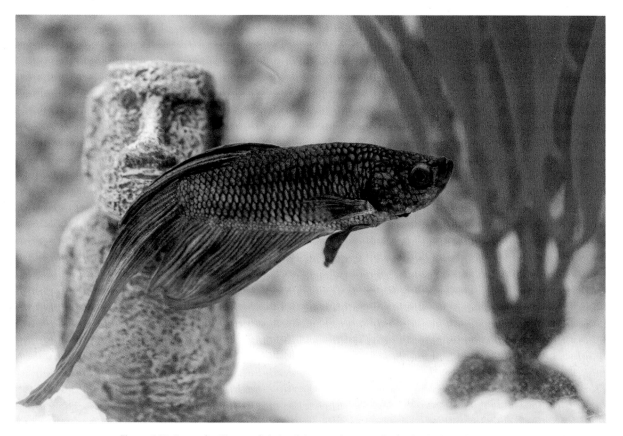

Figure 7.18 Betta, the Siamese fighting fish, was photographed in his little tank with a 40mm macro lens. Getting this shot took about an hour of waiting.

Nikon D3200 • ISO 800 • 1/1250 sec. • f/4.0 • 40mm lens

Photographing Rabbits

Rabbits are growing in popularity as pets, and why not? They are cute, fluffy, and have distinct personalities, and for the right type of person can make a great companion. Rabbits can learn to respond to their names, can use a litter box, and can live for quite a long time.

But some issues arise when you have a rabbit as a pet. Rabbits are natural escape artists and have a tendency to chew and dig everything, which can make them rather destructive. Rabbits are prey animals that are hunted in the wild by hawks, owls, cats, and foxes, just to name a few predators. This makes them particularly fearful of open spaces, and they prefer to stay close to walls or hide under tables. This fear can make it difficult to photograph rabbits out in the open. Another effect of rabbits as prey is that they can be very skittish and easily frightened by new people and sounds, including the sound of a camera shutter. Photographing rabbits is an advanced lesson in patience.

Patience

Rabbits have a very distinct way of exploring an area. They start in a spot in which they feel safe and then venture out a little way before retreating. They do this a lot, increasing the range of their travels each time as long as something (or someone) doesn't cause them to panic. If you own a rabbit, you can get the pet used to your camera just by having it around and using it during the course of the day. The rabbit will get used to the sounds and not be frightened.

Figure 7.19 While the rabbit groomed herself, she finally got used to the noise of the camera and I was able to photograph her without being a distraction.

Nikon D4 • ISO 1600 • 1/500 sec. • f/4.0 • 70–200mm lens

If you are photographing a rabbit that is not your pet and doesn't know you, you'll have to sit and wait until the rabbit is comfortable around you. For **Figure 7.19**, I sat on the other side of the room continuously taking photos while the rabbit sat and groomed herself. After a while the rabbit stopped paying any attention to me or the camera. It's also best to have some favorite treats available that the owner can give the rabbit when you're taking photos so the noise of the shutter release can coincide with a positive experience for the animal.

Timing

Rabbits tend to be more active early in the morning and in the evenings, but each animal has its own schedule. Talk to the owner about the rabbit's pattern of behavior and the best time to photograph their rabbit. You should photograph the animal when it is active, not just sleeping in a cage.

When I was photographing at the San Diego House Rabbit Society, the rabbit was placed on a low table covered with a towel. The new environment meant that the rabbit would need to take a minute or two to get used to everything, which gave me a minute or two to get the shot. As you can see in **Figure 7.20**, the rabbit just sat there while I took the photo. Using a 70–200mm lens at 200mm allowed me to photograph the rabbit from a distance, and it turned the back of a wooden bench into a great background.

Figure 7.20
A long lens plus a few minutes to get the shot while the rabbit got used to the new surroundings was all that was needed to get this portrait.

Nikon D4 · ISO 1600 · 1/400 sec. · f/4.0 · 70–200mm lens

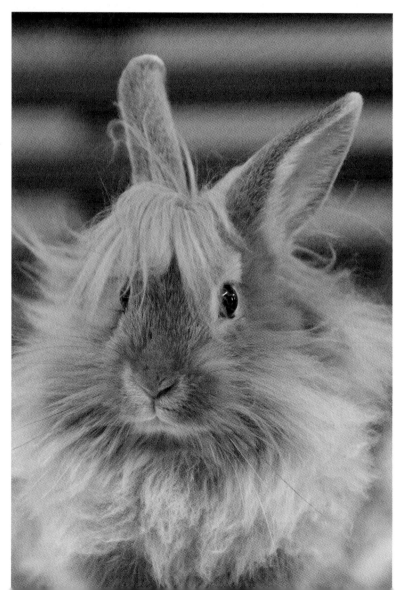

Red-eye

Rabbits get red-eye in the same way as humans, so avoid using a flash aimed directly at the subject. It is better to bounce the light off a wall or ceiling, which creates a softer light as well. Red-eye is caused when the light from the flash bounces off the back of the subject's eye and back out through the eye. The closer the flash is to the lens, the more likely the light from the flash will bounce back and cause red-eye.

One way to avoid any type of red-eye in rabbits is to photograph them while they are looking forward. This angle reduces the way the light enters the eye and bounces back out. In **Figure 7.21**, I used a flash mounted on the camera and aimed over the head of the rabbit to help light the very dark fur. If I had taken the photo with the rabbit looking to the left or right, the flash would have caused red-eye. But instead, I waited until the rabbit was looking directly at me; as you can see, no red-eye is present in the image, even though the flash fired. You can actually see the bright spot from the flash in the rabbit's eyes.

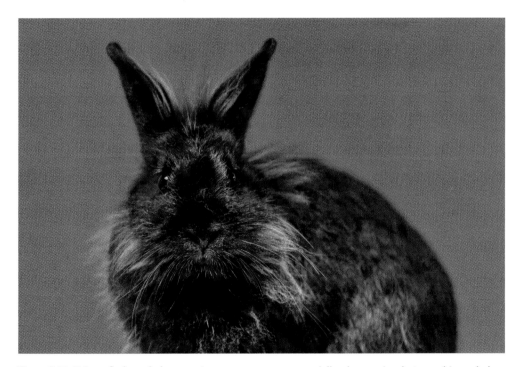

Figure 7.21 Using a flash can help you get a proper exposure, especially when you're photographing a dark, furry animal, but it can also cause red-eye. The angle of the flash and the angle of the rabbit reduce the chances of red-eye.

Nikon D4 · ISO 800 · 1/250 sec. · f/4 · 70–200mm lens

Happy Bunny

Situations in which the rabbits are comfortable and happy will make it easier to photograph them. An unhappy rabbit will let you know it's not happy by either running away or by thumping (stomping) its legs. With rabbits (as well as with all animals) you need to immediately stop taking photos once the pet gets upset so as not to have them equate the sight and sound of the camera with a bad experience. Find out if the rabbit has a favorite place to sit or a favorite toy or treat. These little diversions can make a huge difference between keeping the bunny hopping along happily and scampering off to hide. The rabbit in **Figure 7.22** had just been given a treat and was waiting to see if another was on its way when I took this photo. The floppy ears and the look on her face are priceless.

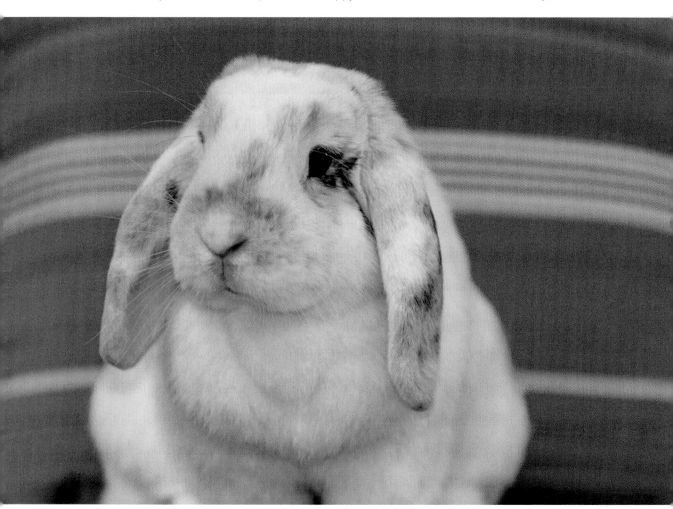

Figure 7.22 A treat does a great job of keeping a pet interested in the photo shoot.

Nikon D4 • ISO 800 • 1/300 sec. • f/2.8 • 70–200mm lens

Photographing Reptiles and Amphibians

Talk to people about snakes, lizards, and other reptiles, and you usually get one of two reactions: People either love them or hate them. I happen to be one of those people who finds reptiles to be very cool and enjoy watching them and holding them, even though I've never owned one as a pet. For those people who hate reptiles, you might just want to skip this section and jump ahead to the rodents.

Snakes, lizards, and turtles, and amphibians, such as frogs, are all kept as pets and can make great photo subjects.

Macro Lens

Unless you're photographing a sizeable snake, most of the reptiles kept as pets are not very big. Therefore, to get a great shot with them filling the frame, you'll need a macro lens.

A macro lens allows you to capture very small subjects at greater-than-life size. With a macro lens you can get incredibly close to the subject, because this lens has a very small, minimum focusing distance. Nikon calls its macro lenses Micro-Nikkor: The Micro-Nikkor 40mm f/2.8 DX lens has a minimum focusing distance of 6.4 inches, and the AF-S Micro-Nikkor 105mm f/2.8 has a minimum focusing distance of 12 inches, which is extremely close.

These lenses allow you to capture the smallest detail in a reptile, such as the pattern of scales under the chin of the bearded dragon in **Figure 7.23**.

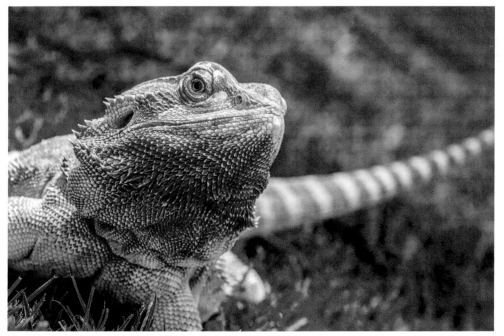

Figure 7.23
Photographed outdoors on a small grassy area, the low angle and macro lens allowed me to get close and fill the frame with the lizard.

Nikon D4 · ISO 800 · 1/800 sec. · f/9.0 · 105mm lens

When you're using a macro lens, you must be very aware of the depth of field. One of the factors that determines how shallow or deep the depth of field is, is the distance from the lens to the subject. The closer you are to the subject, the shallower the depth of field; so when you're working very close to the reptiles, the depth of field can be very shallow, even at f-stops that would usually give you a relatively deep depth of field. You can see in **Figure 7.24** that the background goes out of focus very quickly, even at f/16. To get shutter speeds fast enough to freeze the reptile action and a deep-enough depth of field, you'll need a lot of light, a high ISO, or both. I prefer to photograph the reptiles outside in the shade if possible because it provides the best light and backgrounds, but only if you can guarantee that the reptile is safe and can't get away.

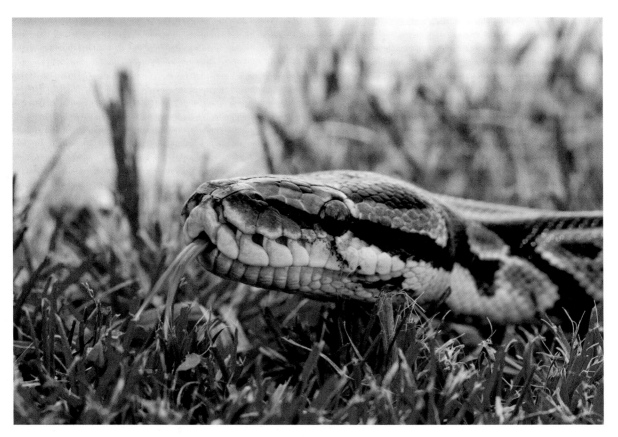

Figure 7.24 **Using the 105mm macro lens I was able to get up close to this ball python, and even at f/16 there is a very shallow depth of field due to the short distance between the lens and the snake.**

Nikon D4 · ISO 1600 · 1/200 sec. · f/16.0 · 105mm lens

The Habitat

A reptile's habitat, or home, can be a small enclosure or a giant, tank-like structure depending on the reptile it is meant to house. Habitats used for reptiles usually have clear glass sides and a screen top that allows for proper airflow and lighting.

Photographing a reptile in its home can be a challenge due to the reflective nature of the glass or plastic. The same techniques used for photographing fish come into play in this situation as well. Setting the camera close to the habitat with the lens perpendicular to the glass will reduce the reflections. As you can see in **Figure 7.25**, you can get great shots of a reptile in its enclosure because such habitats are usually created to replicate the natural habitat of the pet.

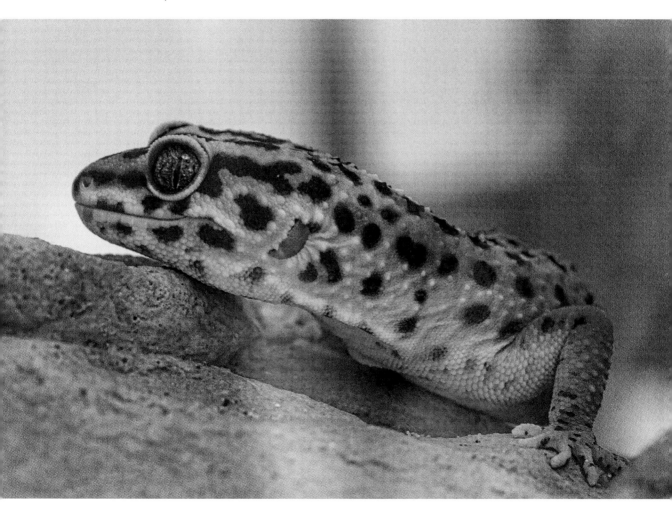

Figure 7.25 **This lizard was photographed right through the side of its habitat.**

Nikon D4 · ISO 800 · 1/800 sec. · f/9 · 105mm lens

Timing to Capture the Tongue

Timing is of the essence when you're trying to get that great shot of a reptile sticking out its tongue. A snake's tongue is an amazingly complex sensor system. Although the forked tongue has been given a bad rap, it is compelling to watch it flick out quickly and it produces a very cool photo.

Snakes have a small notch in their lip so they can flick out their tongue without opening their mouth. You need to focus your lens directly on the mouth of the snake and set the camera to Continuous Shooting mode. The key is to shoot continually during the entire tongue flick to get the full extension as the snake explores its environment. **Figure 7.26** shows the difference that capturing the tongue can make in an image.

A snake uses its tongue as part of its vomeronasal system. When the tongue flicks out, the forks gather small chemical particles from the air and then retract and deposit those particles into two small openings in the roof of the mouth. The snake can then process the information and decide what to do next.

To capture the tongue flick, I shot the image using Continuous Shooting mode and kept the focus point right on the opening where the tongue comes out. Because the snake uses its tongue to sense its surroundings, a tongue flick is guaranteed. It's just a matter of time.

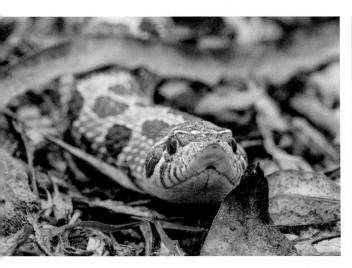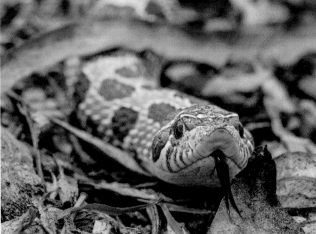

Figure 7.26 These images show the tongue in and out of the snake's mouth. By far, the more intriguing image is when the tongue is out.

Nikon D4 · ISO 1600 · 1/500 sec. · f/9.0 · 105mm lens

Cold-blooded

Reptiles are cold-blooded, which means they have a limited means of keeping their body temperature constant and they rely on external sources of heat. Technically, they are cold-blooded when the external temperature is low and warm-blooded when the external temperature is high. When reptiles are cool, they tend to be more sluggish, and although it may seem like a good idea and be easier to photograph them when they exhibit less movement, there is a downside to this condition. Many species display brighter colors when they're warm compared to when they're cool. Deciding when to shoot becomes a trade-off between acquiring the more vibrant colors when the reptile is warm and active and settling on less vibrant colors when the reptile is cooler and less active.

Hiding Out

Turtles and tortoises have a built-in avoidance mechanism they use to thwart the paparazzi. They just back up into their shells and shut the door behind them. This can make photographing them very tricky to say the least. But patience and possibly a treat can make it easier to get a great shot.

The box turtle in **Figure 7.27** was out cruising around, so I just lay still and tracked him using a long focal length. Incidentally, the belief that turtles and tortoises are slow is a myth. They actually move rather fast, so be aware that they might turn and scurry away.

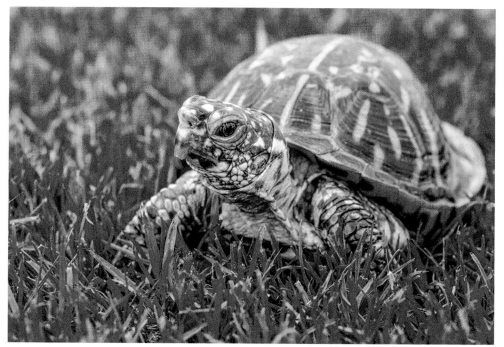

Figure 7.27
When this box turtle emerged from his shell to check out his surroundings, I was ready and started photographing as soon as he poked his head out.

Nikon D4 • ISO 1600 • 1/500 sec. • f/9.0 • 105mm lens

Other amphibians and reptiles can camouflage or hide themselves to avoid predators, and cameras. But you can use this information when you're preparing to set up a photograph. The tree frog in **Figure 7.28** was positioned high on the reed, but as I moved closer, he descended and tried to hide behind the leaves. I started at a low angle and waited for him to move down because I knew that would be his natural reaction to the perceived threat.

Figure 7.28
This cute guy moved down the reed and tried to hide behind the leaf as I moved closer.

Nikon D4 · ISO 1600 · 1/500 sec. · f/9.0 · 105mm lens

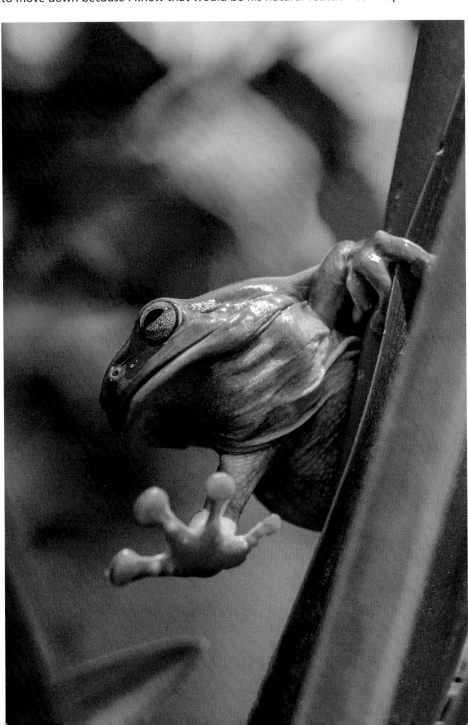

Photographing Rodents

Many types of rodents are kept as pets as well. The following sections describe the most common types and some of their characteristics. Each of the rodents covered make great photo subjects. However, you need to think about a few general considerations when you're photographing rodents.

One factor is their size. Rodents are very small, which makes it challenging to fill the frame without using a macro or good zoom lens. I use two different macro lenses, the 105mm Micro-Nikkor on my full-frame DSLR and the 40mm DX Micro-Nikkor on the cropped-sensor DSLR. These lenses allow me to get in very close and fill the frame with the pet. If you are serious about photographing rodents or any small animal, a macro lens is a necessity.

Rodents can become very restless, so it's best to keep the photography sessions short. I don't like to work with a subject for more than 10–15 minutes maximum. You can capture lots of photos in 10 minutes, especially if you set up the camera, background, and any props you want to use before actually photographing the rodent.

If you use a flash, make sure the power is dialed back because you'll be in close proximity to the rodent when you're using a macro lens. If you aim the flash directly forward, the light can actually pass over the pet due to the height of the flash and the small size of the pet. Special flash units are available for macro photography that go around the lens. Although these can help, keep in mind that the distances are very short, so make sure the flash isn't firing at full power. If possible, keep the flash turned off and never use the built-in, pop-up flash.

Hamsters

The most common type of hamster that is kept as a pet is the domesticated Syrian hamster. The average size of these hamsters is 5–6 inches long; they have large eyes, ears that stand straight up, short, stubby tails, and come in a variety of colors, including white, black, cream, and gold. In addition, they are bred with one of four coat types: short-haired, long-haired (as shown in **Figure 7.29**), satin, and Rex. The short-haired and the long-haired coats are self-explanatory; the satin coat has a very glossy sheen; and the Rex looks as though the hair and whiskers have been crimped.

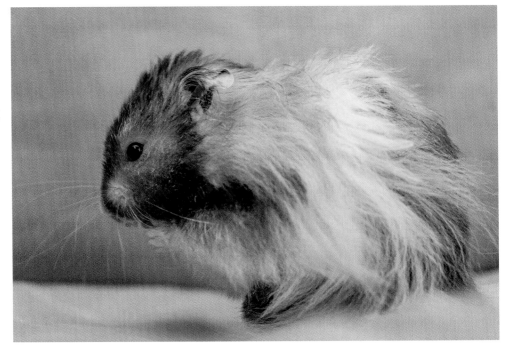

Figure 7.29
This cute little long-haired hamster was photographed sitting on the couch. It made for a nice neutral background.

Nikon D4 · ISO 3200 · 1/200 sec. · f/5.6 · 105mm lens

Gerbils

Gerbils are bigger than hamsters and range in size from 6–12 inches. Gerbils are found in pet stores all over the United Kingdom and the United States except for where I live. It is illegal to purchase, import, or keep a gerbil as a pet in the states of California and Hawaii, and in the countries of Australia and New Zealand due to the threat that they pose to the local ecosystem. The fear is that these rodents might get loose and disrupt the native wildlife, crops, and vegetation.

Gerbils come in a variety of colors, commonly brown, black, and white. They generally do not like to be handled and can nip at you, so be aware of this behavior when a person is posing with one.

Gerbils need to be able to burrow in their home, which is an activity to look for when you're photographing them.

Guinea Pigs

Guinea pigs, also known as cavy or cavies, are small, plump rodents. They are not pigs, nor are they from Guinea. This rodent belongs to the *Caviidae* genus, which is where the name cavy comes from.

Guinea pigs are popular as pets because they are very docile, easy to care for, and easy to handle. Currently, 13 breeds of guinea pig are recognized by the American Cavy Breeders Association, and they vary in hair length and color.

Guinea pigs can be a little frustrating to photograph because they can just sit motionless, which might seem great to start with but can be a bit boring after a while. Just be patient. They will move, and you'll need to be ready to take that photo. Use the time while the pet is sitting still to fine-tune your exposure and composition. The guinea pigs in **Figure 7.30** sat still for a good 2 minutes, allowing me to find the best angle and make sure my exposure settings were spot-on. I started in Aperture Priority mode at f/9.0 and ISO 1600, which gave me a shutter speed of 1/200, but when I took the photo, it looked too bright; so I dialed in −1/3 exposure compensation and produced a better image.

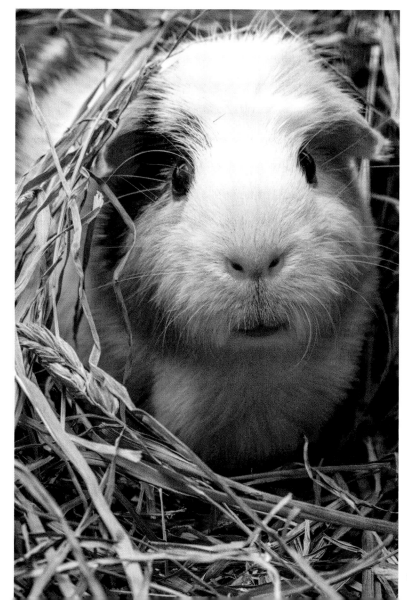

Figure 7.30
The guinea pig sits calmly in her cage, allowing me to get the proper exposure.

Nikon D4 · ISO 1600 · 1/250 sec. · f/9 · 105mm lens

Mice

Domestic mice have been bred to be pets and can range in size from less than 4 inches to more than 6 inches. The mice can be more difficult to handle than larger rodents, such as rats. It can take quite a while for mice to learn to trust their owners. Mice need to be handled starting at a very young age so they can get used to their owners.

When you're photographing mice, keep these considerations in mind:

- **Mice are nocturnal.** Mice are more active at night. If you want photos of the mice awake and moving, photograph them in the evening. Of course, it might be easier to start earlier so you can capture the mice when they're not fully awake and active.

- **Let the owners handle the mice.** Mice are skittish, and being handled by a new person will make them more afraid and less likely to make good photo subjects.

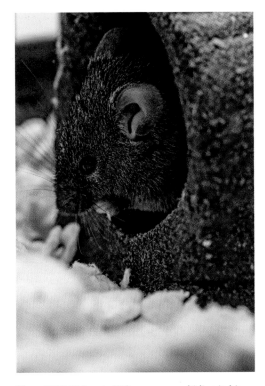

Figure 7.31 **This cute little mouse was hiding in his house, but after a while he started to poke his head out, and I was ready to get his photo.**

Nikon D4 • ISO 1600 • 1/200 sec. • f/9.0 • 105mm lens

- **Get in close.** Because mice are so small, use a macro lens and get in very close. If the mouse is in an enclosure that you can photograph through or over, work your way in slowly.

- **Capture natural actions.** Some of the best photos of these little critters is when they're exhibiting their natural behaviors, like grooming or burrowing into or out of their bedding. In **Figure 7.31**, I waited until the tiny mouse poked his head out of the hollow log he uses as a home in his cage. I didn't try to pose him or even take him out of the enclosure, but just photographed him through the open door.

Rats

Rats are very similar to mice but are usually larger, about 10 inches from the nose to the base of the tail. The tail can add another 7 inches. Rats come in a variety of colors and markings, ranging from shades of brown and beige, to gray and even black. Their eyes can be four different colors: black, ruby, pink, and those with two different-colored eyes.

Rats are very motivated by food, and you can use this to your advantage to get great photos. Not only can you use the treat to make the rat move to where you want it, but photos of a rat eating can be entertaining because they hold their food in their hands and nibble away. Just keep the focus directly on the hands and mouth to get the best results (**Figure 7.32**).

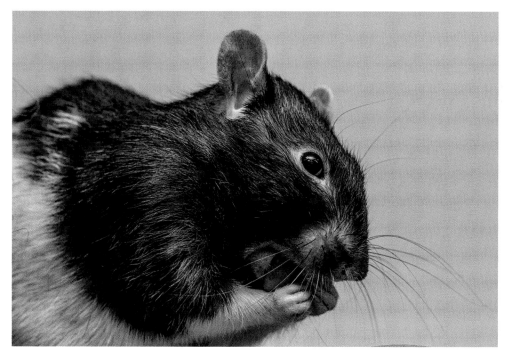

Figure 7.32
This rat has a little snack to keep him busy.

Nikon D4 · ISO 1600 · 1/1250 sec. · f/5.6 · 105mm lens

Chinchillas

Chinchillas are the supermodels of the rodent world. The have lush coats, furry tails, large eyes, and big ears. Because they are also easily stressed and don't like loud noises, photographing them can be slow work. Chinchillas, like mice and rats, are nocturnal and are most active at dawn and dusk, which are the best times to photograph them if you want active shots.

Try to make the photo shoot part of the pet's regular play to get them used to the shutter noises and the camera. As with all the pets mentioned in this book, using a piece of the chinchilla's favorite food can do wonders. Placing an almond or nut into their little hands can make for a great capture. Because chinchillas are very easily frightened, have the pet owner hold them and feed them to keep them calm or as calm as possible.

Chinchillas take dust baths to keep themselves clean. The dust bath helps keep their thick fur smooth and silky, and chinchillas can really get into rolling around in the dust. A special dust is specifically created for chinchillas to take dust baths in. The dust absorbs the oil and dirt from the fur, which cleans the pet. A chinchilla taking a dust bath is a fun opportunity for images, just be sure not to get too much dust on your camera. Chinchillas shouldn't be allowed to bathe in the dust too often because it can dry out their skin. If you know you'll be photographing a chinchilla, ask the owner to hold off on the dust bath for a day or so before the shoot. The length of the dust bath is approximately 10–15 minutes, which is plenty of time to get some amusing photographs.

Using Props

If you ever saw the movie *The Green Mile*, which was based on the Stephen King book, you'll recall that one of the significant plot points had to do with a mouse that did a specific trick. In the movie, the mouse rolls an empty thread spool across the floor. Using props with pet rodents is a very effective way to create great shots. Not only does a spool make a great prop, but also little children's toys and the accessories that come with action figures or dolls. But be sure to keep the pet rodent safe, and don't let it eat the prop unless it's food. When photographing the rat in **Figure 7.33**, I couldn't get her to roll a spool, but she did like the ball of yarn.

Figure 7.33
A simple ball of yarn makes for a great splash of color in this photo of a pet rat.

Nikon D4 • ISO 1600 • 1/250 sec. • f/9.0 • 105mm lens

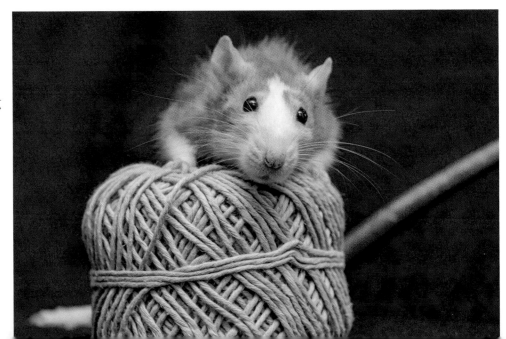

Chapter 7 Assignments

Do Some Research

Understanding why certain animals act in specific ways is very helpful when you need to photograph them. While working on this book, I talked to many pet owners, vets, and others who work with animals. Any information you can acquire will help you capture the pet in the best possible way. Understanding why cats need to stalk prey or how a snake uses its tongue to smell the air can help you get that great shot.

Use a Macro Lens

Getting great results with a macro lens takes practice. The very shallow depth of field can be very tricky to control. You don't have to buy a macro lens because many places allow you to rent one for a fraction of the purchase price. When you're photographing in close and tight, keep your safety and the safety of the pet in mind; some species don't tolerate having anything too close to them.

Step Out of Your Comfort Zone

Some folks don't like reptiles, and others are afraid of horses or dogs. Take the opportunity to go out and photograph an animal you normally wouldn't. Look for the beauty in your subjects, and talk to the owners. Let their love and affection for their pets sink in. Even though you might find it difficult to deal with a certain animal, the owner might love to have a pleasing portrait of their pet.

Share your results with the book's Flickr group!
Join the group here: flickr/groups/petphotographyfromsnapshotstogreatshots

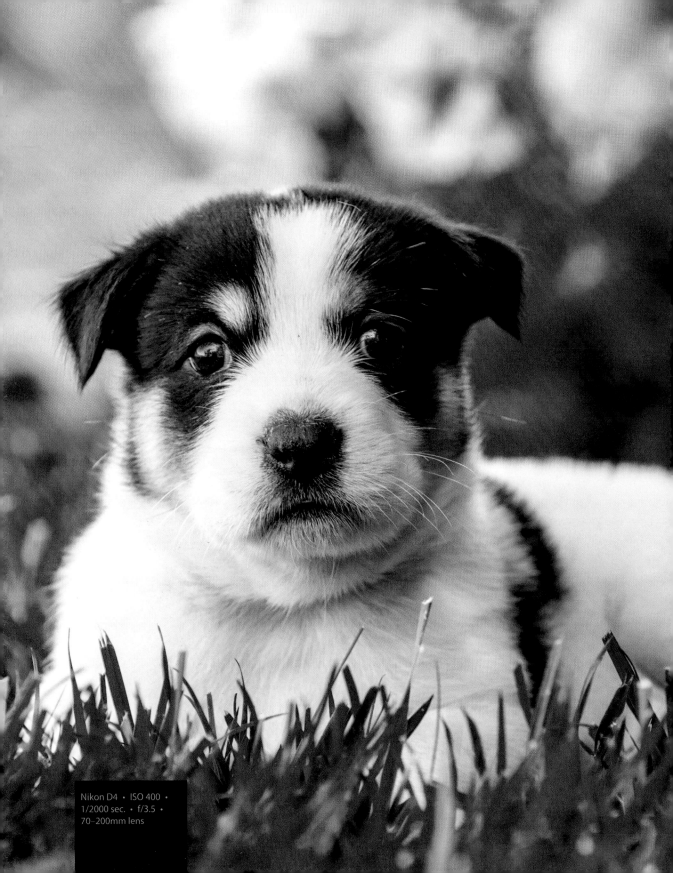

Nikon D4 · ISO 400 ·
1/2000 sec. · f/3.5 ·
70–200mm lens

8

Working with Challenging Subjects

The young and old, multiple pets, and people with their pets

Some subjects are more difficult to photograph than others. These subjects need more time, more patience, or more understanding to get that great shot. Photographing very young pets can be a technical challenge due to how fast they move, their small size, and lack of any training. On the flip side, photographing older pets is not technically more difficult than photographing a young pet but can be emotionally trying. And if you think taking a photo of one pet is a challenge, capturing two or more in the same photo can be a lesson in frustration. In addition, because pets are considered part of the family, getting a photo of the pet with its owners is important and can range from being straightforward to exasperating. All of the aforementioned situations are covered in this chapter, starting with photographing young pets.

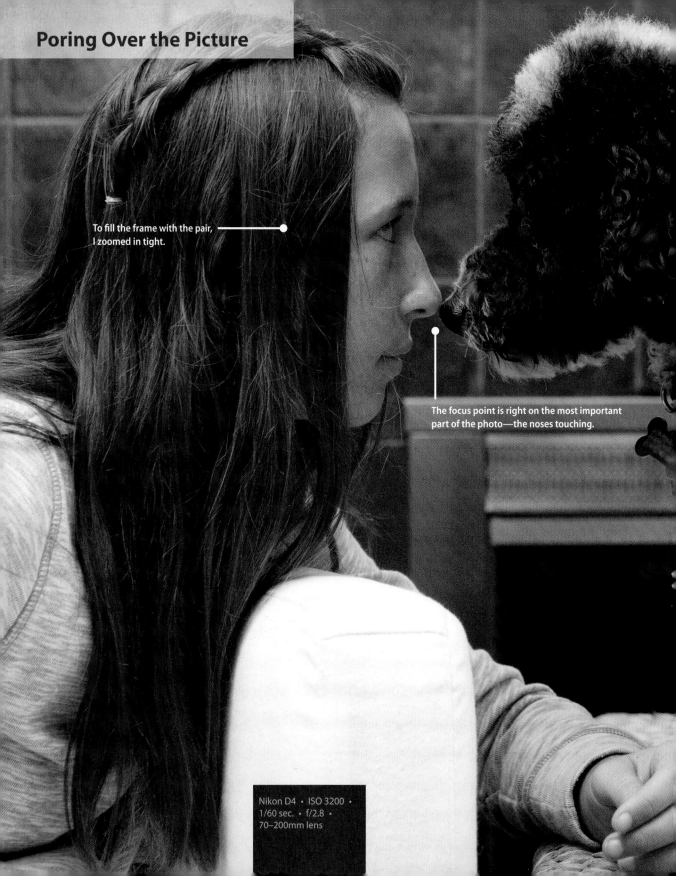

Poring Over the Picture

To fill the frame with the pair, I zoomed in tight.

The focus point is right on the most important part of the photo—the noses touching.

Nikon D4 • ISO 3200 •
1/60 sec. • f/2.8 •
70–200mm lens

While photographing Alfred, a little Poodle-mix dog, in the living room with his owner sitting close by, they looked at each other and then started moving closer until their noses touched. This tender moment lasted only a second or two but made for a great photo of the two of them.

Using a flash aimed at the ceiling added some extra light and evened out the shadows, because the only other light was coming in from a window to the right.

Poring Over the Picture

The 24mm focal length was wide enough to capture both dogs as well as some of the surrounding area, adding a sense of time and place to the photo.

I lay on the ground to get a more intimate angle of the two dogs.

Nikon D4 · ISO 800 ·
1/250 sec. · f/4 ·
24–70mm lens

These two characters were photographed in a park close to their home, where they love to play fetch with a tennis ball or two. They had just brought the ball back when Jackson decided to lay down right in front of me. Meanwhile, Jake looked on hoping for some more fetch action.

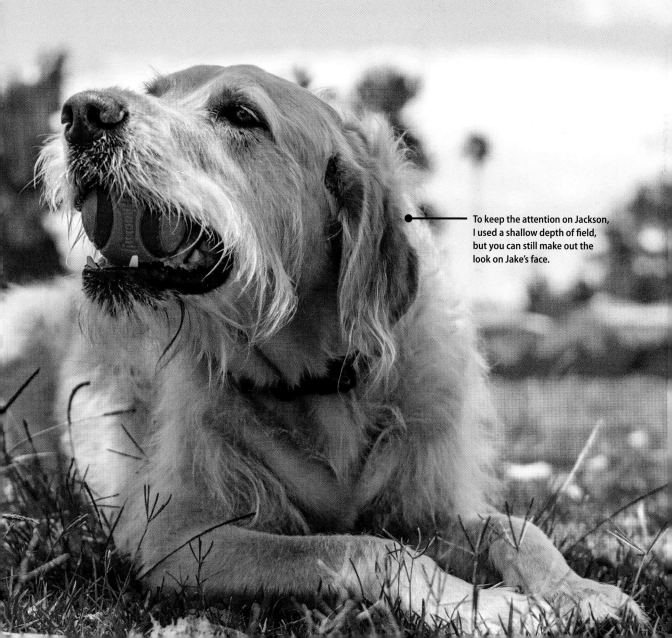

To keep the attention on Jackson, I used a shallow depth of field, but you can still make out the look on Jake's face.

Working with Puppies, Kittens, and Other Young Animals

Everyone loves photos of puppies and kittens. They are so helpless and cute that you just can't help but ooh and aah. When photographing young pets, it's important not to expect too much and to keep the photo shoot fun and flexible. Most of all, have a game plan. Prepare for the shoot so you'll be sure to bring the right gear and choose the right lens to increase your odds of getting great shots. It's equally important to be able to adjust that plan and not get frustrated or stumped when the young pet doesn't want to cooperate. Start with your plan, but be ready to just go with the flow. When photographing the puppy in **Figure 8.1**, the plan was to get a portrait-type shot against a clean background. I rested the backdrop against a wall where it would get a lot of light, and then did some test shots to make sure my camera settings were right. Then it was just a matter of waiting and photographing the puppy as he wandered around the room. I asked the owner to give the puppy a treat when he was roughly in the spot where I wanted to shoot the photo. The puppy hung out there for a few minutes while eating the treat, allowing me to get the shot. I didn't try to pose the dog or force him to sit in a particular spot, but instead just let the natural desire for a treat work to my advantage.

You'll need to consider a few essentials when you're photographing young animals:

- Make sure all the animals and humans are safe.
- Play a little first, and be ready before the shoot even starts.
- Remain calm and let the pets dictate the pace of the shoot.

Figure 8.1 While finishing a treat, the puppy sat in the designated spot.

Nikon D4 · ISO 1600 · 1/1250 sec. · f/4.0 · 70–200mm lens

Keep Everyone Safe

Puppies, kittens, and other young animals don't have fully developed immune systems, which means they are at greater risk to contract environmental germs. For the health of the pet, don't bring them to public pet areas until they've had all their shots.

Young animals want to explore their environment, and most will not have learned what they can and can't jump off yet. If you want to place the pet on a table or chair, have a helper nearby to keep them from leaping before they look. In the same vein, make sure there is nothing in their vicinity that they can chew on or grab and pull that can hurt them. During one shoot, I mistakenly left my camera on the counter with the strap hanging down. True to form, the puppy I was photographing grabbed it and started to pull. The camera started to slide off the counter and would have landed on the puppy; however, I was able to grab it at the last minute. Fortunately, no damage was done to the puppy or the camera, but the incident did hammer home the fact that anything not puppy-safe needed to be way out of his reach.

When you're photographing young pets that can easily be hurt, take extra care to ensure they are in no danger. The shoot location and situation could really limit the amount of time you have to photograph the pet. The baby turtle in **Figure 8.2** was only a few weeks old, making the time available to shoot very short because the owner was not comfortable having the turtle out in the grass too long. We were shooting in a rather large park area, and other animals were close by. We made sure that the turtle was in no danger, but it did reduce the amount of time I was able to spend photographing the baby turtle. I was in place and ready to go with a macro lens to capture the baby's steps, but after a minute or two the turtle needed to be moved back into its enclosure for safety, and the shoot was over.

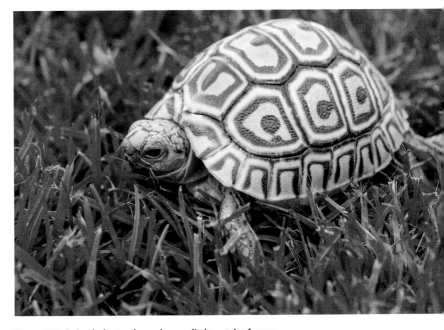

Figure 8.2 **A tiny baby turtle explores a little patch of grass.**
Nikon D4 • ISO 800 • 1/1250 sec. • f/9.0 • 105mm lens

Play First, Photograph Second

Puppies and kittens have a ton of energy and can dart around from spot to spot. A little playtime before the shoot can burn off some of that energy, making it easier to photograph them. Taking puppies out for a walk before trying to get some photos is a great way to use up some of their excess energy and get them used to the photographer. Playing gently with kittens and other young animals, and getting them to chase a toy or run back and forth in a controlled environment will make the difference between a wild pet and one that is just tired enough to sit still for a few seconds.

Young animals usually need more sleep than adult animals, so don't be surprised if after playtime you get only a few minutes of shooting time before it's naptime. The puppies playing in **Figure 8.3** produced some fun photos, but it also helped to tire them out.

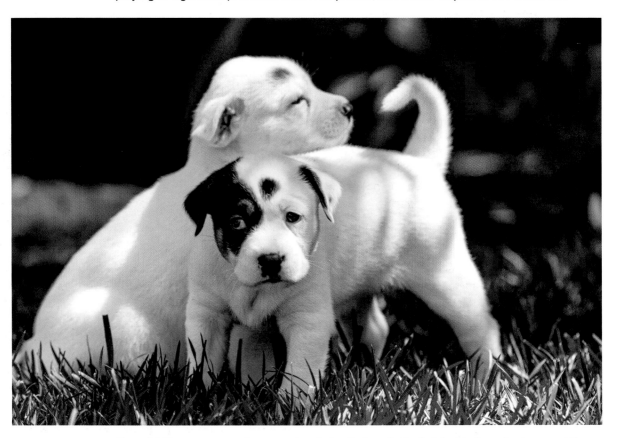

Figure 8.3 **These young puppies were out exploring the lawn for the first time and were having a great time.**

Nikon D4 • ISO 400 • 1/1000 sec. • f/5.0 • 70–200mm lens

Be Ready

The Boy Scouts' motto is "Be Prepared!" It also needs to be the motto for photographers who want to photograph young pets. The camera, lens, lighting, and area you want to photograph in should all be set up beforehand to avoid wasting any time. Here is a list of the tasks I complete in order before each shoot:

1. **Charge batteries and format memory cards.**
 I always start with a freshly charged battery and a formatted memory card in the camera, and carry a charged spare battery and extra memory cards in my camera bag. You have no idea how many photos you will take on a shoot and how long the battery will last. Having spare batteries and memory cards will ensure that you are ready to shoot for as long as you need to.

2. **Look around.** When you are at the location you want to use for the shoot, look around and ask the following questions: Is it safe? Will the background add to the photo or distract from the subject? Is there enough space to work in front of the pet? The answers to these questions will determine if you need a backdrop, which lens you need to use, and where you should shoot from.

3. **Look at the light.** The light in the scene will govern the settings you need and whether or not you should use a flash. It will also establish where the photos should be taken. Is there a large window or door that allows natural light to shine in? Is the area outside, and if so, is some open shade available that you can use to get a nice soft light? If you're inside, can you bounce the light off the ceiling or wall to get a more even, softer light? The puppy in **Figure 8.4** was sitting in the shade at the end of the yard with some light coming through behind him, making for a great photo.

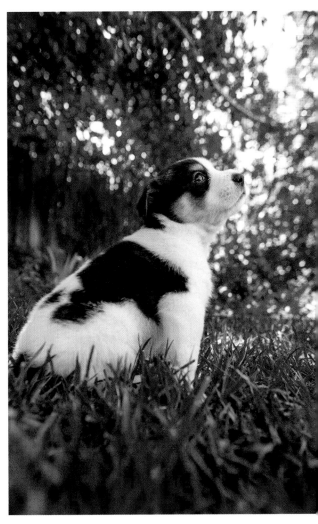

Figure 8.4 **A large tree provided a great spot of shade at the end of the yard with enough light coming through to really illuminate the background.**

Nikon D4 · ISO 400 · 1/400 sec. · f/4.0 · 70–200mm lens

4. **Choose the best angle.** Because I like to photograph on the same level as the pet, I make sure there is a spot where that can happen, one that still gives me the background and light I need for the photo. Some young pets are very shy around new people; therefore, I like to make sure I have a lot of space to work and still manage to give the pet its space.

5. **Choose the lens.** Make sure the lens you want to use is on the camera and ready to go. The focal length will be determined by how much space you have to work with and how much you want to fill the frame with the pet. Wider-angle lenses can be easier to work with because they capture more of the area in front of the camera as well as a moving pet. You can always crop photos later if needed.

6. **Set the exposure.** Using a shutter speed fast enough to freeze the action is important, especially with young pets that move quickly. I start with the camera in Aperture Priority mode and choose an aperture that will have the desired depth of field, usually around f/5.6 so the animal's eyes and nose are in focus. Then I set the ISO depending on the amount of light. The more light, the lower the ISO can be. For low light, I set it to ISO 1600; with plenty of light, I set it to ISO 400. Then I take a test shot, and the camera picks the shutter speed. I want the shutter speed to be at 1/250 of a second or faster. If the camera indicates a speed lower than that, I increase the ISO. Then I'm ready to go when the pet arrives.

7. **Take a test shot.** Once the pet arrives, I take a quick test shot to check the exposure (**Figure 8.5**). I check the photo on the screen on the back of the camera. If the pet looks too light, I dial in −.3 or −.5 exposure compensation; if the pet looks too dark, I dial in +.3 or +.5 exposure compensation and try again. Once the exposure is fine-tuned, I can start the shoot.

Figure 8.5
Here is a test shot I took while this puppy was eating.

Nikon D4 · ISO 1600 · 1/250 sec. · f/2.8 · 70–200mm lens

8. **Take a lot of photos.** Memory is cheap and you can always delete the bad shots, so take as many photos as you can, while you can. Keep the camera on Continuous Shooting mode and Continuous Autofocus mode, and keep the focus point right on the most important part of the subject, usually the eye.

Be Calm

Young animals can be more frightened of new people and new sounds than older animals. Where a squeaky toy might bring an adult dog running toward you, the same toy could send a puppy scurrying away. I witnessed this firsthand with our two dogs: Odessa loves to greet new people and moves toward them happily; Hobbes tends to shy away, and, as a puppy, would hide behind my leg. If you're trying to photograph a very shy or scared puppy, take it very slow and remain calm. Let the pet owner interact with their pet while you just stay still and photograph from a greater distance. A photograph of a scared puppy will not please anyone. If necessary, have the owner just hold the puppy or kitten on their lap. Hopefully, they will calm down and get used to you. If the pet falls asleep, that works too because a sleeping puppy makes a great photo. Remember to be flexible with your plans.

Let Young Pets Be Themselves

The best way to get great photos of puppies, kittens, and other young pets is to just let them do what they want to do naturally and capture it. Once you have the location set up and the safety of the pet and people is ensured, just let the puppy be a puppy. The same goes for photos of kittens. Give them some yarn or a toy to play with. They will have fun, and you will get some great photos while they expend some of that energy. When they start to wind down, it will get easier to photograph them. The puppies in **Figure 8.6** were exploring the lawn area for the first time, and even as they tried to wander off on their own, mom was still around to check in on them. After a little while exploring it was naptime, and in **Figure 8.7**, Grace Kelly thought that the flowerbed made a great spot to rest her head for a few moments.

Figure 8.6
These young puppies were still under their mother's watchful eye. She was around to reassure them and make sure they didn't wander too far away.

Nikon D4 · ISO 400 · 1/5000 sec. · f/4.0 · 70–200mm lens

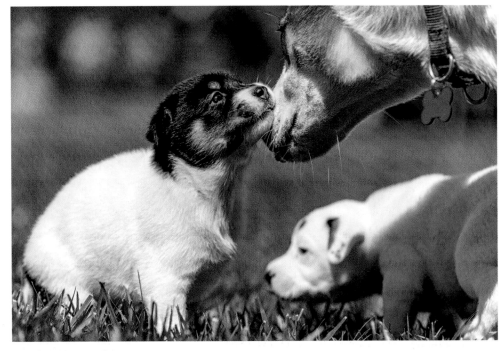

Figure 8.7
Puppies need their sleep, and this one thought the best place for a nap would be the flowerbed.

Nikon D4 · ISO 400 · 1/200 sec. · f/5.0 · 70–200mm lens

A final word on photographing young pets is that sometimes you just need to pack it in and try again at another time. There's no point in getting upset or frustrated with the pet, because they are just doing what comes naturally, not trying to ruin your photo shoot. If you're photographing someone else's pet and can't reschedule, just take a 10-minute break. Put the camera down and walk away for a while. Come back in a few minutes and try again.

The Challenges of Older Animals

Older pets need a little more time, tenderness, and care when they're getting their photo taken. Unless you have one of the pets that can outlive their human companions, most likely you'll have to deal with a pet getting older and finally passing away. Many people first learn about life and death with the passing of a pet, and although it is very emotionally draining, photographing an older pet can be very fulfilling. On numerous occasions I've been asked to take a final portrait of a family pet that is near the end of its life. Although I dread these calls, I know how important these images can be. In **Figure 8.8**, you can see a lot more gray in Odessa's muzzle as she gets older. She might not have the same spring in her step as she once did and getting a portrait takes a little longer, but it is well worth having these photos.

Figure 8.8 Odessa poses on the back deck. Even though the amount of gray in her coat seems to increase daily, she is still a beautiful dog.

Nikon D4 • ISO 1600 • 1/160 sec. • f/2.8 • 70–200mm lens

Go Slow

Older pets and those in poor health tend to move slower or don't want to move at all. It can heart-breaking to see a once-active pet slow down to the point where they would rather not get up when you ask. Just take it slow, and try to work around where the pet has decided to sit or lie down. The bodies of some older dogs and those in ill health can display visual areas where fur is missing or where you can

see a tumor or other growth. You need to carefully watch the angle at which you shoot, and try to minimize these areas in the photos as much as possible. Also, some aging pets can become hard of hearing or deaf. In such cases, it is difficult to get the pet's attention using a verbal command, so you'll have to rely on the owner to help get the pet's attention and pose it in the right direction.

Many pets have a favorite spot where they like to spend their time. You get used to seeing your pet in this spot, and it becomes part of what makes them unique. Taking photos of them in this spot will have more meaning later on when that pet is no longer with you. Our cat, pictured in **Figure 8.9**, used to love hanging out on the deck railing in the sun. This photo of her in that spot means more to us because we know it was her favorite spot. Discuss with the owner where their pet likes to spend its time so you can capture that photo. It might not be the prettiest area or the best spot for a photo, but it will have an emotional impact they will appreciate in the years to come.

Figure 8.9
**At the age of 14
our cat loved to sit
outside on the deck
rail, trying to scare
away the birds.**

Nikon D2X • ISO 200 •
1/160 sec. • f/5.6 •
24–70mm lens

Just because a pet is in its golden years doesn't mean you should let your guard down or assume the pet will be friendly to you. Sometimes elderly pets can be rather set in their ways and not want to meet new people. It is also possible that the pet might be in some discomfort and may not want to pose or move.

As pets get older, they can start to forget their training, and their behaviors can change. For example, dogs that used to be friendly to everyone can start to shy away from strangers and can become distant and uninterested in the things that used to motivate them. To keep your pet healthy and happy, it helps to continue to play with them and keep them active as they age.

Make the Shoot Special

Make the photo shoot special for the pet. For example, get a batch of their favorite treats or something special they like to eat. Or take them for a car ride or to their favorite spot, like the park, or for the dog in **Figure 8.10**, to the beach. We never really know how much time we have with our pets, so make the most of every opportunity.

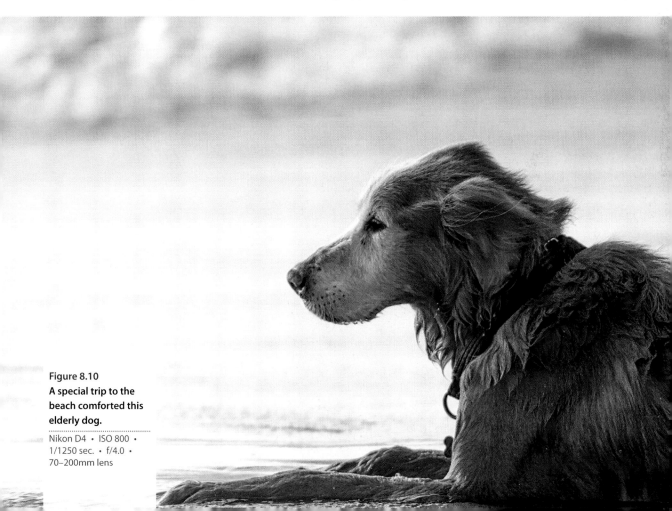

Figure 8.10
A special trip to the beach comforted this elderly dog.

Nikon D4 · ISO 800 ·
1/1250 sec. · f/4.0 ·
70–200mm lens

In these special locations, take as many photos as you can because certain situations might not happen again. When a pet is very sick or near the end of its life and you know it will be their last trip to the park or to the beach, make it as joyful as possible and focus on the great life they've had.

Final Portraits

The difficulty in photographing senior pets is not in the technical settings. It isn't that the pets are untrained or might try to run away. The real difficulty in photographing senior pets is that it is sad to see a pet that is no longer able to do what they used to do. The emotional toll of this type of photograph can be very high. The images you take might be the last great photographs of this animal before they pass away, and that can be a tremendous weight to carry. The portraits of the dogs in **Figures 8.11** and **8.12** were taken in their advanced years to make sure the owners had commemorative photos of the dogs after they passed away. The owners didn't want to wait until the last minute to get a portrait of their dogs, but instead tried to capture great images all through their lives, from the puppy stage to their declining years.

Figure 8.11 (left)
Duchess, the Great Dane, had a great face, even as she got older and grayer.

Nikon D700 ·
ISO 400 · 1/250 sec. ·
f/4.0 · 70–200mm lens

Figure 8.12 (right)
This portrait of Murphy was taken as he got on in years. The owner wanted to make sure she had a portrait of him while he was still healthy and active.

Nikon D4 · ISO 200 ·
1/250 sec. · f/9.0 ·
70–200mm lens

Photographing Multiple Pets

Photographing one pet can be a challenge, but photographing multiple pets simultaneously should not be tried alone unless you enjoy being irritated. Some pets are very well trained and will sit and stay while other animals walk around them. These pets can hold a pose like a professional model. When you work with these pets, photo sessions will be that much easier, but most of the time, working with multiple pets is a coordination nightmare.

With multiple pets you'll have a choice of two types of photos: those that are posed and those in which you just capture the interaction between the animals. The two dogs in **Figure 8.13** were playing together chasing a ball. But then they slowed down and just started walking together, which was a perfect time to get a photo of the two of them.

Figure 8.13
These two love being with each other, and it was easy to get a photo of them together as they walked toward me.

Nikon D4 · ISO 1600 · 1/2000 sec. · f/5.6 · 70–200 mm lens

Posed Shots

Animals have a distinct hierarchy that involves a leader and a follower or a dominant and submissive animal. The submissive animal will usually go along with what the dominant one does. You can use this behavior to get the pack under control because the leader of the pack will look up to you.

These are the steps I follow when I'm setting up a posed shot:

1. **Choose the location.** Choose a location that allows all the animals to fit comfortably and gives you enough space to work. Make sure the area is containable so the pets can't run away (assistants can help). I prefer to shoot outdoors in open shade so the light is even across the entire scene. When shooting indoors, I look for an area that is lit by a large window or has a wall or ceiling I can use to bounce the light from a flash.

2. **Set up the camera.** Set up the camera before the animals are in place. You won't have much time to tinker once the pets are posed. Place a substitute model in the same spot to set the exposure mode. When photographing multiple animals, you'll need a deep depth of field to keep all the subjects in acceptable focus. You can use the depth of field to decide which of the pets will be the center of attention.

3. **Anchor one pet.** In my experience it is easier to start with one pet, the best-trained one, and place it as an anchor. Then add the other pets to the scene. The number of pets is limited only by how well trained the animals are and the number of assistants you have to maintain order.

4. **Use assistants.** Trying to control multiple animals and at the same time compose the scene and take a photograph alone is practically impossible. You need help. Solicit help from the pets' owners or some of your friends. Have them try to keep the animals' attention and focus until you're ready to take the photos. Discuss exactly what you want before the shoot to ensure that everyone is on the same page from the start.

5. **Shoot fast, shoot often.** I start taking photos as the animals are being placed into position, and I continue to take photos as long as they are all in position, which usually isn't a very long time. When the first pet is in the light, I take a shot to check the exposure and make any fine adjustments. Then it's just a matter of taking photos throughout the entire process.

The group photo shown in **Figure 8.14** was taken in a backyard in the biggest area of shade possible. These dogs were all trained to some degree, but it was still tough getting the six of them together in one photo. Because this shot was taken at the end of

the afternoon, they had all spent a good deal of time running and playing so they were tired, making it easier to get them to sit calmly. Four other people were nearby helping me keep control of the pack. But as soon as the dogs were all sitting, I got off only about eight frames before one or another of the dogs started to get restless and wander off. In the image you can also see how the background is in acceptable focus due to the deep depth of field used to make sure the dogs were all in focus.

When you're photographing multiple pets that don't or can't follow verbal commands, use treats to get them into the desired position. The two lizards in **Figure 8.15** were easy to pose because they both wanted the mealworm treats we were using to get them into position.

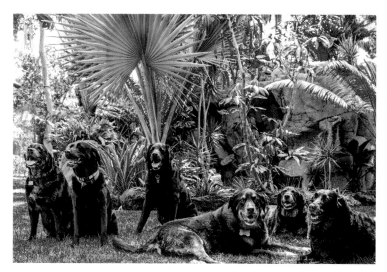

Figure 8.14
It is much easier to work with a group of dogs after they've been playing and burning off some energy.

Nikon D700 · ISO 1600 · 1/500 sec. · f/9.0 · 24–70mm lens

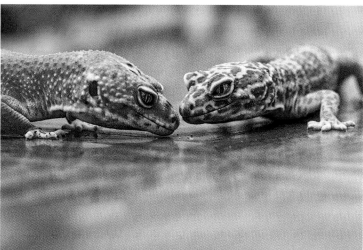

Figure 8.15
These two lizards were looking for another treat when I took the photo using a macro lens to get in close.

Nikon D4 · ISO 1600 · 1/500 sec. · f/9.0 · 105mm lens

Playtime

Photographing animals playing together or just hanging out together can be easier than trying to set up a portrait-type photo. As an added bonus, when you photograph the pets as they interact with each other, you can capture some of their personality and behaviors that you don't see until you freeze them at high shutter speeds. For example, the dogs in **Figure 8.16** are actually playing together, not fighting, even though you see a lot of teeth. To the naked eye, these two dogs were just running on the beach, but at 1/3200 of a second, the photo tells the real story.

Before you start photographing animals playing together, take a few moments to watch how they interact. Make a mental note of which of the animals is instigating the behavior and which is following along. Watch the direction of the play. Are they running into an area of better light, or is the light the same everywhere? How about the background and the speed of play? Is the background plain and uncluttered, allowing you to use a deep depth of field and not be distracting, or does the background need to be blurred with a shallow depth of field? Are the animals running at full speed, which requires a very fast shutter speed, or are they moving slowly, not needing as fast of a shutter speed? The answers to these questions will help you set your camera to capture the action properly and the multiple pets interacting.

Figure 8.16
Running and playing together on the beach, these two were having the best time retrieving the ball from the surf and then racing back to their owner, only to repeat the activity.

Nikon D4 • ISO 800 • 1/3200 sec. • f/4.0 • 70–200mm lens

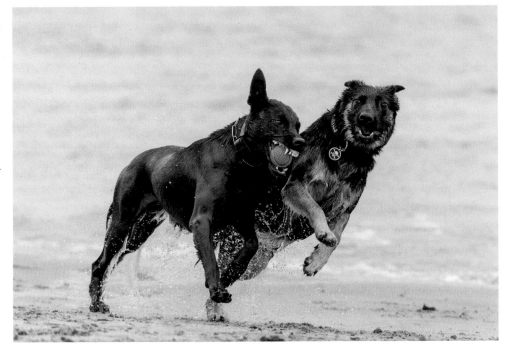

One of my favorite photos of our two dogs shows the first time they played together in the yard. In **Figure 8.17**, you can see the older, bigger Odessa running and playing with the much younger, smaller Hobbes. I watched them run back and forth before positioning myself perfectly so the dogs were running toward and away from me, allowing me to capture them head-on.

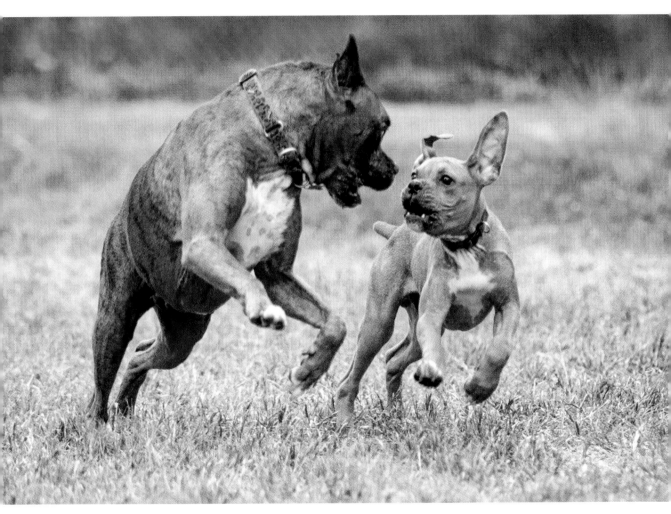

Figure 8.17 **While my dogs played together for the first time, I used a wide aperture to blur the background, but because the dogs were far away and their heads were close together, they are in acceptable focus.**

Nikon D700 · ISO 1600 · 1/500 sec. · f/2.8 · 70–200mm lens

One of the best times to get a photo of multiple pets is when they start to wind down after playing and take a break. Using a long lens will allow you to capture the moment without getting too close or disturbing them. A shallow depth of field can also help make the subject clear. In **Figure 8.18**, I really loved how the second cat was looking out over the head of the first cat, but I wanted to make sure the subject was the cat in front: The f/2.8 aperture blurred the second cat slightly.

Figure 8.18
These siblings just lined up perfectly as they watched me warily from a distance. The second set of eyes peering over the top of the cat in front made for a compelling composition.

Nikon D4 · ISO 1600 · 1/640 sec. · f/2.8 · 70–200mm lens

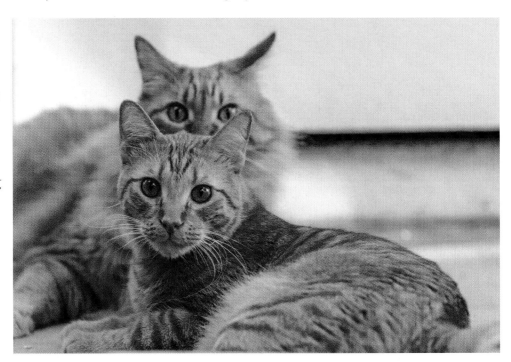

People and Their Pets

So far, this book has been about photographing pets alone or with other animals. Pet owners have been tapped as a source of information about their pets or put to work assisting in the actual photo shoot. But now let's consider how to photograph pets alongside their humans. **Figure 8.19** shows a photo I took of my wife and our dog on a trip to Chico some years ago. While walking through a park, the position of this fallen tree made for a great prop. I had the dog climb up to sit next to my wife in the shade and then called to them to look over at me. Because we consider our pets part of the family, this photo will remind me of a moment I will always treasure.

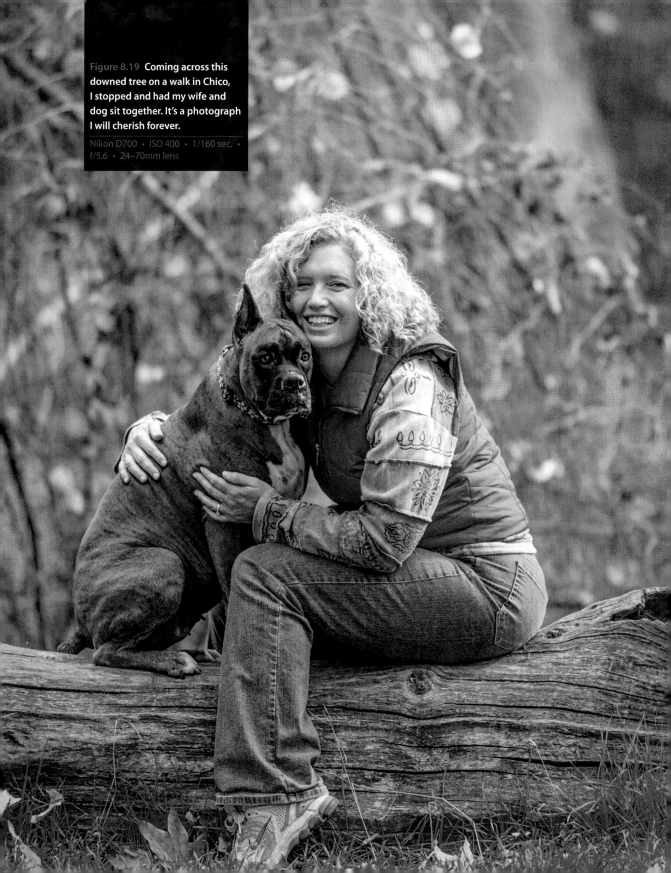

Figure 8.19 Coming across this downed tree on a walk in Chico, I stopped and had my wife and dog sit together. It's a photograph I will cherish forever.

Nikon D700 • ISO 400 • 1/160 sec. • f/5.6 • 24–70mm lens

Part of the Family

My wife and I are not alone in considering our pets as part of the family. Many people feel that way about their pets, and no family photo would be complete without including them in it. Many times it is easier to get a photo of the pet with the family or a family member than alone. The pet feels more comfortable and secure with trusted family members close by. But it can also be more difficult to get the people to pose naturally than the pet. Pets have no vanity and don't care how they look to the camera; they just live in the moment, whereas people can be trickier to photograph. In my experience, I've found that if you photograph a person and their pet for long enough, usually the actions of the pet will give you the best shot. In **Figure 8.20**, I was taking a series of photos of three dogs and their owners. As this dog and its owner were sitting looking at the camera while I took a few frames, the dog suddenly turned and licked the owner's face. The pure spontaneity of the moment made it my favorite frame of the entire shoot.

Composing a photo of an entire family is the same as composing a shot of multiple pets. You need to decide on a location big enough for every one, choose the best angle for the available light and background, and then anchor one person and build the group around that person.

Figure 8.20
You have to be ready to capture those unexpected moments, such as when your model turns and licks his owner's face.

Nikon D4 · ISO 400 · 1/250 sec. · f/2.8 · 24–70mm lens

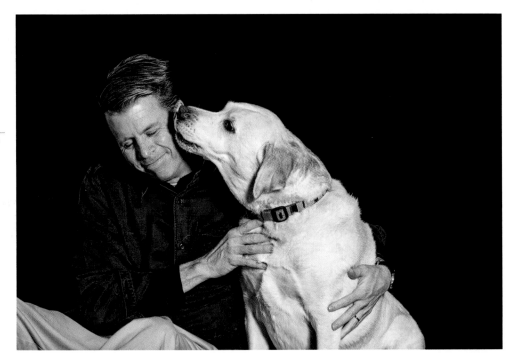

Focus on the Pet

To keep the pet as the main subject, even in photos where the pet is together with its humans (after all, this is a pet photography book), here are a couple of techniques to use:

- **Focus point.** One of the easiest ways to keep the attention on the pet is to just make sure the focus point is on the pet when you're taking the photo. It sounds simple, and sometimes simple is best. The viewer's eye will be drawn to the most in-focus area of the photo, so make sure it's the pet. In **Figure 8.21**, I made sure the focus point was on the dog's face, and with a relatively deep depth of field, the girl is mostly in focus.

- **Depth of field.** If the pet and the owner are not right next to each other, you can use the depth of field to keep the attention on the pet. The greater the distance between the pet and the person, the easier it is to separate the two.

- **Partial body shot.** When you're photographing a very small pet, like the snake in **Figure 8.22**, consider using only part of the owner's body in the photo. With other pets, like a dog or cat, you can just show the human's legs with the pet sitting in front of them, or a hand feeding a horse a treat.

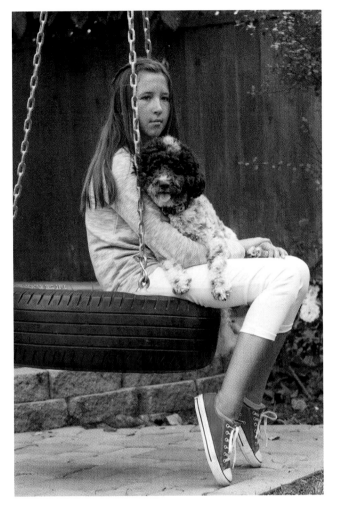

Figure 8.21 I love the way the red shoes and the yellow chain add a splash of bright color to this shot of the Poodle mix and his owner.

Nikon D4 · ISO 800 · 1/500 sec. · f/5.6 · 70–200mm lens

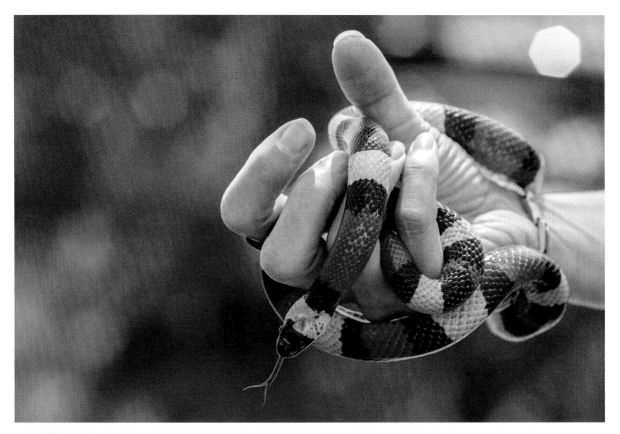

Figure 8.22 The small snake is intricately wrapped around its owner's hand.

Nikon D4 · ISO 800 · 1/500 sec. · f/2.8 · 105mm lens

Candid Moments

Capturing the interaction between a pet owner and their pet makes for a powerful image. You can see the bond between the two in those moments, and the images will speak volumes about the relationship. Candid images tend to be evocative and can tell a story in a way that posed images don't. More photojournalistic than portraits, these images can be more difficult to capture. In **Figures 8.23** and **8.24**, I wanted to capture the relationship between the horse and the owner, not only in the training pen but also on the way back to the barn. I scouted the locations before the shoot started so I could be in place without disrupting either the horse or the owner.

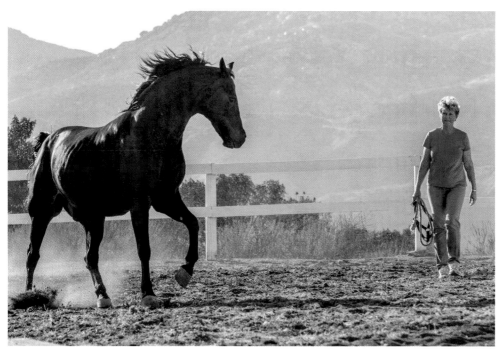

Figure 8.23
I waited to take this shot until the horse and the owner were looking at each other in the training pen.

Nikon D4 · ISO 800 · 1/2000 sec. · f/5.6 · 70–200mm lens

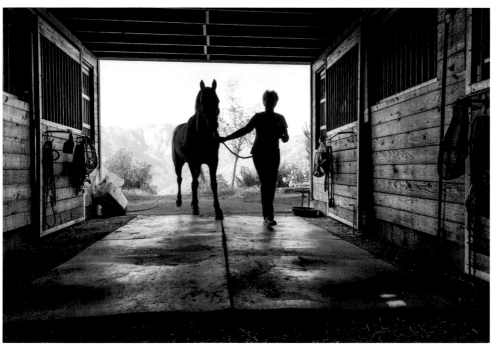

Figure 8.24
At the end of the shoot, the owner walked the horse back to his home. I had seen how the light looked coming in through the barn doors, so I made sure I was in position to capture this moment.

Nikon D4 · ISO 800 · 1/250 sec. · f/5.6 · 24–70mm lens

Here are some tips that can make capturing that candid moment easier:

- **Know your gear.** The better you know your gear, the easier it is to change settings while shooting without having to look at the camera. Practice at home by holding your camera, changing the shutter speed, and changing the aperture without looking at the camera. When you're out shooting and want to change the aperture, you won't need to take the camera down from your eye.

- **Use Aperture Priority mode.** This is my preferred mode when I'm shooting in changing light. In this mode I control the aperture, which controls the depth of field. I can also control the shutter in a roundabout manner, because as I open the aperture wider, the shutter speed increases. If I'm using a particular aperture and the shutter speed looks too low, I'll increase the ISO.

- **Choose the best metering mode.** Because Aperture Priority mode uses the information from the built-in light meter to set the shutter speed, it's important to choose the best metering mode for the situation. I start with Matrix Metering, which does a good job in most situations, unless large areas are very bright or very dark; in that case, I use Spot Metering.

- **Push the ISO.** For candid photography, I prefer not to use the flash because it can be distracting and draw attention to the camera. Instead, I'll increase the ISO as needed so the shutter speed doesn't drop too low. I'd rather have some digital noise in the image than use a flash and ruin the moment.

- **Move around.** As the pet and owner interact, keep looking for the best angle and move around. You always want to be thinking and planning on where to move in relation to your subjects so you can get the best shot possible.

- **Watch the background.** As you move around and watch your subjects in the viewfinder, you might become so focused on the interaction that you stop looking at the background. An unattractive background can really mess up an otherwise great photo, so make sure you keep an eye on what's going on behind the action as you move.

Pets bring a lot of joy into the lives of those who spend time with them; be sure to let that joyfulness come through in the photos.

Chapter 8 Assignments

Photograph Dogs Playing Together

Go out to any leash-free area or park and practice capturing dogs at play. Watch how they run together and use their bodies and voices to communicate with each other. Practice getting two or more dogs in the same frame with both in sharp focus.

Compose People and Pets

Work on different groupings with pets and people at the same time. When you're working with small children, it is sometimes easier to position the pet first, and then bring in the small children. It takes patience and perseverance to get these type of shots, so it's best to practice when the subjects are not expecting you to create a masterpiece. When I want to practice this composition, I just ask my neighbors if they have a few minutes to pose with their cats and dog. It's a lot less stressful and makes it easier when you're working for hire or when you're trying to get that special shot during a family reunion.

Practice Taking Candids

The best way to get better at taking candid photos is to practice, practice, and practice some more. Grab a friend who has a dog or cat and just try to capture them playing together. It can be more difficult than you think. Keep in mind all the tips and techniques discussed to get that great shot. Get down on their level, keep the focus on the eye, stay safe, and have fun.

Share your results with the book's Flickr group!
Join the group here: flickr/groups/petphotographyfromsnapshotstogreatshots

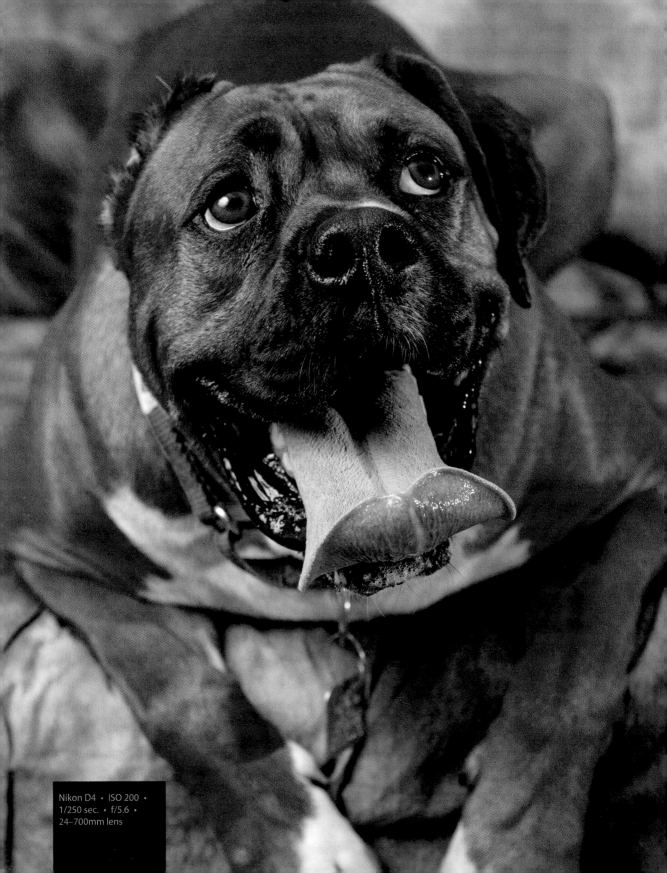

Nikon D4 · ISO 200 ·
1/250 sec. · f/5.6 ·
24–700mm lens

Appendix
Working with Rescue Organizations

A Great Way To Practice and Give Back

Many of the animals whose photographs grace these pages have spent time at a rescue organization. Some are still there. It would be ideal if every animal that needed a home got one, and one way to help attain that goal is to provide quality photos for the rescue to use. In addition to the feeling of goodwill knowing that you are trying to be part of the solution, as the photographer, you'll get lots of practice and access to an abundance of willing subjects.

Photography Can Help Shelters

Great photos can help all those animals sitting in shelters in three ways. First, great shots draw the attention of perspective adopters and can reduce the time it takes for an animal to get adopted. The more interest in an animal, the faster it is adopted, which opens up more space for another animal to be rescued.

Second, great shots of the pets can be used to create postcards, calendars (**Figure A.1**), and other pet-related products that can then be sold to raise money for the organization. This is a great way to fundraise and raise awareness, and works especially well for the breed-specific rescues. Creating products does take more time and effort because you need to work with a designer and printer to make the products, and you need a way to sell or distribute them as well.

Third, you can offer a photo package of great shots to those adopting the pet. For example, you can do a portrait of the animal and its new family. This portrait can be taken at the animal's new forever home or set up at the rescue, and the photo can also be used to show the success stories of the animals from the rescue organization.

Figure A.1
An example of a calendar mockup created for the Last Chance at Life rescue organization.

Nikon D4 · ISO 400 · 1/250 sec. · f/9 · 24–70mm lens

Choosing the Right Rescue

Before you just show up at a rescue with your camera willing to work, you need to consider a few factors.

Choosing the right organization to work with is important because your reputation can and will be linked to theirs when you start to work together. Sometimes an organization might have the best intentions but fails to follow through on what it promises, or people running the organization might not act in a professional manner. That reputation can then follow you just by association. But many rescues are run by people whose main goal is to save the animals and get them into good homes. However, they might not understand the power of photography or what it can offer them.

Don't be afraid to ask them questions about how the rescue is run and what they need and expect from a photographer. Once you start working with a rescue organization, your character and standing will be related to theirs. Therefore, consider answering the following questions before you decide to work with an animal rescue.

Does the organization specialize in one type of animal or breed?

If you want to work with a variety of subjects, you need to find a rescue that shelters more than one specific breed. Many rescues try to focus on one type of animal or breed because it is easier for them to target a certain type of adopter. For example, if they rescue Chihuahuas exclusively, they only have to reach out to small-dog lovers to try to find homes. However, working entirely with one breed allows you to learn a lot about that specific animal, which can make you very good at working with them, somewhat like a breed specialist. And there is nothing wrong with that, especially if that is where your heart is. We have two rescued Boxers, and I really love working with them and other large breeds. So, for the past two years I've helped the photographer at a rescue that mainly deals with Boxers and other big dogs (**Figure A.2**). But some people need more variety in their lives and in their photo subjects; if that's you, consider

Figure A.2 Bam-Bam is 120 pounds of big-dog love, and yes, big dogs tend to drool.

Nikon D3200 • ISO 800 • 1/400 sec. • f/3.5 • 40mm lens

working with an organization that takes in all kinds of animals. Remember that all kinds of rescue organizations exist, and range from those dealing with rabbits to horses and even rodents. Choose one that you are interested in on a personal level.

How big is the organization?

Will you be working with just one or two people, or does the organization employ many workers, use several volunteers, and have a proper organizational structure? The size of the organization will determine who you work with and how much help you can get. Some rescues consist of just a few people trying to do everything from making sure the animals are healthy and exercised, and groomed and looking their best, to going to adoption events to try to find the animals new homes. With these smaller rescues, it is more likely you'll be working on your own, meaning that you won't have anyone to assist you on a regular basis. Making each photo will be more work, but you'll also have more flexibility as to when you're able to volunteer and take the photos. Consider what your style is: Do you enjoy the challenge of working alone or prefer to have someone with you helping out? In my experience, working alone while trying to take pet portraits is very difficult.

Larger organizations can have a more rigid structure that you will have to fit into. They probably already have someone who takes photos for them, and they might even have a set time when the photos are taken. But perhaps they need someone to act as a photo assistant to just step in when their regular photographer is busy. It's always best to ask to work with the regular photographer, not take over their job. Don't be surprised if you experience a little resistance at first, because many rescue groups are very close-knit and might consider you an outsider.

Does the rescue use foster homes?

Some rescue groups use foster homes while the pets await adoption. This is a huge advantage for the pet because it can help them become more socialized and get trained, and usually offers a much calmer environment compared to a kennel-type situation. Foster homes can also offer a wider range of photo opportunities and the chance to show the pet in a more inviting environment.

Does the rescue work with a vet?

A reputable rescue will have a positive and beneficial working relationship with a local vet. The health of the animals will be of utmost importance to the rescue; if it isn't, there is a problem. Ask to speak to the vet to ensure that the organization is putting the health of the animals first. If the organization has a bad reputation in the veterinary community, find another rescue to work with.

Does the rescue understand your copyrights?

The rescue might not understand all the copyright issues involved in photography. Remember that you own the copyright on the images that you take, but you're allowing the rescue to use them. It is best to make sure that you and the rescue are on the same page from the start, so discuss the usage of the images up front. Will the rescue use the images on the Internet only, or does it plan on creating products for sale? If your images will be used on products that generate income, ask where that money is going or how it will be used.

Rescue Photography Tips

Here are some specific tips to put into practice when you're working with rescue animals:

- **Play first, photos second.** It's a lot easier to photograph a pet after they've had a little exercise and have calmed down a bit. Many rescues use volunteers to walk the dogs or play with the cats. Photograph the pet at the end of their walk or playtime when they've had time to release some of their pent-up energy.

- **Have a dedicated photo spot.** One of the hardest places to photograph pets is in the kennel environment. It's loud, distracting, and generally not very attractive. Try to create an area where you can take the pets and photograph them in relative peace. Consequently, you'll produce quality, consistent results. As you can see in **Figure A.3**, the area doesn't have to be huge; it just needs to have enough space for the pet to sit comfortably.

Figure A.3
The setup for the rescue pet portraits. One off-camera flash fired through an umbrella and a cloth backdrop transforms the room into a makeshift studio.

Nikon D4 · ISO 200 · 1/250 sec. · f/5.6 · 24–70mm lens

- **Have help, but not too much.** In my experience it's best not to have too many helpers, because instead of helping, they can act as distractions for pets. With the photo-shoot area set up, you really need only one assistant to help position and pose the pet. With more people in the room or in close proximity to the pet, the more preoccupied and confused the pet will be trying to keep track of everyone.

- **Be truthful.** Some of the pets that end up in rescues are there because they are unique looking or have some medical issues. This could entail scars, injuries, or other abnormalities that you might have an urge to cover up or hide. Resist that urge, and make sure the photographs show the pet exactly the way they look. You are not helping anyone by hiding the negatives.

- Once you've set up an area for the photography and have enlisted an assistant to help position the pet, the actual photography is pretty straightforward. The photos of each dog in **Figure A.4** took less than 5 minutes. After each had the opportunity to sniff the room and check out the light stand, the dog then sat on the bench. While the assistant kept their attention, I just took the photos.

As you can see from these images, the overall look is the same and very generic, keeping the focus on the pet. The room being used is an old vet's office that the rescue uses as its main location. The entire process, from setting up the area to photographing the seven dogs, to then breaking down the setup, took less than 2 hours. Also, the cloth backdrop I used was easily washable after use.

Figure A.4
Portraits of the dogs in the rescue shelter.

Nikon D4 · ISO 400 · 1/250 sec. · f/9 · 24–70mm lens

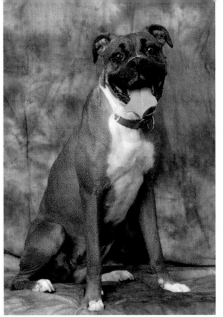

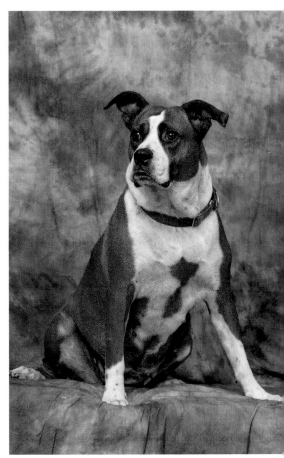
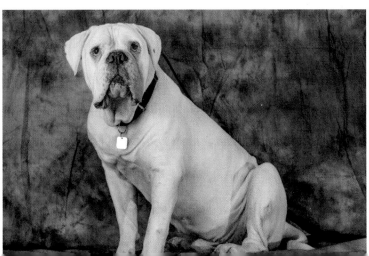

Index

stress signs, 79–87
 in birds, 86–87
 in cats, 82–83
 in dogs, 79–81
 in horses, 84–85
 in reptiles, 85–86
sunlight
 action photography in, 98
 available light from, 27, 128–134
 pet portraits using, 128–134
 white balance setting for, 30
 See also available light
Sunlight white balance, 30
supplemental light, 27
sync speed for flash, 109–110

T

tail actions, 81
telephoto lenses
 cropped sensors and, 53
 focal length of, 58
 pet photography using, 77
terrier group of dogs, 153
test shots, 198
tongue flick by snakes, 178

toy group of dogs, 153
treats, 16, 139–140, 163
tripods, 166, 167, 168
TTL metering mode, 135
turtle photography, 86, 179, 195

U

umbrellas, 64
underexposure, 36, 42, 43
up lighting, 32

V

variable maximum aperture, 61

W

whining dogs, 81
whinnying horses, 84
white balance settings, 30–31
white (or lighter) animals, 101, 102, 160
white reflectors, 63
wide-angle lenses
 cropped sensors and, 53
 distortion caused by, 10

focal length of, 58
window light, 130
working group of dogs, 153

X

XQD memory cards, 68, 88

Y

yawning dogs, 81
young animals, 194–201
 being calm with, 199
 playing with, 196
 preparing to shoot, 197–198
 safety considerations for, 195
 shooting many photos of, 199

Z

zoom lenses
 focal lengths of, 11
 maximum aperture of, 60, 61
zooming flash head, 62